Art Recollection

EDITED BY
GABRIELE DETTERER

Art Recollection

Artists' Interviews and Statements in the Nineties

DANILO MONTANARI & EXIT & ZONA ARCHIVES EDITORI

Edited by Gabriele Detterer
Layout by Matteo Nannucci and Mauro Pispoli
Translations by Henry Martin, John Southard
Proof reading by Nadine Rosenberg
Published by Danilo Montanari & Exit & Zona Archives
Lithographes by Mani Fotolito, Florence
Typesetting by Arte e Professioni, Florence
Printed by Tipografia Morandi, Fusignano (Ravenna)

We wish to thank all the artists, critics and authors,
who were involved in the project for their kind support and also
the following periodicals: Artforum, Art in America, Art Monthly,
Artscribe, Art & Text, Bomb, Flash Art, Noema, Public, and the
galleries: Massimo De Carlo, Anthony d'Offay, Barbara Gladstone,
Jay Jopling, Massimo Minini, Christian Stein, David Zwirner.
A special thanks for her help to Judith Blackall

The publisher is not responsible for the content of the contributions.

Distributed in the U.S. by D.A.P., New York
Distributed in Canada by Art Metropole, Toronto
Distributed in Italy by Centro Di, Florence
Distributed in Germany by Walther König, Cologne
Distributed in U.K. by Data Art, London

Contents

Introduction

The process of selection requires a clear recognition of the essential. This is surely true in the field of art as well. In the 1990s, the spectrum of tendencies in art has broadened considerably with the spread of media art, and viewers of art are confronted today with a veritable flood of images. Where, then, lies the key to the essentials needed for an informed understanding of artworks?

A close look at the ways art is received during the 1990s shows a pronounced widening of the gap between highly professionalized criticism and shallow art infotainment. Against this background, arguments arise which place increased emphasis upon communicative forms that reinvest artists with the power to define, enriching the vocabulary of interpretation and bestowing new roles and competencies upon the viewers of art. Seen in these terms, artists' interviews and statements must certainly be counted among the forms of communication that enrich and enliven the discussion about art.

Dialogue with the artist offers an opportunity for direct research. Attitudes and motives take visible shape; methods and approaches involved in the process of creating art can be identified and more readily understood. The artist's own comments provide stimulus for reassessment of interpretive paradigms. The quest for key information suggesting approaches to a reading of artworks also leads to the statement as an articulation of the artist's aesthetic position, free of intervention by an art critic bent upon interpretation.

Art Recollection comprises interviews and statements from the nineties and documents a segment of the art of this decade. What criteria were used in the selection of items for presentation? Of primary importance was direct access to the thinking of the respective artist. Statements provide such direct access, and the interviews presented here reveal relationships between an artist's thought processes and working methods, shedding light at the same time on the factors that have an impact on the artist's work. The dialogues confront the immediacy of visual perception with the reflected directness of an artist's responses.

How do art magazines assess the value of this genre as a source of information? Close attention was given to the question of interviews in art magazines. In this way, a spectrum of different print media concerned with the subject is documented.

The anthology is the fruit of numerous encounters with art events during the nineties, and, like all collections, reflects personal preferences. As the weighting of the selection clearly indicates, the foremost consideration was the artist's experience, rather than the primacy of the latest rage in art, as my intent was to document the interview as a valuable source and a key to an understanding of art.

Art Recollection probes the worlds of thoughts of different generations of artists. This cross-section imposes a diachronic matrix upon the comparative analysis of parallels. While a view of the art of the nineties through the eyes of several generations of artists reveals shifts and breaks, it also brings lines of continuity to light: practicess such as context art and neo-conceptual art appropriate paradigms from the artistic tendencies of earlier decades, restructuring their creative discourse with the codes provided by the cultural and visual repertoire of the nineties.

One characteristic shared by the majority of artists presented here is the deliberate tendency to replace the vision of the unique artistic creation with the concept of extended distance from the object of art. The detached aesthetic view corresponds to a shift in perspective that makes it possible to contemplate both concept and context in art. One consequence of this change in attitude is a redefinition of the communicative function of art. This supports the line of argumentation according to which interviews and statements are not only to be seen as attempts at dialogue but should also be presented as integral parts of an artist's concept and practice, thus directing attention to a view of art that incorporates the artist's vital role as a mediator as well.

"Works are unified entities that gather history into themselves but are not subjected to it". The remark by Walter Benjamin can be reformulated at the end of the century as a question - a question that in view of our changing perception of time and our growing sense of displacement is clearly very relevant today. Beyond any attempt to classify the art of the nineties, this question provides for me an approach to art, a leitmotif, for exploring the texts presented in *Art Recollection*.

Gabriele Detterer

Florence, May 1997

Artists' Interviews and Statements in the Nineties

THE EXPERIENCE OF NON-IDENTITY

Listening to the voice of the artist can be a stimulating, revealing and fascinating experience. A focus on the artist interview as a genre, however, requires an approach through different modes of perception. This is comparable to casting a stone into a pool of water and observing the widening circles of ripples it creates, the extent of which can only be roughly outlined in the present essay.

When artists talk about themselves and their work and publish the comments in the form of an interview or conversation, they expose both their art and their personalities to the limelight of public scrutiny. The question-and-answer scheme generates open situations that demand continuous redefinition. The artist is compelled to establish a balance between introspection and the presentation of an outward view, and to do so in the presence of a broad public audience and under the gaze of powerful supporters in art media. Despite the tensions and situational constraints associated with interrogation, the artist's voice is frequently and clearly heard in our decade. There can be no doubt that this is now fully integrated into the culture of communication in the contemporary art world. The most important art magazines mix reviews, documentation and essays with modes of direct discourse with the artist. Continuing in the tradition of Andy Warhol's magazine *Interview*, the *Contemporary Art Journal* (New York) and *Intervista* (Milan) publish interviews and conversations exclusively. In view of both the openness of artists to such forms and the print media's interest in conversations with artists, it seems appropriate to ask about the particular qualities that distinguish the interview from other genres of art criticism and publishing.

Conventional wisdom regarding the proper way to write about the visual arts clearly favors the literary-philosophical essay. Essays written by scholars with the intent to interpret artworks within the context of the history of philosophy are likely to be appreciated most. The German and French traditions of art interpretation in particular show an inclination to incorporate contemporary art into a theoretical discourse. Points of reference for the convergence of art and theory are found within a history of ideas whose lines of development lead from Kant, Nietzsche, Wittgenstein and Heidegger to contemporary thinkers, such as Jacques Derrida, Gilles Deleuze, Paul Virilio. A critical reception of art oriented towards philosophical and historical discourse and dedicated to the communication of aesthetic insight forms one pole of a broad spectrum at the opposite end of which we find popular forms of art infotainment frequently broadcast or published in the mass media.

Characterized by great diversity in approaches to a discussion of art and by widely differing degrees of rigor and levels of reflections, the situation nevertheless opens up a vacuum, fostering a desire for transparent communicating capable of providing direct access to an understanding of art practices and leading those interested in the subject to particularly significant, authentic sources of information. This orientation towards the concrete reality of work in art corresponds to a return to the artist as the originator of discourse about art.

The interview: hybrid - fragmentary - authentic - polyfunctional

Interviews could be considered a kind of text with *shadows* that form *bubbles, stripes, clouds* (Roland Barthes) and which originate in the interplay of subject, ideology and presentation. Such *shadows* eliminate sterile objectivity from the text, interweaving facts with an authentic personal tone and thus reducing distance.

Dialogue as a back-and-forth between question and answer builds bridges to understanding. Retrospection and an eye to the future, remarks on artistic practices, reflection on aesthetics and art theory combine to form a cross-over that is diluted with diversions and small facts. Precise thoughts and secondary miscellany collide. The simultaneity of everyday language and the diction of art theory links separate worlds. Borderline areas make the text a hybrid source that motivates the reader to set forth on a *tour d'horizon* through the artist's work and thinking and to approach an understanding of art as conceived, contemplated and lived experience. The reader learns the specifics of an artistic credo; the subjectivity and originality of statements emphasize credibility of thinking and communicate confidence.

The interview is a junction between past and present. In the precarious relationship between transitoriness and a tendency towards overexposure of the present, it tends to accentuate what is current. The verbal dialogue illuminates specific aspects of the contemporary and reflects, by virtue of its fragmentary and fluid nature, a perception of time in which the transitory is made present. In this sense, the interview appears to simulate a present that synchronizes the dissonances of time.

If one bundles together the different intentions that structure an action, it is possible to distinguish between value-based and purpose-based axes of action, to use the terms coined by Max Weber. Applied to the interview as a form of linguistic interaction, this means that the artist expresses convictions and principles without regard to consequences on the one hand, while pursuing at the same time instrumental, purposeful intentions on the other.

The polyfunctional character of interviews and statements derives from the interplay of these two axes: Texts are artifacts, self-portraits, sources of interpretation, and they provide the artist a flexible means with

which to communicate in a purposeful way with the audience about an artistic program. The roots of the artist's striving to integrate art and communication can be found in the programs of the early avant-garde in this century.

Communication as artifact

In the early years of the 20th century, avant-garde activists propagated a new concept of art and redefined the artist's relationship to the public. Futurism, Constructivism and Dadaism strove to forge a direct link between art and everyday life. Artists dismantled the conventional concept of the pictorial, crossing the boundary between the categories of pictorial image and language and transforming all available means of communication into a highly provocative form of art.

The art movements of the sixties and seventies took up the early avant-garde's objectivized concept of art. The change of paradigm undertaken in minimal art, conceptual art, Fluxus and Performance involved a critical questioning of aesthetic means and a redefinition of the roles of artist and viewer. Within the context of this new concept of art, statements by artists gained in importance. *Paragraphs on Conceptual Art* (1967) by Sol Lewitt and declarations of principle such as *Statements* (1968) by Lawrence Weiner, articulated principles of an art practice which, as a concept, was to be realized in the mind of the viewer. This approach not only demystified the image of the artist as a creative genius but expanded the communicative function of art and extended the artist's range of involvement with the public as well. Communication with the public was initiated for the purpose of making the creation of art transparent as a deliberate and methodical process. This interaction was intended as a kind of double-edged intervention directed as part of an oppositional art practice not only against the aesthetic conventions of art but against the communicative conventions of the media as well.

What is the meaning and significance of artists' interviews and statements in the nineties? Increasing diversity in art, coupled with the progressive individuation of the artist, have broadened the spectrum of specific manifestations of the genre. A look at artists' utterances within the framework of these developments shows that the forms of this multifaceted mode of communication oscillate more strongly than ever, depending upon the kind of artwork in question, between opposition and conventional messages. Viewed in quite general terms, the increasing availability of interviews in art magazines brings our attention back to the artist, the artwork and the way of communicating with the public. It has clearly become more important for artists to define themselves and their work in their own terms, and to do so through direct dialogue.

I would like to leave a message (Luciano Fabro)

Articulating thoughts about concepts of art in the presence of a broad audience is an important avenue of communication for those artists who regard concept and context as the focal points of their work. As is evident in the statements by Fabro, Kosuth and Paolini, the act of recording the inner dialogue serves as a way to reconstruct chains of thought. The statement offers the opportunity to develop a line of inquiry in the classical sense of the dialogue in a clear and comprehensible manner without the necessity of responding to intervention by others. As Ludwig Wittgenstein remarked in the *Philosophical Investigations*, the task of philosophical thinking is not to develop a finished and final model but instead to make the condition existing *prior to* the resolution of a contradiction impossible to overlook. If one presumes to apply this principle to art, it could be said that inner dialogue and dialogue with an interlocutor make it possible to expose the antagonism or condition that existed *prior to* the act of creating art. Statements and interviews have the ability of becoming preliminary, tentative fragments and points of reference in the process of creative activity. These kinds of texts offer no final solutions or interpretations; they are working papers that assist the person interested in art in a methodical approach to the process of making art; and they are sources to be explored in search for answers to questions about the origin and the determinants of artworks.

The interview - a singular portrait in a highly diversified art world

Interviews establish fixed points in an artist's effort to develop and anchor identity at a time in which the rhythms of art production are rapidly changing. Not only has the speed of change in movements in art accelerated, the degree of diversification within movements has increased as well. Representing a co-existent diversity of multi-cultural, neo-conceptual, neo-social, site-specific tendencies, a considerable stream of movements based to one degree or another on approaches established during the sixties and seventies meanders through the art landscape. The task of building a life's work in the difficult environment characterized by turns, shifts, intense competition and the powerful presence of mediators and supporters demands consistency, presence and the appropriate selection of means of communication. The artist of today is hardly likely to regard the interview as a pleasant game of questions and answers, as interviews published in art magazines ensure maximum exposure of a visible front in a dual sense: the front as façade, as genuine identity, and the front as a line of demarcation on terrain that must be continuously re-evaluated by both artist and viewer like.

In the interview, self-presentation and retrospective reflection combine to form a artist-self-portrait that takes on more pronounced shape in the

course of the dialogue with the interlocutor. The artist approaches the other in conversation, including him as an alter ego in a deliberate effort to make art practices comprehensible. Art critics play the role of the interlocutor in a variety of different ways. Critics capable of forging paths to understanding by virtue of their knowledge and empathy contribute to the significance of the interview both as a method of discourse and a source material that fosters rethinking of patterns of interpretation.

Conversations with artists evoke a sense of closeness, of intimacy. Discussion strategy is embedded in the context of shared communication. The community of interlocutor and respondent is expressed in speech utterances, in agreement upon linguistic codes and in the identification of common values.

The components of mutual understanding and the desire to overcome the barriers of individuation take on even greater significance in cases where artists converse with one another. There are examples of conversations that call to mind the dialogue forms of the Romantic period: in the process of writing lives and in the prolific exchange of personal correspondence, the other becomes a central point of reference in the effort to specify and realize artistic intentions.

In an atmosphere of mutual understanding between discussion partners, the artist is able to reveal his or her thoughts and to express critical self-appraisal without fear of injecting a polemical tone into the conversation. In the interview, the artist is the originator of tension-filled contrasts. Artists are the actors communicating their own self-portrait to a broad public, and with that portrait they place themselves in the center of the art world. The interview is an instrument of the power to define. Their personal authority allows them to guide the public in its perception of the art work and to integrate their own thinking into a larger system of values and objectives of relevance to culture and society. In addition, the dialogue offers an opportunity for intervention in opposition to role assignments and patterns of interpretation - or for the subversion of discourse.

The study of interviews and statements as a source material in an analysis of art places great emphasis on the experience of differences. This point of view counterbalances conventions of art reception and interpretation that place art in its historical context and tend to concentrate on the classifications of identities. In contrast to this interviews form a crossover pattern or mosaic covering a variety of subjects concerning art, culture and society, consequently perspectives change and sudden turns in thought cause breaks. The immediacy of the artist's statement motivates us to follow lines of thinking that can lead to unexpected insights into the artist's work and bear witness of the creative freedom of non-identity.

*A storyteller observes his surroundings closely, draws a subject from his obser-
vations and reshapes it with his imagination. Originally a painter, John Bal-
dessari* turned to the images of film, television and photography during the six-
ties. Found pictures form the basis for various experimentations, removing the
image from the context and connecting it to unrelated images and signs. Inter-
vening with lightning impact, Baldessari explodes the smooth surface of sugges-
tive, visual clichés with his ideas. Language and elementary geometric signs serve
the artist´s purpose as very viable materials in the process of reshaping. One
system used to transform image surfaces employs dot patterns. The gestures of
the photographed subjects are overlaid with colored spots; this masking has the
effect of a signal that erects a barrier to the rapid gaze of the viewer, causing
him to re-read and to reconstruct the image.*

*The concise formal vocabulary and the use of contiguous but different systems
of signs and meanings refer to conceptual methods in art. Ultimately, however,
John Baldessari retains a flexible artistic approach in order to expand the frame-
work of his practice in art. How else could a storyteller keep the moment of sur-
prise alive? (G.D.)*

John Baldessari
I will not make any more boring art

JOHN BALDESSARI INTERVIEWED BY LIAM GILLICK

LIAM GILLICK: The trouble with trying to talk to you is that I have an idea
of what you've done and a peculiar idea of history that may bear no re-
lation to reality. One received idea about your work is that you have tried
to remain mobile and flexible. Is it possible that the broad scope of work
in Manchester and the forthcoming Serpentine show is indicative of this
position? It indicates the negotiable status of meaning in your projects
across 30 years of production?

JOHN BALDESSARI: Somebody recently asked me if I keep work and I said
no, because it is the investigation that is of interest to me. To see if I can
do something, to see what's on my mind. So in one way I have some a pri-
ori ideas and in another way I don't. It's like that answer sometimes given
to why people take photographs, "So that they can see what they're look-
ing at". You're firing retro-rockets, correcting your course all the time.

GILLICK: I think I am working among a group of artists who have often re-

* 1931 National City, California / lives in Santa Monica.

ferred to certain ideas that you have played around with. Time is one of the issues.

BALDESSARI: I could address this by saying that at the start, when I was a painter, time was an issue in the sense that I didn't have enough of it to give to painting. Working on canvas takes up a lot of time, and I realised that photography was faster. It's even faster if you get someone else to do your own work. It might be that you could make a whole argument for conceptual art occurring because people sort of ran out of time. They had to find ways to do the same things more quickly. You revert to a short-hand in order to get to the essentials.

I also got tired of static work and started exploring film and video and as a result of that I think my films and videos began to look like still images and my static work began to look like movies. Now I sort of miss time, because there are so many demands on me that I don't have the chance to play as much as I used to. I would like to think that I am purely a strategist. You figure out how to do something and that's that. The doing of it is not very interesting because you have already done it in your head.

Unfortunately that's not good enough for most people and you have to come up with some hard cash on the line. So you have to do something. Things change, and the idea that seemed terrific turns out to be not so terrific at all. The whole process is a point of departure, as you work, something else begins to happen.

GILLICK: It seems that there were points when you felt it necessary to puncture the more pompous proclamations around conceptual art, the rather more fixed positions. How did you feel about the context within which you were working at the beginning?

BALDESSARI: I don't think that there are any progenitors of conceptual or minimal art or anything else for that matter. There is a kind of zeitgeist. We all read similar books, magazines and watch TV or go to the movies. So a person of reasonable intelligence could come up with similar ideas to someone else in another part of the world. I have always had a strong resistance to being told what to do. A pragmatism. What does it matter how the job is done as long as it gets done?

One thing that used to bother me on forays into New York would be the sense that things had to fit into history or they weren't viable and my attitude was always "don't be a slave to history". I think what I miss a lot lately is the sense of permission to fail - things have to be right from the start. Sometimes I have the feeling that artists are not doing what they really want to do. I know that people interact with their culture but it's often a case of the tail wagging the dog.

GILLICK: I remember seeing the new pieces that combine painted and

photographic elements and being a little taken aback. Was that an example of you doing something that people aren't supposed to do at the moment?

BALDESSARI: I think a lot of my teaching is connected to nudging people. That affects your own life too. So if you make the statement "I will not make any boring art" in a teaching context, then you have to make sure you try that too. So I have always thought that teaching was giving permission and maybe I still try and do that with my art. Give permission to myself, say, "It's OK you can do this". I remember years ago at some comprehensive Picasso exhibit, these two people stopped in front of a work. Picasso had indicated a painting in the painting with a broad sweep of the brush, and with a pencil he had marked out a Baroque frame. One of the people pointed at it and said "I didn't know you could do that...". The other replied, "What?" And she said: "...use a pencil in a painting". I think we all labour within certain parameters, but occasionally someone makes a breakthrough.

GILLICK: But are there cut off points for you?

BALDESSARI: Yes, sure there are some things you don't have time to explore properly. I would still like to be conducting chemistry experiments in my father's garage. But you narrow the scope of your search a little. Lately, it seems that I am following a multiple track, because compartmentalisation still annoys me. I would love it if all that artists did was to make museums implode. You couldn't have departments any more because there would be no reason to have departments. It seems like such a tired and old fight but it's still there. It's one thing that interests me about photography. How photography sees the world. How it's used compared to other mark-making devices. There are other ways of recording the world. But if I can explore one kind of art making in parallel to another kind of art making, then certain stuff opens up for me that I haven't seen before.

GILLICK: It's funny that you talk so much about photography because even now some people try and drag that "art v. photography" non-problem out into the open. But was there a time when the use of photography in an art contest really affected the way in which work was read? Where people would say "Fine, but all you've done is to take a funny photograph"?

BALDESSARI: Yes, and that's why I did it, because I thought "What an interesting terrain". People tend to rebel against current art practice and I wondered what would happen if you gave people what they wanted. Text and photography. That was certainly around them, in advertising and magazines. The curious thing was there wasn't any text and photography in

the art galleries and museums. So it was a perfect set up. And to get that kind of stuff through the front door I would print on to canvas, but even then you would get a lot of resistance. I remember the time I first put some straight photographs in a gallery, in a group show, they were sold, and everyone was dumb struck. I gave up using text some time ago because I thought that the battle had been won to a certain extent. Photography on the other hand continues to interest me. We live in a very visually literate society, especially when you consider things like MTV and condensed books. All you have to do is shift the attention a little bit and people can read your work. I don't have a feeling of 'them and us', but I do recognise different levels of engagement. Hybrid situations really interest me. But Roy Lichtenstein once said something like, "There's as big an audience for art as there is for chemistry", and maybe he's right.

GILLICK: I was surprised to hear you talking recently about process and materials.
BALDESSARI: I seldom get concerned about materials. When you're a student at art school you often use what's cheap. I didn't know what acid-free paper was until I was about 40. And even now I am not certain about some of the materials that I use. I use a particular type of photographic paper because I like that way it looks. Kind of bland. I tend to avoid anything that has too much of an artful look about it.

GILLICK: Some people we both know used to drive around with a bag in their car that had "Learn to draw" printed on it. Where did that come from?
BALDESSARI: It was from a rubber stamp that I had made during the heyday of Conceptual Art. You would get all these proposals and invitations to participate in complex projects. At a certain point you could get a headache from reading all these things so I just stamped "Learn to draw" on them and sent them back. And I had these bags with the same phrase on them made up for a few friends. I had another stamp that said "Born to paint" and a friend of mine in the Hells Angels designed an embroidered patch for me with a skull, palette and crossed paint brushes. Brice Marden has one of them.

GILLICK: Did you have one of those childhoods where people would say "Oh, John, he's an artist".
BALDESSARI: No, I didn't. Both my parents were European but if I expressed any interest in art I was steered away from it, the implication being that I wasn't going to make any money. But in school you seem to get that tag. If there's a mural to be done about Christopher Columbus discovering America, you're the one that gets to do it.

GILLICK: But are you an art fan, someone with a broad interest in other people's art?

BALDESSARI: I think so. I go to as many shows as I can. It's part social and part doing homework. Seeing if there are ideas I can steal from anybody. In that way it is just like a doctor keeping informed of a new procedure. I think it's pretty important.

GILLICK: One of the first book works of yours I got was Ingres and other Parables and there's something about the way that book is written that avoids the legalistic tone that is so familiar in other Conceptual work. It was funny that you were saying that some people in America used to see you as something of a European artist, maybe it is because you are so clearly implicated in some of those earlier pieces.

BALDESSARI: I think that anything I say for anyone else has to involve me too.

GILLICK: I tried to ask that question the other night about the way in which your use of film stills suddenly mined a rich source of visual material right at the point when people were saying it is the end of this or that, the end of painting or the end of art.

BALDESSARI: The use of film stills came about rather gradually. They were widely available and 10¢-a-piece. In fact, not all of them were film stills, some were publicity shots and newspaper material. But then I realised that these images contained certain recurring subject matter. So guns and kisses were the first files, and the first works covered those areas. I have a whole file of people falling off horses not necessarily from Westerns - just people falling off horses. You can use this material metaphorically. Allowing certain things to click in the brain.

GILLICK: It is one thing to use a photo for a straightforward documentary reason and another thing to start altering the image with circles, crops and colour. A conceptual orthodoxy seemed to emerge very rapidly and you broke that down once more.

BALDESSARI: There are ways of making people look elsewhere. And then there's the issue of creating another surface. In the case of a second surface of colour and shapes you often don't know where to look anymore.

GILLICK: There's something about the way you can get really high, consuming photographic images.

BALDESSARI: Sometimes I sweat over an image and it still doesn't work. But I keep going because I know there is something in the photo. The amount of sifting and winnowing I do is incredible - there must be 500 images for each piece that is out in the world. There are 20 pieces in the latest show

at Margo Leavin but there must be at least 200 maquettes, and just to get to the maquette stage involved a lot of choices.

GILLICK: But did you always work that way?
BALDESSARI: That's always been the way. But the rapidity of consuming photographic information is something that I try and slow down.

GILLICK: The contemporary cliché is that people have a two-second attention span.
BALDESSARI: I still abide by that. You've got about 30 seconds to prove yourself.

GILLICK: There's this idea that some of your work is funny and it is funny. But it's quite hard to be funny with an art work. There's witty art and ironic art but to actually be funny is something else altogether.

Liam Gillick is an artist based in London and New York.

The interview originally appeared in *Art Monthly*, no. 187, June 1995.

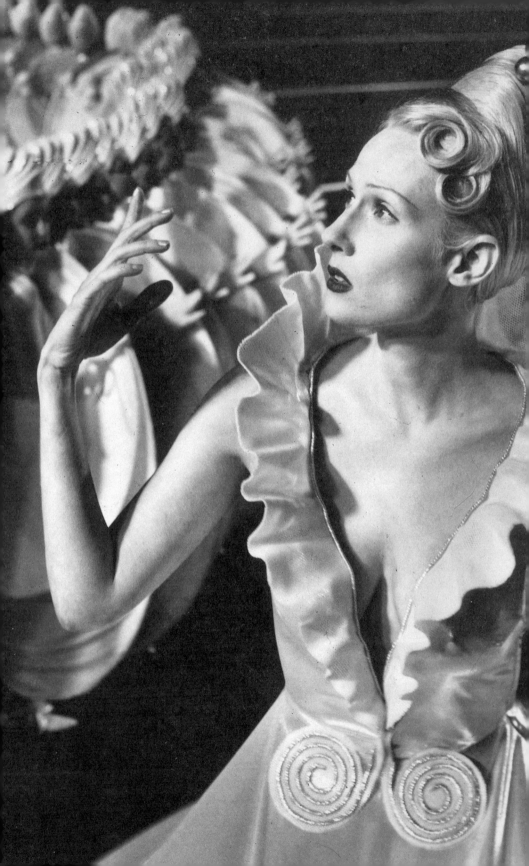

Matthew Barney's performances and video installations deal with the subject of mass cultural phenomena affecting attitudes about the human body at the end of our century. Fashion, sex, sports and medicine have assumed the function of rituals for the collective control of fears and obsessions.*
Barney's artworks focus upon the body as an abstract aesthetic surface. Physicality becomes an interchangeable shell capable of altering its own shape, of augmenting or reducing itself at will. Thus the identity of body and subject is dissolved. The subject begins a process of immersion into an endless series of multiple metamorphoses, taking comfort in the pleasure of auto-erotic play in response to the loss of unmistakable singularity. Clear outlines and solid positions disappear under the influence of the transgression. Continuous transformation demands materials of a soft consistency. Matthew Barney uses a variety of greases, plastics and thickened liquids for his works. Such materials allow for permutations that grow to become provocative, often repulsive hypertrophies. (G.D.)

Matthew Barney
Travels in Hypertrophia

INTERVIEW BY THYRZA NICHOLS GOODEVE

MATTHEW BARNEY: Have you ever seen a bullfight? There's this passage when the bull's head gets heavy and tired and it bows down to the bullfighter. The bullfighter cocks his hips and walks toward the bull, exhibiting his crotch. They call it "showing sex", I think that's the translation.

THYRZA NICHOLS GOODEVE: And it occurs only at the moment when the bull is overcome?
BARNEY: Fatigued but not overcome, and it's amazing what happens between the bullfighter and the crowd. If he's not precise, they heckle. In other words the minute something goes wrong the support shifts to the bull. Everything has to be done right. If it's not done right then it's wrong.

GOODEVE: Precision, control - you're interested in Houdini, who's all about escaping from extreme self-imposed controls, slipping through resistance, defeating physical limit.
BARNEY: Houdini knew how to pick a lock that hadn't even been invented yet. I'm interested in the physical transcendence that kind of discipline proposes.

* 1967 San Francisco / lives in New York.

GOODEVE: But it seems your work is less about transcendence than about the activity of the struggle to transcend - the working through of perpetually unresolved proposals, tasks, rituals.

BARNEY: It's actually about something between those things - not so much about transcendence as about an intuitive state with the potential to transcend, and about the kind of intuition that is learned through understanding a physical process. Back in school, I was working on these drawing projects that were about the relationship between resistance and creativity. I was interested in hypertrophy, how a form can grow productively under a self-imposed resistance, so I wore a restraining device to make drawings. They were linked to my interest in how a muscle can grow under the resistance of a weight.

GOODEVE: Athletics and particularly football are constants in your work. What do you like about that game?

BARNEY: I like the way order can be made out of a completely confusing field of people moving in opposite directions. I think the really beautiful how - eventually - a puncture is made in that haze.

GOODEVE: The world you fabricate is itself that kind of labyrinthine complex field. Each piece has its own resonance, yet also a whole series of other levels when seen in relation to the larger organization of the whole.

BARNEY: I always think of those videos as only a possible narrative of what might have happened in that space; rather than being truths, they're proposals. For me it's like that Caspar David Friedrich painting, "Wanderer above the Sea of Fog", where a man with his back to the viewer is standing in an exaggerated contrapposto on a rock looking out over a valley. The painting is in a state of suspension, you know eventually he's going to have to turn around and activate the proscenium, but for the moment he's trapped in the state of potential. There's something about classical contrapposto - it's quivering on the threshold between hubris and some kind of real but repressed omnipotence. All these amazing things can happen on that threshold, these powerful internal narratives.

GOODEVE: It's been said that interna/space, the interiority of the self is both diminished and exaggerated by contemporary technologies that dissolve the boundary between the body and the machine. I feel a return to some kind of intuitive but violated internal landscape in your work; there's this wild, dreamlike stuff coming out, inflected through machines and technology - like in "Drawing Restraint 7", where you have the satyr being swaltowed by the car, or becoming part of it.

BARNEY: Yes, part of it. In the closing sequence, while the two satyrs in the

back seat align their Achilles tendons and flay one another, the upholstery in the front seat is flayed and torn as well.

GOODEVE: What's significance of the satyr to you - the myth? The part-human, part-animal quality?
BARNEY: I was interested in the fact that "Pan" is the root of "panic". It's because Pan leads you to Bacchus - he gives you the moment of unease before you let yourself go. Ottoshaft took on the form of the bagpipe, which comes from the panpipe they added a bag to maintain the drone. But I thought it would be interesting to go deeper, which I did in "Drawing Restraint 7", with the satyrs. The satyr Marsyas challenged Apollo to a musical competition and was flayed for his hubris. All those things informed the use of the satyr.

GOODEVE: What about the car - cars are important to you, aren't they?
BARNEY: Vehicles are. I'm making an installation in September called "Pace Car for the Hubris Pill". Its elements, which I'll take from other projects, will all have to do with vehicles, or with the trajectory of narrative.

GOODEVE: The sense that narrative takes you somewhere, like a carryout ride?
BARNEY: Yeah. But a show like this is about trying to make clear or at least to think about, the space between projects rather than the clarity of what's going on in one project.

GOODEVE: None of your pieces is about completion; there's the feeling of an endless production of a cosmology. Does each piece raise questions that you carry on through the characters in the next?
BARNEY: It's like a game of add-on. The pieces have become more about storytelling: "character zones" are created for a given project, and as they reach their limit of development (or lack of it), the remaining, unarticulated aspects of that zone become the outline for the next set of characters.

GOODEVE: Forms too move through your work - things from wrestling mats to hydraulic jacks to tapioca break free of their received meanings to become semantic bits in narratives that run from piece to piece. There's also a recurring symbol, a capsulelike field with a line or bar across it. It's in almost everything you do.
BARNEY: That came out of drawing, out of this notion of an opening into an organism and its self-imposed closure, whether it be a blindfold, a titanium screw, or whatever. The piece "Field Dressing", where a chunk of Vaseline was frozen into that field form and then used to fill and close off the various orifices in the body, also relates to that idea.

GOODEVE: You are a performance artist who performs in private: for an exhibition in 1991, for example, you videotaped a climb around the gallery's walls, with ropes and pitons, before the opening. Does this combination of a private experience with a public view also arise out of that idea of a simultaneously open and closed field?

BARNEY: It has to do with a lot of things one is my reticence about theater, and about that kind of relationship with the audience. But it also has to do with how an action can become a proposal, rather than an overdetermined form. A taped action in an installation can float. It doesn't really have to declare itself, or even to answer to gravity. It wasn't that that video made sense of the evidence of the climb that was left on the gallery ceiling: there was the possibility that it was all an imagined activity, that it never happened.

GOODEVE: You've said you're less interested in formal relationships than in the idea of developing a cosmology (you were talking about Joseph Beuys and Bruce Nauman, but you've developed a very articulate visual language, and you once said that Jim Otto, the former football player who appears in different ways in your work, is ultimate/just a form to you - the double O's of his number and his name become orifices/anuses, and the two T's of his name resound with the shape of the goalpost. The meaning of "Jim Otto" was a person matters less than his use as form. Do you see yourself as a formalist - developing forms into language - or more as a mythographer and storyteller.

BARNEY: The forms don't really take on life for me until they've been "eaten", passed through the narrative construction.

GOODEVE: That metaphor is interesting, because the word that keeps coming to me about your storytelling, which clearly isn't linear, is "metabolic". And in your new video "Cremaster 4", you cover one structure with padded vinyl like a skin.

BARNEY: Yes, but I'm less interested in skin than in fascia - connective tissue. Have you ever dissected something? Fascia is the filmy stuff that connects organs, the thing that gets punctured in a hernia.

GOODEVE: You studied medicine in college? The title of "Cremaster 4" is also a corporeal image, isn't it?

BARNEY: I was pre-med briefly. The cremaster muscles are the muscles that control the height of the testicles, which usually varies with changes in temperature. If it's cold outside they're drawn into the body so they stay warmer.

GOODEVE: Is that why you used a freezer in your installation? "Transexualis" (1991), so all the guys who come in.

BARNEY: Get back to the seven-week stage of pregenital experience? (laughter).

GOODEVE: Your work can easily be discussed in terms of a critique of masculinity; but it's actually more about trying to produce this other... myth, really: You've set up this elaborate system about a hard-to-describe gender - not neuter, certainly not female (football, testicles - these aren't part of a traditionally defined female world), but not traditionally male, either.
BARNEY: The notion of a pregenital model shows up over and over again in the stories. In "Cremaster 4". for instance, the yellow motorbike-team, the Ascending Hack, is essentially in that ascended state, or, in its movement on the course, is attempting to maintain that state. The blue team is interested in a downward, developmental movement. The Loughton Candidate and the Loughton Ram are the third pole, in that they have either four sockets in their head, like the Candidate, or four horns like the Ram, so that together they're about the maintenance of both states.

GOODEVE: The Loughton Candidate is the character who's tap-dancing near the film's beginning, the Loughton Ram is the red four-horned sheep who shows up later on. Where the Loughton Candidate has sockets in his head, are his horns lost or are they in a state of potential?
BARNEY: They haven't grown. He's a candidate to become the Loughton Ram.

GOODEVE: They look almost like wounds. There's a gentleness to the way you reveal them, parting the hair and displaying them to the viewer.
BARNEY: It's about that field of undifferentiation where the horns draw a system in both states simultaneously. The story comes from the possibility that a single organism can endlessly fracture itself into different aspects. They're all part of the same form. So the story has nothing to do with the relationship between them - they're never in a duality with something outside themselves.

GOODEVE: So the video's final image, that extremely strange crotch shot, is again about not resolving but maintaining that tension? Just as the Friedrich painting shows the scene of perpetual edginess - the state of threshold?
BARNEY: That image is a kind of drawing of the conflict between the yellow, ascending team in terms of the state of those organs. On the yellow bike the organs rise from a set of slots, but on the blue bike they descend down across the thigh onto the ferring, the sidecar passenger's fiberglass tray. The two teams want to keep it that way. Each has its own interest in the organs that are in the center of that frame.

GOODEVE: I don't think I've ever seen work that's testicular as opposed to phallic (laughter). Also, even if your work is inflected with a horror-movie veneer, it doesn't seem based on a fear of a monstrous female, as a lot of horror movies are. And when you dress up in drag, it's not about, Gee I want to be a girl. How does "woman" appear in your work?

BARNEY: The characters in the black gown and the white gown in "Ottoshaft" were called "the feminine Jim Blind". I would call that aspect of the narrative "she", but I wouldn't call it a representation of a woman. I would just say that at that point the piece went into a more feminine field. The idea that the organism being one sex or the other, or even one of three possible sexes, is limited; it could have a million different zones of sexual articulation.

GOODEVE: There's this kind of hush around sexuality in the Barney criticism; one writer has said: "The artist's sexuality is not of importance". Yet sexuality is everywhere in your work, or both everywhere and nowhere. How important is your sexuality, or sexuality in general, to this mythological system of pregenital being? You are trying to get away from normative ideas of sexuality?

BARNEY: Well, I guess for me it's erotic, it's autoerotic.

GOODEVE: Again the single organism - you don't need another person.

BARNEY: I don't know if it's about whether or not I need another person, but that the form is in dialogue with itself. I used to think about a three-phasic diagram: Situation, Condition, Production. Situation was a zone of pure drive, useless desire that needed direction, needed to be passed through a visceral disciplinary funnel, which was the second zone - Condition. The third zone, Production, was a kind of anal/oral production of form. It gets more interesting if Production is bypassed: at that point that the head goes into the ass, and the cycle flickers between Situation and Condition, between discipline and desire. If it goes back and forth enough times something that's really elusive can slip out - a form that has form, but isn't overdetermined.

GOODEVE: Is there any reproduction in this autosexual world?

BARNEY: It's more of a digestive model.

GOODEVE: Is that where tapioca comes in? Little balls that melt and turn into something else?

BARNEY: I started using tapioca when I was making these pieces to do with a metabolic transfer between a complex carbohydrate and glucose. "Ottoshaft" ended up as the clearest manifestation of those works. In "Pace Car for the Hubris Pill", the hubris pill is a glucose tablet.

GOODEVE: Literally?
BARNEY: It's actually a prehubris pill - glucose is the state of prehubris. In "Ottoshaft", Otto and Al Davis try to take this glucose pill through the metabolic change from glucose to sucrose to candy to petroleum jelly to tapioca to meringue and then to pound cake. If they could just get it to pound cake - its state of hubris - then the bagpipe would play "Amazing Grace". But it never gets there; it gets trapped in meringue.

GOODEVE: Where's the pound cake?
BARNEY: Behind the pace car there's an eight-foot pound cake that sits on the floor. It's divided in the center, where that notch is the pill.

GOODEVE: (laughter) There's humor here, visual puns?
BARNEY: You mean in the forms themselves?

GOODEVE: Yes, objects become funny - funny but also moving. In "Jim Otto Suite", when you're on the balancing bar with the hydraulic jack, it's completely beautiful, melancholy and erotic. But when the jack reappears in "Cremaster 4", at the fairies' picnic, it's dressed in tartan (laughter), with ribbons and all. I don't know what you're doing but there's a marvellous humor to it, and also the memory that the jack has a history in your world, is part of this other moment when it was almost going into your body; when it was both sexual and dangerous.
BARNEY: Then it gets dressed up and taken to Sunday school. It doesn't really want to be there.

GOODEVE: So what is its role in "Cremaster 4"?
BARNEY: It's another vehicle, another device of a drawn movement - the rise and fall of the hydraulic shaft. As the thermos, the centerpiece of the fairies' picnic, it becomes the form that's pitched in the triple option they execute - whether this form is going to be kept, pitched, or passed out of play. The Ascending Fairy pitches it to the Descending Fairy, who isn't interested in accepting it.

GOODEVE: And why is that?
BARNEY: Because when that two-ball form is sitting up at the picnic, it's in the descended state. The Ascending Fairy wants the balls to ascend, and the Descending Fairy wants nothing to do with that. Meanwhile the Loughton Fairy is playfully creating interference. Then, in the pit stop, the Descending Fairy is trying to prop up the bike in order to enable the migrating organs to get down farther into the passenger's tray. So the same jack is used to prop up the bike.

GOODEVE: The pit stop is also where the fairy puts the fleshy wheel with the two balls on the bike?
BARNEY: She fits and rotates it and then puts the proper tire back on.

GOODEVE: Obviously if that form was put on the wheel, it wouldn't turn?
BARNEY: Right.

GOODEVE: As in the "vehicle" of sexual differentiation, you're stuck going one way or another. The Ascending Hack gets sidetracked by water and has to turn around; that doesn't happen to the Descending Hack, the blue team. No boundary or barrier obstructs it.
BARNEY: That's because ascent is the more difficult path.

GOODEVE: "Cremaster 4" - why "4"?
BARNEY: There are actually five of them.

GOODEVE: You made five?
BARNEY: No, I'm going to. I just made number four first. I'm going to do number one this summer in a stadium in Idaho that has blue Astroturf. "Cremaster 2" is on a glacier, like an ice cap. "Cremaster 3" is in the Chrysler Building in New York, "Cremaster 4" was shot in the Isle of Man, and then "Cremaster 5" is in a bathhouse - the fully descended state.

GOODEVE: The name of the Isle of Man, which is in the Irish Sea, is obviously important, but did anything particularly interest you about the island's history and myths?
BARNEY: There were myths I read while I was there, particularly about fairies and their general relationship to the island, which is a sort of sketchy contract. There are certain bridges that you can't cross until you pay your respects to the fairies. If you don't, they'll turn on you.

GOODEVE: And how do you pay respect?
BARNEY: You stop your car and you say hello to the fairies and then you go on.

GOODEVE: Did you see people doing that?
BARNEY: Oh yeah, people get in cabs and the cabs won't move until everyone in the cab pays respect and then the cab takes you to the airport.

GOODEVE: And the fairies' lovely gowns - did you sew those costumes?
BARNEY: No, I worked with an incredible woman, Michel Voyski. We looked at pictures and took ideas from different periods, though we tried to stay in the 1910-20 period - post-Victorian. I wanted to place "Cre-

master 4" in the period of "physical culture" in which Houdini and these other performance artists took on the Victorian ideal of how physicality should be expressed.

GOODEVE: That also relates in a way to the time delay in your work - the fact that the videos of your gallery feats it's as if you're showing us a memory of what happened, a history, and then when we walk through the space of the gallery it becomes a field of evidence- suggestive, unresolved. There's a moving, melancholy feel to it.

BARNEY: The most memorable thing anyone has ever said to me about my work came from this guy who had a custodial job in a hockey rink. He'd go there at five in the morning every morning and turn the vapor lights on, and he'd sit down in the front row behind the Plexiglas at the edge of the empty rink. Those lights go rose and then green and then they start to get cool and go whiter and whiter. He described my work as like watching that artificial sunrise - the melancholia of experiencing something in a state of potential.

Thyrza Nichols Goodeve is a writer living in New York; her writings on art and culture have appeared in *Artforum*, *Parkett* and *Art in America*.

The interview originally appeared in *Artforum* no. 9, May 1995.

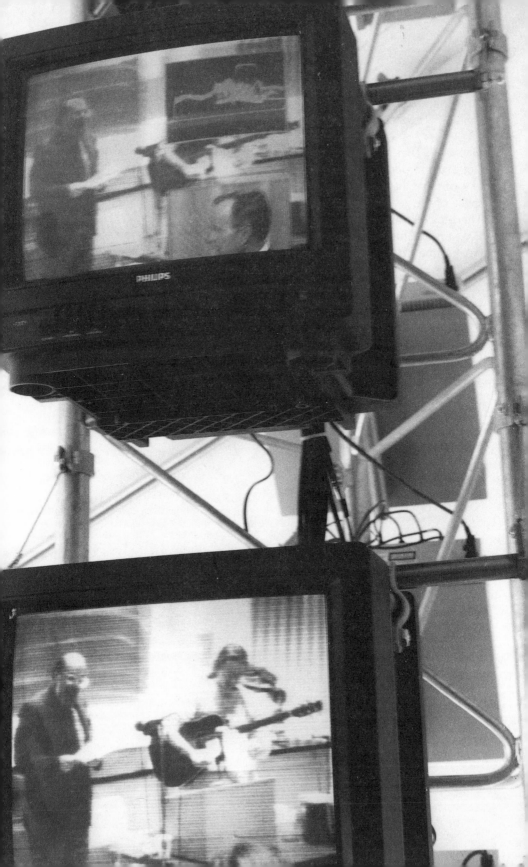

Why are people in the arts ignoring the common visual experience of most people? This was the first question taken up by Dara Birnbaum when she began experimenting with electronic media in the seventies. The artist bases her working hypothesis on a broadly understood cultural space that extends beyond the boundaries defined by cultural institutions and on the presumption of "holes left within mass mediums"- areas ripe for creative artistic actitivity. Dara Birnbaum extracts representative narrative patterns from the language of cinematic television formulas, altering them through formal means and removing them from their familiar context through the parallel presentation of images which are highly diverse in content. These artificial images dismantle the suggestive pictorial language of a familiar genre and block the rapid, unconscious intake of cliché-ridden content.*

The pictorial material relates to a socio-political context - to the stereotyping of female role models, to television news coverage of political affairs, to sports, to war and to acts of terror, such as the abduction of the German industrialist Hans Martin Schleyer ("Hostage", 1993/1994). In the layout of her video and photo installations, Dara Birnbaum emphasizes the interplay of medium, content and architecture. (G.D.)

Dara Birnbaum
An Interview

BY HANS ULRICH OBRIST

HANS ULRICH OBRIST: In your recent show at the Paula Cooper Gallery, in New York City, I had the same impression of being a victim and a doer at the same time; - in your ability to target while looking outside and yet at the same time being targeted. At every moment it represents both positions simultaneously.

DARA BIRNBAUM: If you take a half-step backwards, you are a total observer. The works don't bring an answer, but they always bring a question; which I think is important. If you have a good question it's the first answer.

OBRIST: So could one say it is like an oscillation at a thin, porous membrane, back and forth.

BIRNBAUM: I don't know what the membrane is made of. It's an intriguing issue as to what substance, how porous, how transitory it is; what speed

* New York / lives in New York.

or what slowness it takes to get through it. We were talking the other night about Raves, and if you go into the Rave you have become a particle within it. Not a part of it, but a particle within it. If the oscillation in that particle is different, you are almost expelled out; in the force field you can feel yourself being pushed out. If you are within that systems oscillation you are virtually engulfed within it. This also needs to be constantly kept in mind with regard to Media and the newer relationship to the extended sphere of the computer.

OBRIST: Appropriation, is in your very early video works like *Wonder Woman* and *Kojak* and so on. Was there a dialogue with other artists, in the 70s in New York, using appropriation as a strategy? You were much more into appropriation of popular imagery from television, while other artists were into an appropriation of art history.
BIRNBAUM: I didn't feel like there was much of a dialogue. Earlier on I belonged to a group of artists, where first I helped someone put their work together and then they encouraged me to make my own work. We were always trying to express ourselves in alternative spaces. Alternative: meaning finding a loft here; a space there; something that can work for each specific event. I think that it is still a belief that I have held onto. I'm on the Board of Directors for Creative Time, an organization that has a nucleus but re-determines its spatial properties in relation to the needs of each artist's specific work. Maybe this is also similar to the activities of museum in progress, in Vienna. What happens within specific events determines what space is occupied. Do you use the space of media for the 'holes' that are left in it? To re-occupy the newspaper, *Der Standard*, in Vienna, is very much like Brecht's belief that you use the holes left within mass mediums, such as radio, newspaper, and television.

OBRIST: It leads maybe to the barber shop installation.
BIRNBAUM: It was a *salon*... but I like your use of the term "barber shop", it's wonderful, - very Nineteenth Century America. As a Salon they were trying to be a little exotic; they were probably the first store in New York to have a video monitor in their window. Now you can't get away from this use of video. The installation consisted of one monitor along with the Salon's own photographic imagery montaged in the background - their own choice of representation in static form. The photos were great because they had three images, in color, of a woman with her hair being pulled back away from her head and a man's hands coming after her with a scissors trying to cut her hair off. So it was a complete reverse mythology of power. The monitor could play to the street, or it could play to the inside of the store and entertain the customers. The sound was issued out to the street too, which was a great advantage. So I said to the woman

owner of the salon: "Could I show my work in this window?" And she said, "Well what is your work?" The easiest thing was to say, "Wonder Woman".

And she said, "That's great! I love Wonder Woman". And then she said, "I've been told that I look like Wonder Woman", ...and she did! And so she said, "Great we'll put it on!" We put it on a few weeks later and people would stop in the street to look at it. On Saturday, because it was Soho, a lot of people would be watching. You know I felt very pleased, and there were so many people in the street.

OBRIST: Like passersby....

BIRNBAUM: Passersby became stoppersby. And I thought, 'It's working!' I told her I was very excited by the number of people stopping to watch. She said "You can put TV on anywhere and people will stop".

OBRIST: It leads to your *Rio Video Wall* somehow: you put the video on, you put it in a public space, and you have the people walking by.

BIRNBAUM: It is in a public space, an open plaza. It's interesting because there are so many different kinds of public spaces, especially now when we face new aspects of Virtual Reality and Cyberspace, which affect what definitions of private and public space are going to exist. The dynamic of the passerby on the street of New York, looking in a shop window, is not really different than the Rio Plaza. It's all just what in video you would call an "attract-loop". It causes you to come again to the Plaza to shop. With the *Rio Video Wall*, instead of Wonder Woman's body there are two cameras that pick up your body as you enter into the public space, or public dynamic.

OBRIST: It's permanently re-newed... It engenders a dynamic standstill. It creates a break, -a rupture, -a stop which is dynamic.

BIRNBAUM: Yes, you are opening up a space within the original visual imagery; the actual landscape that had been there before the Plaza was built, the natural elements which were ripped down. As you enter the shopping center, you break open the memory of the old and your body transmits the memory of the new. You have no control over the imagery coming through your own body. You can only control how you move in the frame and what part of the news frame you want to expose, but you can't control what comes through.

OBRIST: So it changes permanently?

BIRNBAUM: It has to change to be permanent. I had the feeling that what they wanted was to make a beautiful video water-fountain, a kind of static-permanent, and I thought: Can I use imagery in a video-related work,

in a public-space, that doesn't become old? What kind of flux can the images have? So I used three types of imagery, each one representing a different aspect of video historically. These video images would merge and form a kind of montage, which had to be always exciting, always stimulating. When you came into the shopping center from two different entry points your body image was made into a silhouette, you became a black hole which went up onto the video wall. I was able to fill that black hole with satellite transmissions, a CNN news feed. CNN's headquarters are in Atlanta, where the Wall is, and our CNN-feed would fill your body with the news of the moment; it filled that area that had become voided.

OBRIST: Didn't it change a lot since, in the last years, in terms of blurring of categories? One was always having categories like Cinema, Photography, Video, Painting or Sculpture, and I think the whole question now is just about images and what happens between images. I think it might be interesting if you talk about these photographs you took from TV, as a sequence, your very first work which was very much about the in-between space. Godard says "Everything is in-between".

BIRNBAUM: At the end of the 70s and into the 80s, we all spent time arguing about the difference between film and video. Now everything becomes just information, digital bits, - so it's a different way to look at the world. I like the idea of playing the kind of chess that video was, technically speaking, in the early years. I had to be seven moves ahead and seven behind, and I could never see the one that I always saw in my mind. This was a good excitement. The first things were right off TV in '77, when you didn't have Betamax and VHS or anything, you just had everything coming at you. And I thought: How do you capture these images? I tried to look at what the main images were, what was the C-major chord of the images? It was the reverse-angle shot at prime-time, the hour when everyone looks at TV the most in America. What do they see? They see crime-drama. What is crime-drama? It's a lot of reverse-angle shots; which create a tension of whom you identify with. So I took examples of these reverse-angle shots and I put them up and surrounded the gallery wall with this kind of imagery. Then I isolated the audio so the text becomes an additional form of visual image of the narrative. If you really stopped action at that time and you read what was being said within that framework of visual representation, it was even worse than I had imagined: two policemen in a car look out through the windshield at a black man. Even today in America of course he must be the perpetrator; he must be the one we have to get, - he did the crime. The two policemen are saying: "Do you think that's our guy?" "Yeah, that's our turkey". One says: "Yeah, I want him so bad, I can almost taste him". That was American TV.

OBRIST: So it became an instant critique of clichés.

BIRNBAUM: Yes, because unfortunately it was all clichés; everything was stereotyped, especially when I wanted to deal with the role that was assigned to women. You can see that in all the early pieces like *Wonder Woman*. She transforms, she saves mankind. Of course it's good to have a *Wonder Woman,* because it's not a Superman, a Batman, a Hulk. So here a woman transforms into a more primitive race. She is asexual. She changes her image from normal secretary into Wonder Woman, and as an Amazon she goes forward to save mankind.

OBRIST: After extracting the images, you went into video. With *Wonder Woman* did you change speed in order to create your narrative?

BIRNBAUM: Never, not at the beginning. I took exactly what was there.

OBRIST: There is only repetition, - difference through repetition?

BIRNBAUM: Because it is taken out of the narrative flow, when you look at it you think the speed is wrong. Or as in *Laverne & Shirley,* my first installation work which was called *(A) Drift of Politics,* there were two women as the prime characters. That work became all about the "two shot". They confront the world together; they face the world together. This is the end of the so-called nuclear family in America, meaning: Where is the father? Where is the mother? Where's the kid? We are as adolescent Americans, alone now. They are women, but girlish women. They go out, they work on an assembly line. This was around 1977, when they took off their rubber gloves and put them over the Coke bottles. Now with AIDS, there seems to be the need for everything to have this rubber protective membrane, but here Laverne and Shirley cover the bottles with these rubber gloves. They leave the plant and go out into the world, becoming their own nuclear family. In my first two exhibitions I presented my work with another woman, Suzanne Kuffler. We were both doing our own work, but for me it was like *Laverne & Shirley;* that we had to go out and face the world together, and at least I had another very bright woman to talk with. We wouldn't make collaborative work, but we would collaborate in getting the work out. Regarding my own work, I thought it's really important not to change the speed, not to change the medium; not to speak from another voice, but to use the media on itself. For example, with *Laverne & Shirley*, I made only butt-edits. Then I made subtitles for the video, because I took the audio and placed it in a separate room. I let the audio run like a radio play in a separate space and let the other space concentrate on the imagery, the two-shots. In that space, you could read the subtitles, what they were saying within each frame. The subtitles went by so fast we couldn't believe what they were saying.

OBRIST: So all this became visible through a mere shift of context?
BIRNBAUM: Absolutely, and through not shifting the medium. There was a peer group, as you mentioned, which I related to, - other young people who were dealing early on with media-related images - like Jack Goldstein, Robert Longo, Cindy Sherman, and Sherry Levine. But Robert Longo, as an example, would take an image from a Fassbinder film, of someone who was shot in the back, and freeze the moment and isolate it. Longo and Goldstein, for example, would talk about media space as a kind of empty space and Nam June Paik talked about it as a non-gravitational space, - so the image was extracted also. Robert Longo sometimes made this extracted figure into relief painting. Goldstein sometimes made it into a painted-filmic form: rotoscoping the image and thereby isolating it. He did some very brilliant films in this manner. For me though, Goldstein and Longo always translated the medium, and I wanted to use the medium on itself. Eventually in Amsterdam they had a multi-part exhibition which the organizers, as a compliment, stated that they named after what I was doing. They called it "Talking Back to the Media". I think this was it: I wanted to arrest the image without translating it. I thought: How do you put video onto video? Television onto television? - especially at a time when you don't have Betamax and VHS. So people said that I became a pirateer: "Oh, she's the one who is the pirateer of the images". It's interesting that in the 70s I had this ferocious image. I was just a single woman, and pirates are not so often women alone. In the early 80s it was said that "she appropriated the image, in the late 80s "she's stolen images", and in the 90s "she samples images". It kind of goes like that as the generations change.

OBRIST: Some time ago you made a book with exploding sources with regard to Situationism. - In terms of stealing, creative theft, as Deleuze says.
BIRNBAUM: Well the creative theft process was resolved by the Situationist. At the very beginning, my book, *Every TV Needs A Revolution,* is dedicated to the people who made these anonymous street posters and their actions. Something I really respect: That the original was seen as a multiple owned by everyone. These images were basically silk-screened and then plastered onto the streets and walls of Paris. You were offered to take these images, you could take these words, there was no copyright. Whereas I'm actually in a dilemma. I took images that I thought belonged to me, that didn't, like *Wonder Woman*: "No, you cannot make my landscape into that image of a woman. You cannot send that image only one-way at me; a woman who transforms by a burst of light and spins around in space three times". This was a special effect in 1977: in a burst of light she changes. It was not acceptable, and it was my landscape. TV at that time

was being watched by the average American family seven hours and twenty minutes a day. So I said to myself: 'This is my landscape, I can paint it as I want to.' I took the imagery and put these images back out again, like a kind of throwing-up... taking it in, throwing it back out, in a Baudrillardian sense. I threw it back out, I put it on cable-TV opposite the real *Wonder Woman*. I put it into a film festival of avant-garde film, making it into a bar-room B-film. It penetrated the store-front of H-Hair. But what happened, was that years later I felt like I owned that image. And that was strange.

OBRIST: Like a boomerang.
BIRNBAUM: It's a boomerang. It comes back again. But what I'm saying is that with the Situationists they created images, as with their posters, which were sent out to affect mass numbers of people, and they didn't attempt to own those images. The images were made to affect a relationship with the viewer.

OBRIST: There was no a priori signature.
BIRNBAUM: No one signed them; the posters remained anonymous and you could take them. Okay. I've become an owner in some ways of *Wonder Woman*. I think that for me I have to constantly, with consistency, question myself: What am I making that's consumed? How sellable does it become? What market-place am I playing into? You know there is an image-highway, not only an information-highway. And the image-highway, in part, has been the galleries and related system of selling images. For us, meaning my video peer-group, I would say that at the very beginning many of us got into video because we thought of it as a multiple. You know, it didn't carry the "aura".

OBRIST: Lucy Lippard once said about feminism, that the goal of feminism is to change the character of art and to directly attack the infrastructures of the art-world. Were you also interested in this idea of attacking the infrastructures of the art-world, or at least undermining them?
BIRNBAUM: I think we thought there would be something else. I don't think my work was made so much to directly undermine the structure of the art-world, since I had such a non-belief in it. My belief, and I want this still to be true, was in the message. I just knew something had to be said, especially with regard to the medium and the industry of television. Perhaps I saw art very idealistically, as an activist position. It seemed that art provided one of the few positions that could be held that was still activist. Then the more I learned, the more I saw what is controlled within that system. Then I wanted to become the one who penetrates the system. Do you want to be the hacker? I don't know.

OBRIST: You always saw video as a vehicle for content.

BIRNBAUM: Maybe I saw art as a vehicle.

OBRIST: We were talking about the Salon, the barbershop, then the *Rio Wall*, - so about your projects in very different contexts; where you showed your work. You also placed exhibitions or interventions within television directly. What does this mean, for you, like for instance your MTV projects?

BIRNBAUM; There were two products. One was an *Artbreak*.. MTV came to me in 1987. They selected six artists in the United States, but I was the only video-related artist. They said you can do whatever you want to do. MTV really had at that time the most grotesque representations of women, as they still do, and perhaps of men also. So, they said you've got thirty seconds and you have no budget. Okay, I said: 'Artists working with video never have a budget.' They said, "No, we mean you can go wherever you want. We are paying your bills". For an artist that is a very privileged position. I was already beginning to feel somewhat censored in the art-world of America. So in thirty seconds, what do you say? I had friends, I remember, some of whom gave me a very stern warning not to cooperate with MTV. I said I'd rather enter, and risk, and fail, and somehow learn from it, than not enter at all. I went for a very early cartoon animation of Coco the Clown, by Max Fleischer. The series was called "Out of the inkwell". The characters would fall out of the inkwell. Fleischer would first draw Coco the Clown; then Coco would get into a fight with the very guy who animated him. He would take the pen away from Fleischer and say, "You're not going to animate me anymore. I'm going to animate myself!" So I guess I was very sympathetic to Coco, both growing up and later as a woman in America. Oh, fuck your images of women on MTV, this is really getting ugly. So, I will animate myself. Anyway, I took the Fleischer footage, cut it up, and made a very quick collapsed version of the original animation. In thirty seconds and in this kind of quick mini-narrative you see that: Fleischer draws Coco; Coco looks up; there is a machine which draws a woman for Coco; he gets up and he gets really excited looking at this image of a woman. The machine has an erase-arm and it erases the woman. He gets very, you know, very angry. Anyway, for the *Artbreak* I changed the animation. I found someone who did illustration for Fleischer Studios in the 40s; he did cell-animation. I thought I'm going back to an original form of animation; especially because everyone, in 1987, was looking for the newest digital animation effect, or a digital version of scratch film. You know people would be sitting there wasting a fortune of money trying to make MTV videos look like scratch film. So, instead of making scratch film, they would make beautiful images with expensive 35mm film or top-of-the-line video cameras and then they'd get someone in post-

production to put in the scratches, and you're sitting there for a thousand dollars an hour, putting scratches on film. So I thought, I'm going back to the original cell animation, and we will re-draw it. In my case the kiss that she blows to Coco becomes an MTV logo: a rock in the form of the MTV logo. It lands on Coco's crotch and he falls out of the frame. At the end of this *Artbreak*, you see a woman animator trying to make a new image; she has already assimilated Fleischer into her palette. So that even this clip's own history has already become just simply digital information. You know we're all becoming part of the palette.

OBRIST: And the second MTV project? Which I believe you created in 1992?

BIRNBAUM: Years later MTV came back; as you said in 1992. The Whitney Museum, The American Center in Paris, and the Public Art Fund in New York came and said, "You are one of seven Americans we picked to do a work with video imagery. We will be able to give you some money to create a piece which will be shown on MTV". This series of TV-spots was called *Transvoices* and my piece was called *Transgressions*. Now historically, in the practical history of video-art making, or let's say art-making with video, you have a five year difference between the first work created for MTV, the *ArtBreak*, and the second work *Transvoices*. The difference was, that for *Transvoices* I got twice as much time, sixty seconds instead of thirty seconds, to express myself and much less than half as much money. It was very funny. In 1987 there was no limit to my budget and MTV went anywhere and everywhere they wanted to go. By 1992 you were offered, as an artist using this kind of visual medium, almost no money. Someone in the commercial area, doing commercials for MTV, would probably use up the money that was given to us to make the entire sixty seconds spot in a few hours, by talking on the phone. The *Transvoices* series was aired on MTV in the United States and on Canal Plus in France. It was meant to be a trans-Atlantic dialogue about 1992. We were told that for America it's the celebration of the five-hundredth anniversary of Christopher Columbus finding America and in France it was to be the commencement of the EEC. These wonderful things we were meant to celebrate didn't exist for me at all. You know the EEC didn't go together in 1992. And it seems a little perverse to say that Christopher Columbus founded America. Of course he did find one history of it. So we had a cross-dialogue, a *Transvoices*, seven American artists and seven French artists, through video. My work shows a lot of mappings; the growth of the United States and of France. Everything in transition, boundaries and transitions, like in the texts of Virilio. We are dealing with more and more invisible boundaries; boundaries much less visible to us. This again becomes part of a new work for St. Pölten, which is being declared the new capital of Lower Austria

on May 31, 1996. And I thought that for this new project, *Four Gates*, I'm going to find references for St. Pölten as far back, historically, as I can. I even found St. Pölten on the old Roman road. I wanted someone who travels through the present space and time of the new Government Complex to see the constant fluidity of what we call "boundaries".

OBRIST: The St. Pölten project, and also the new large-scale project for Kunsthalle in Vienna, lead me to another question. There is, I think, a shift in your large-scale installation work in the 1990s to more and more a notion of "passage" in a Benjamin sense. And the idea that basically there is not one viewpoint but lots of different plateaus within an exhibition. Maybe as a last point it would be interesting if you talked a little bit about your two works, *Tiananmen Square: Break-in Transmission* and *Transmission tower: Sentinel*, which you've already mentioned with regard to Documenta IX, - as far as the content is concerned but maybe also formally, perhaps as a spina dorsale in the space; as well as your *War After War* work for *City Lights Review.*

BIRNBAUM: Yes, I think they are each a little different; but they are each, for me, an investigation. *Tiananmen Square* was made almost immediately after the *Rio Video Wall*, where the television, as a box, became one of twenty-five units. This could eventually relate to the pixel... microcosm and macrocosm. But anyway, the *Rio Video Wall* is the illustration of the television breaking through its frame for the first time in history; - because the image was once contained but then pushed out and beyond, making it multi-framed and larger than it previously could be. Whereas for me, *Tiananmen Square* was already a very large image. It was CNN around the clock bringing news images that I had no way, and still probably have no way, to really absorb or relate to. Certainly if there was a *Tiananmen Square*, the Gulf War did it better and worse at the same time. And seeing that, I then made very small boxes; a landscape of imagery utilizing LCD-monitors, an image that you could only see frontally. If you go to the side it burns out. When you enter the exhibition space, you see these monitors only as lights hanging from the ceiling, as if information was coming down at you. They are not video-pedestals; video put on a pedestal. Here it was always the attempt to hang. I think because the feeling was already that, as with the *Transmission Tower*, it's coming from out there... Dropped from out there; opposing the way museums and institutions usually chose to contextualize video by building a platform for it, as a base for a sculptural event. I thought of *Tiananmen Square* as utilitarian lights; at a distance you only see small lights. When you come closer, you see the image. So, the proximity of the viewer to the image is determined by the space the viewer has to travel through to see many isolated small images. My point of view is that there is no "eye-witness". We have that slogan for Chan-

nel 7 News in New York, - it's one of the bases of ABC, one of the big networks: "We bring to you "eye-witness news". No, you bring to me, obviously, a mediated portion of the news. And in America, since about the year 1965, they owned this "news" before that it was in the public domain. So, in America, if ABC presents Tiananmen Square, they own their presentation of the news and you have to buy it from them. So, if you go to, say ABC, and say that you want to do this work which re-represents their news, they would question who you would want to make the work for. "Will you make it for the State of New York? Then we charge you one rate per minute for the news... Is it for the country of America? Oh, you also want to go to Europe? Which countries?", and then you get all different rates, amounts you have to pay out. And, you even have a rate now for the Cosmos. The Networks and Corporations know already where this is all going.

OBRIST: Like an image bank; a TV bank.
BIRNBAUM: Not only a bank, but they want to own territory as well. The most important thing for me in my work has been to find out first what the mechanism of television is; to question it. Then to find this larger developing mechanism, this networking of communication that happens. Even the television industry knows this and has already projected itself out into space. You know someone on a distant planet will pick up *Wonder Woman* and they will see it at a different time and through a different space. So with my works like *Tiananmen Square,* etc., I want to say: You've made an awfully large image for me on TV. I have to deal with that size and I have to know that there is no real unity in that image.

OBRIST: In the work *Tiananmen Square: Break-In Transmission,* I thought also of a parcours, but a parcours where there is not a path given. It's a parcours where every viewer finds his or her own path.
BIRNBAUM: Yes, this is true. There is a large monitor in the background and there is a hidden surveillance switcher. And the surveillance switcher is going around the room and taking grabs from the collective pool of imagery and putting them up on a large monitor as "TV". So there is all of this too... I think the work is about control; whether you are in control, or whether you are out of control. Either you are in control of your own representation, or out of control of it. Do you have the ability to control it? Even going back to 1979 in *Kiss The Girls: Make Them Cry,* it shows women trying to present themselves in a grid structure of tic-tac-toe boxes. And I very purposely used specific images of women that the game show *Hollywood Squares* presented, and stereotyped them even further so as to look closely at the clichés... a blonde, a brunette, a young girl, a red head. And each one makes a different gesture and you see it all the more clearly

because I dislocated and repeated it. You see how they are fighting to find an identity to over ride their stereotype. How do you introduce yourself to an audience of millions? What becomes your identity? Is it in the smallest nuance of gesture, or form? And now, how do you introduce yourself into the World Wide Web? Because we now have, in a certain way, a big, big television audience. You are introducing yourself, you are going on a bulletin board. Which bulletin board? Nam June Paik had said, "Ah video, very good, no gravity!" Now you have no identity, you make your identity. Oh, I think I'll be Dara today. To escape, someone says... "This is great! I can live out my fantasies in a good way! " The first case of "stalking", of a man pursuing a woman, already happened a few months ago. Can you sue someone? Can you Mack a legal judgment? "Stop! He is stalking me!" You know, you become a rapist... Can you rape through the system? And can you rape identity? So I guess there is an evolved crisis of identity and the ability to act as an individual in a highly technocratic society. I knew from the very beginning, from *Wonder Woman*, I knew that this reflected a very technocratic view of a woman... you either heroize her or you under rate her as a secretary. And where did you ever create for me this meaning, my representation? Where am I, if I am I in-between? There was no space in-between. The burst of light said that I am a secretary, I am a Wonder Woman, I'm a secretary, I'm a Wonder Woman, and nothing in-between. And the In-Between is really the reality we need to live in.

Hans Ulrich Obrist is an art critic and curator, he lives and works in Paris, London and Berlin.

The interview was originally conducted as part of a project for museum in progress, Vienna and was originally published in the catalogue Dara Birnbaum, Kunsthalle Wien, 1995. This version is edited with the assistance of Knut Asdam.

Consistently true to his principle which considers art as a philosophy of ques-
tioning, James Lee Byars involves the viewer of his art in a fascinating dialogue.*
The artist has created his own symbolic world which, far removed from prag-
matic rationalism and linear causality, is based on a metaphysical postulate of
"The Perfect". The other world of James Lee Byars represents the rediscovery of
lost associations of Beauty generating a microcosm of magical signs and enig-
matic symbols.
The form of the ball symbolizes the artist's emphasis on the spherical and gold
assumes a central role in this personal mythology as the most abstract form of
the sublime. The colors black and red reflect spiritual thought that opens doors
to the mystical teachings of the orient. James Lee Byars is a constant traveler in
search for marvellous stones and magical materials to enrich the vocabulary of
his mythology. He selects suggestive places for staging his world; performances
such as "The Perfect Thought", "The Perfect Smile", "The Perfect Death" center
upon the transcendental experience of "The Perfect" as an allegory on the ideal
of Beauty. (G.D.)

James Lee Byars
The Perfect Question

INTERVIEW BY JOACHIM SARTORIUS

JOACHIM SARTORIUS: The "Thinking Field" is one of the works you're cur-
rently showing at Museum Ludwig. It consists of a hundred marble
spheres, all the same size, and arranged on the white floor of a totally
white room into a flawless pattern where the distance from each to the
ones around it is always the same. The viewer who confronts this work
is moved by the perfection of the material from which it's made - by the
absolute purity of the white marble - and also by its system of intervals,
which directs our minds to the eternal laws of the cosmos. The feeling of
staring at the starry sky is something I experience quite frequently while
looking at your work. My gaze is utterly unencumbered, to the point that
this sky begins to take on real existence as something unfolding in the
depths of my own interior. This was the way I reacted to your three-part
work in Stuttgart, "Sun, Moon, Stars", and now it's a part of the feelings I
experience while standing in front of "The Thinking Field". Heinrich Heil
has referred to "The Thinking Field" as a temple for the asking of ques-

* 1932 Detroit, Michigan / lives in Santa Fé, New Mexico.

tions. You too at times have defined yourself as the founder of "The First Totally Positive Interrogative Philosophy". What does that mean?

JAMES LEE BYARS: Basically I attempt to answer questions by asking questions. My works attempt to do that too. The questions they raise are very comprehensive. They also explore all the questions we ask ourselves.

SARTORIUS: What happens when you simply add a question mark to the end of a statement? For example, "You can turn a question into your autobiography?" Or "Philosophy is a question?" Or, "What I can do for you is to give you attention?" These are some of the statements you've turned into questions.

BYARS: I think that attaching a question mark to the end of a statement is a way of filling that statement with life, and of pulling it back into the realm of art or poetry.

SARTORIUS: I see your works as expressions of a great mind. And this mind - in my opinion - has created a poetically self-sufficient system, just like the systems of Basho, Dante, or Beuys: it's something that future generations will have to return to, as a source of inspiration.

BYARS: Self-sufficient? I certainly hope not! I deal with questions since I see them as the very symbol of the indeterminacy and openness of the whole universe. Questions also represent freedom from the strictures and limitations of answers, from all the disorder and disturbance fomented by answers. The figure that lies at the basis of a freedom that steeps itself in questions, of a whole philosophy that consists entirely of questions, is the point: the point that gives birth to the perfectly circular "O" and then to the "Q" - the "Q" of "Question". A one-page book with a single, tiny perforation exactly in the middle of the black page is something we've talked about doing together, and it's something I continue to want to do. It could only be wonderful! This book we have in mind would be a single, completely black page with a tiny hole in the middle of it, or at least a dot, if a hole turns out to be too difficult.

We can imagine a philosophy that would find its roots in the way in which all philosophers have defined "the question". Kant, Hegel, Heidegger. Just imagine! Whenever you encounter a question, it's already charged with all the information that lies at the highest level of spiritual perception. Perhaps. In any case, I intend to hold this point of view until hearing proof of the contrary.

SARTORIUS: Let me get back to "the gang of four" - Duchamp, Broodthaears, Beuys and you. All four of you are iconoclasts and shamans, and yet I see an important difference between you and the other three. You're involved in a very specific quest: a quest for the beautiful and the sublime.

And the nature of your quest also explains your specific affinity with the cultures of Japan, late Renaissance Europe, classical Greece and ancient Egypt. Your notions of perfection strike me as no less important than the notion of "The First Totally Interrogative Philosophy". So, does "The Thinking Field" lead the viewer to "The Perfect Thought" or instead to "The Perfect Question"?
BYARS: To both?

SARTORIUS: James Elliott remarks that your search for perfection always contains a grain of innocence and romanticism. Do you see yourself as a romantic, or more as a philosopher, as the Einstein among the artists?
BYARS: I'm only interested in perfection itself. Which is also a matter, more than anything else, of the highest level of manual craftsmanship. I don't want to classify myself, but I think that I'm one of the most uncompromising artists at work today. I just can't settle for anything less than what I want.

SARTORIUS: And there are all sorts of stories I could tell about that! Our black book was a pitched battle for nearly three years. It almost caused a divorce.
BYARS: Yours or mine?

SARTORIUS: A true ordeal.
Now I have a question. James, in relation to your interest in "The First Totally Positive Interrogative Philosophy", do you think of death as a positive interrogative experience?
BYARS: I hope so! I hope so! I think it all depends on the specific point, as death approaches, at which a person simply gives up. On the point at which you consign yourself to the "unknown". In the hospital I reached a point where thinking - any kind of thinking - was utterly beyond me. It was something I could no longer do. I abandoned myself to the circumstances.

SARTORIUS: And at that point there are no more questions?
BYARS: Not so fast. You can experience fear. I experienced fear. At that point, the question is fear.

SARTORIUS: Is that a positive question?
BYARS: Yes, in this case. Since there was practically nothing else to turn to. When you visited me at Sloan Kittering, I was in a pitiful state.

SARTORIUS: Not at all. You were very cheerful. You had so much energy. I could hardly believe it. You elaborated the plan for a show at the New National Gallery in Berlin. You wanted to empty that large glass room by

Mies van der Rohe - to empty it quite completely - and then to set up an installation of ten concentric circles made of various materials. You wrote out very precise instructions for me on three postcards. The whole thing was to be entitled "The Palace of Perfect".

BYARS: They had given me a dose of morphine just before you arrived. But you're right: I was full of energy when I woke up from the operation.

SARTORIUS: All artists have a special energy that allows them to get the upper hand on death. But now, to close this conversation, I'd like you to tell me about the most important projects you still want to carry out.

BYARS: One of them, the most important, is "The Golden Tower", right in the center of Berlin. The other, on a much smaller scale, is this book that consists of one black page.

SARTORIUS: The binding is something we should simply imagine?

BYARS: Yes, reaching the level at which this single page is perceived as a book is already quite an achievement. People will have to use their imagination. In any case, I've fallen in love with this idea of a large black page with a very small hole exactly in the middle of it: a tiny perforation which reminds you of a sphere - and also of the fact that this text has the shape of a sphere.

Joachim Sartorius is a writer, based in Munich and Berlin.

The interview is an extract from the complete conversation which originally appeared in "James Lee Byars im Gespräch mit Joachim Sartorius", Kunst Heute no. 16, Köln, 1996.

Provocation in art can be expressed not only through commentaries but in the form of real new creations as well. This remark by the boxer and Dada writer Arthur Cravan, reminds us of the potential which artistic actions have to incite. When the freedom of subjective imagination is coupled with a strategy of mimetic subversion, modes of oppositional art trigger an unpredictable dynamic process that aims at the heart of cultural systems.

Maurizio Cattelan provokes; he distorts, he plays and seeks to destabilize the ritual pillars of the art business. His delinquent research within the system of art results in artistic gestures that amount to parodies of the mechanisms of the market, the media and publicity. During the Aperto exhibition at the Venice Biennale in 1993, Cattelan rented out his space to a company; on other occasions, he has had two soccer teams play table football in an exhibition space and had the door at the entrance to an exhibition locked, forcing the invited visitors to peer through the windows into the building like uninvited guests. With such artistic gestures Cattelan infiltrates the system of art, mixing up the coordinates of context by effectively adding just a pinch of bad taste. The artist himself remains in the background, an elusive, clandestine master of ceremony. But he stays nearby, reappearing to engage in new forms of sabotage. (G.D.)*

Maurizio Cattelan
Face to Face

INTERVIEW BY GIACINTO DI PIETRANTONIO

GIACINTO DI PIETRANTONIO: How does the decision to become an artist come about?

MAURIZIO CATTELAN: I lived in a small, isolated town in Corsica until I was twenty. I was somewhat a loner and I used to play with what was around me - the clouds and the sea. That really was a determining factor in the way I developed and flexed my imagination. I really did spend a lot of time just observing the sea, the repetition of the waves, the simple rhythm through which nature is formed. It was particularly important because it forced me to find the motivation for work in the "simplest" of things.

DI PIETRANTONIO: Yet your work is more well-known for the distance you set up between nature and the technological accoutrements in your arrangements.

* 1960 Padua / lives in Milan.

CATTELAN: Well no; at the beginning, when I was studying at art school in Corsica, a work that I did involved projecting an eighteenth century Italian madonna onto the sea using the foam of the waves as a screen. Of course it was a mobile screen caused by the waves hitting the pier and consequently the image could only be seen every five or six seconds. I've worked quite extensively on the relation between nature and technology, like the work where I projected a beam of light onto a slab of marble.

DI PIETRANTONIO: What does it mean for an artist to be Corsican?
CATTELAN: It means you are remote from everything, constantly surrounded by the sea with the sensation that everything happens beyond the horizon. In fact, when I was still at art school, I used to spend many an hour at Bastia, just watching the ships leaving or entering the port. This is something a lot of Corsicans do. You see the ship sailing away, getting smaller and smaller until it is just a dot on the horizon, finally disappearing without even knowing where it's headed.

DI PIETRANTONIO: Do you think that the ethno-political aspect which differentiates the French from the Corsicans has any bearing on your work?
CATTELAN: I think all works of art are political. Art is politics, insofar as art is a point of view from a man who happens to be an artist, a point of view from within the society he is living. In this respect it is an interpretation of society.. So it is political, even if we mean "political" in quotes.

DI PIETRANTONIO: Well, of course, because art always winds up as a rather closed space.
CATTELAN: Exactly. An artist is closed inside his own internal world but he still belongs to a certain society. I always say my work is only possible in the West - it wouldn't mean anything if I was Indian or if I came from some African village.

DI PIETRANTONIO: Sure, but there's also paradox in all of this. Think back to how art was always expressed through a formal closure until the advent of the avantgarde. I mean it had to follow certain conventions to communicate to everyone although at different levels. Just think of church frescoes. But it is the other way round for a formally open work of art in modernity. Everything can be used; we might even go so far as to say that everything can be transformed into art.
CATTELAN: That's true. But if we go back to Corsica and the open-closed relation, it must be said that we are very closed people, very inward-looking, and you can detect this in my work which, while it is very cold, has a strong internal charge. In this respect, Corsica marked the beginning of an

imagination mechanism. But this is no longer very relevant because I'm an artist who tries to communicate even it towards the interior of a context.

DI PIETRANTONIO: When you eventually took one of those ships you used to watch sailing away, where were you going?
CATTELAN: Towards life, because if you're alone, you leave everything behind - your family, your place - and you start to confront the world, make choices. I arrived in Paris with this mental mechanism that I put into gear when I started as an artist. I wanted to start a dialogue with all those new things I was up against, the modernity of the big city. I've dabbled in philosophy and poetry just trying to find meaning in things.

DI PIETRANTONIO: But did you go to Paris with the intention of being an artist or didn't you?
CATTELAN: Let's just say I didn't go to work in an office. I was after something creative. Actually I tried to get into the Academy of Fine Arts but I failed the entry exam - a painting and sculpture test, which I'm not too good at. So I started to attend a film school where I studied to be a director. I learned how to use lighting and cameras. Meanwhile I was studying aesthetics at the university.

DI PIETRANTONIO: Who did you study with?
CATTELAN: I took courses with Roland Barthes, Michel Foucault, Jean François Lyotard, Gilles Deleuze, it gave me a lot to go on theoretically because at the bottom of their high level of science and philosophy, they were dealing with like, simple things from everyday existence, the mythology of daily life, searching for some deep, hidden meaning in things. Which is, after all, what I try to do in my work.

DI PIETRANTONIO: And what bearing does your film experience have on you art?
CATTELAN: It taught me the value of working alone. I mean of being an artist. In cinema, always a group effort, one idea ends up being split between various people and eventually goes adrift. Working alone, on the other hand, means you concentrate more even if is more difficult. Another reason might have been that I was unable to get people to understand my ideas, and so I went into experimental cinema which was necessary to get to art. At this point, I started to work with light and I started to do installations with projectors which usually serve to focus on a scene, but never on themselves. By putting two projectors in front of each other so that they projected their internal light. I was able to underline this idea of going towards themselves rather than towards others, and

working on their concentrated energy, their silence. Then I did some work whereby I had to manipulate some boxes - an idea which came to me when I was directing videos - and I became aware that, having put the monitors back in their boxes, a switched-on television pointed towards a box could have more power than the energy emitted from the screen.

DI PIETRANTONIO: So your work is a reflection of this image negation of the image relation, symbolization of the object?
CATTELAN: I often use materials and objects associated with the idea of communication or movement like televisions, radios, cars, motorbikes and airplanes. They give an idea of emission and reception, because I think that the artist is always emitting something but it means nothing if the element of reception isn't there. The rest is a metaphor of an art which is constantly changing, being transformed. Art today has got nothing to do with art of the past, it doesn't have same motivation.

DI PIETRANTONIO: So are you proposing a sort of illuminist-evolutionist view of culture in progress which seems to go against what you were saying earlier about those philosophers who theorize about a revaluation of the past in the context of a rather linear development?
CATTELAN: Yes, of course; everything is linked but at the same time everything is different and this what I'm getting at in my work when I use objects of movement. And because art feeds off what there is around it - life, society - there is always transformation.

DI PIETRANTONIO: Is this a reflection of your somewhat varied background outside of art school?
CATTELAN: Well, yes, because the possibilities of ending up working with art are manifold and it doesn't necessarily depend on whether or not you attend art school. Just think of the Renaissance, when the artist was completely bound up with society - they were doctors, architects, poets. Nowadays, that versatility exists but in the inspiration of the artist, the contexts he can cull his ideas from.

DI PIETRANTONIO: To what extent is your reflection on objects - a line of research opened up by Duchamp at the beginning of the century - a continuation or a departure from its originator?
CATTELAN: At the beginning of the century, Duchamp was working with objects and was reacting to the era he was living and working in. While he was counterposing them, nowadays we use objects to distance ourselves from the craftmanship of creation and the fact that creation can be determined by a state of mind, an intimate emotion. This is not the case as far as I'm concerned. I use things which surround me from the society

I live in. These are my objects. My message is that we can find a philosophical idea through the television we watch every day.

DI PIETRANTONIO: You talk in terms of movement, objects from modernity, which is the direction that criticism is taking nowadays; a Duchampian line which, in my opinion, flies in the face of the futurists with their exaltation of our mechanical civilization, modernity, and the symbolism they have attributed to current artistic objects like metaphysics and surrealism.
CATTELAN: Yes, you're right. In fact I am more concerned with the second tendency you mentioned rather than with readymades, although formally it might appear the other way round. I am more interested in the futurist side of things because of the idea of movement, which links it more closely to life, while I find Duchamp very intellectual; his work is like a chess game and his relation with the object almost hysterical. He remains very far removed from the object and although his objects are very cogent, they have nothing to do with the type of object proposed by me or by other artists of my generation.

DI PIETRANTONIO: In what way does your work deal more with international life?
CATTELAN: Well, I work with things I find around me, everyday environments which was not the case with Duchamp. The objects I use in my pieces are objects we use daily, while Duchamp never used a bicycle for instance.

DI PIETRANTONIO: Yes, but your work overturns the normal serial status of objects and makes them into one-offs.
CATTELAN: I always make three of every work because after reading what Warhol had to say about seriality. I don't feel the need to deal in one-offs as someone who expresses himself through painting does. I love the idea of the same piece being in New York, Australia, Europe and Japan at the same time.

DI PIETRANTONIO: Yes, but as soon as an everyday object enters into the realm of art, even if it is produced as a multiple, it loses its original seriality and becomes a unique piece, taking on a new mystique.
CATTELAN: Yes, because the object no longer has its original function. That's why I always use new objects which haven't yet accrued certain connotations through their use or through history. For example, when I used two bulldozers in front of a pile of earth at Le Magasin in Grenoble, they had to be new because I wanted a contradiction between the two things. If, on the other hand, I had put two used bulldozers had moved the dirt. I'm more interested in maintaining that ambiguity on the use of the object.

DI PIETRANTONIO: In this sense, your work is something of a parallel of the philosophy you cited earlier. What is the philosophy you have found in contemporary objects?

CATTELAN: I've realized that the meaning of the object goes beyond what they seem to be telling us, and that goes for its functional use as well. It goes for other things we can refer them to, things spanning from life to death.

DI PIETRANTONIO: When it comes to using these things in our lives - airplanes, cars, televisions, and so on - we can't help but be aware of the makes of the various products: Sony, Air France, Mercedes, like a sort of recognizability through advertising. What is the importance of this in your work?

CATTELAN: Well it's a chance thing really, in the same way it was in the Renaissance where the character depicted in the painting was the buyer, without it being a reflection on publicity. Actually, I have often been put in exhibitions which address advertising though it's something I feel quite remote from.

DI PIETRANTONIO: But when you opt for a Sony television over a Philips, or you use a Volvo instead of a Renault, is it because it is easier to get hold of certain makes or is it a precise question of form and content referred to the object of a specific make?

CATTELAN: It's just the way things work out. I get the idea of using a car which represents the middle classes in my work, like a Documenta where I asked the organizers for a BMW, but they told it would be easier to get hold of a Mercedes, because Mercedes was sponsoring the show and that's what I ended up using. It doesn't change a thing though, since all I wanted to do was to put a car on a pedestal. Sometimes, however, there is an undeniable formalist intention at large, like with the Concorde, which was chosen for its inaccessibility and its particular design, whereas when I did the work with those ships in New York, I used whatever I could get my hands on.

DI PIETRANTONIO: There has been a recent return to earlier concerns in your work, with air and smoke coming back to the fore.

CATTELAN: You're right, because I was getting a bit fed up with being invited to participate in shows dealing with "the object", while my way of working with the object doesn't stem from Duchamp's reflections on the object but from other assumptions I started on in Corsica. That's why I went back to working with nature, with the works on the bombs. For instance, when I was invited to the Seibu museum in Japan, the creators wanted me to put on a show exalting the country's technology, but I was

more interested in the people so I did a work which involved putting together a boy and a girl facing each other their lips close to each other in a kind of kiss.

DI PIETRANTONIO: So your work can be changed by the context?
CATTELAN: Yes, but I am not an in situ artist.

DI PIETRANTONIO: But do you set out with a sort of gameplan which is then modified, or do you create your work entirely without a predetermined idea?
CATTELAN: I refer to my work as arrangements, finding the apt setting for an initial idea so that the space or the economic situation or other situations might modify the work. The part I play is director of these elements.

DI PIETRANTONIO: And that was the idea behind your show at Studio Casoli in Milan?
CATTELAN: What interested me was underground space with so little natural light that you can feel the need for artificial thing like television and light boxes. This space is like a cellar where objects are often deposited. So I put a load of boxes from Brionvega televisions and lined them up, one beside the other with pieces of white polystyrene on top, which stopped you from seeing the object (television set) inside, the object in the box before being used. Along with this closed, minimal work. I placed a light box in another position, wherein there was an explosion, which was in direct opposition with the rest of the exhibit because it liberated energy, it opened towards the outside.

DI PIETRANTONIO: It's like the beginning of a new cycle leading towards the exterior, unlike the objects where the energy is concentrated towards the inside - a passage from a state of culture to a state of nature.
CATTELAN: Yes, and my recent work at the Jerusalem museum involved an installation of light boxes surrounding the museum which served to close the period of my work with objects. Of course you can also detect references to the local situation which sets Palestine against Israel in the explosions.

DI PIETRANTONIO: Coming back to Europe, I see this work with explosions also as the metaphor for an artist attack on the Paris by Corsican autonomism - the ethnic aspect recovered without having to slip into folklore.
CATTELAN: That's why on the cover of the catalogue for the Grenoble show. I put the explosions on the cover and a picture of Corsica inside.

Dı Pıetrantonıo: But is it just an artistic metaphor or are you really involved in Corsican separatist activity?

Cattelan: I'm not directly involved, but I feel very close to their plight. In fact, my piece at the Biennale was called "Nuit Bleu", the night bombs are set in Corsica.

Dı Pıetrantonıo: Is there danger you might become isolated in French art for such explicit politicizing?

Cattelan: No, because art can recover anything by neutralizing it, though, as you say, these explosions are an attempt to fly in the face of the tranquillity of art over the last few years. When I participated at the reopening of the ARC in Paris, where everything had been restored, I put the police motorbikes with the flashing lights. I was trying to get away from the officiality of the museum where everything was new and renovated. I was trying not to see things within the predetermined scheme where the system tends to become more important than the art itself. Once organization is seen as being more important than the artistic product, things are undermined, saturated. This happens because we are now living in a completely simulated condition, where information tells us nothing about reality; when there is something on television about kids dying of starvation in the third world, it doesn't really have that much of an impact on us, perhaps because we no longer receive such images as truth. That's why art should try to regain the territory of truth and bring it back into reality.

Giacinto Di Pietrantonio is an art critic and free-lance curator based in Milan.

The interview originally appeared in *Flash Art* no. 163, Summer 1991.

There is no trailer to channel the viewer's expectations towards the movie plot. The film opens in medias res, the scene appearing "out of the blue", and ends just as abruptly. The scene is over before the viewer has even had a chance to determine whether the action is actually part of a story. The action is torn from its context and reduced to a fragment. Stan Douglas* stages unspectacular films. Scenes are short, much like television advertisements, and shown in a sequence governed by no apparent criteria of order. In this case the spot is stripped of all narrative embellishments and thus exposed as pure structure: the fragmentation of reality, the disruption of chronological sequence, the monotony of interruption and a lack of cohesive narrative structures.

"Monodramas" (1991) renders the coded pictorial language of the mass media transparent and signals a departure from traditional social habits. The structural analysis points to the socio-cultural language of the media. In his extensive research, Stan Douglas investigates both contemporary television forms and historical film material. (G.D.)

Stan Douglas
Television Talk

Network has little terms for what we do as writers - to describe little "hooks", to use one of their terms. For instance, "topspin" - a great network word. "There's not enough topspin". Topspin in network terms is something that happens to propel you to the next scene. Usually someone loses a briefcase or something really exciting, and that's topspin into the next scene. Heat is tension, it's argument, usually someone calling someone a fat mother or some great thing. "Pipe". They say, "We've got to lay pipe here guys, we're not dealing with college people, lots of pipe". Pipe is the history of every character from the moment of their birth until the moment they stepped into that room. God forbid that anyone watching could give any closure to a character on their own. Then you have a "blow", a "hook", a "button". For some reason in network TV no one can leave a room without a joke. I don't know how it is in your home, but in my house a lot of people will just go out, but here you cannot, you must deliver a joke and leave the room. That's blow or a button. "We don't like the button. Change the button. Get a better blow". And the hook would be something like a man just landed, he's from another planet, that's the

* 1960 Vancouver / lives in Vancouver.

hook. Then the audience is going to watch it - we have an alien in our living room" - the audience is hooked.

You never hear discussion any deeper than that about the writing, about character development, and motivation, and reality, and the truth of the moment. But you'll always see a show that'll have heat, topspin, pipes hopefully a good button, and a hook, and a great blow[1].

The Hook

Until its later moments, the 1991 B.C. provincial election went pretty much according to tradition: a spiteful contest between the region's "socialist" and "free enterprise" parties[2]. But, by the end of the election campaign, it was the almost-forgotten Liberal Party of B.C. (not the once-powerful Social Credit) who formed the Official Opposition to the New Democratic Party government that had ended nearly forty years of Socred rule, broken only once, in 1972, by the NDP's previous single, tenuous term in office.

On the day that the election was announced by doomed Social Credit premier Rita Johnson, the local CTV affiliate, BCTV, suggested, with an air of prophecy that would soon become station policy, that voters wanted an alternative to typically polarized provincial politics. At the outset of the twenty-eight day campaign, the station's Voice of B.C. poll was introduced: beyond recording the measure of party preference, the poll would supposedly provide qualitative information from quantitative data - daily, until voters went to the polls on October 17. The first such "qualitative" polling figures were in response to the proposition "Voters in B.C. are tired of Socred/NDP squabbling and now want to elect a moderate, third-party, free-enterprise alternative", - 60 per cent of respondents agreed, with only 36 per cent dissenting[3]. Even in this first proposition, one can find evidence of the kind of the methodological failing that later would grossly distort Voice of B.C. pronouncements. The question asked was both ambiguous and weighted towards a positive response: respondents were not asked if they themselves were tired of the squabbling, but rather what voters in B.C. think, and whether this constituency, however respondents imagine its members, wants an alternative.

During the same broadcast in which the first utterance from the Voice of E.C. was aired, the provincial Liberal party leader Gordon Wilson, appeared, declaring himself to be the hypothesized free-enterprise alternative. While local newspapers and other television stations had more or less refused to take Wilson's party seriously, he would be seen frequently on BCTV. The other media were more interested in reporting on the minor controversies that inevitably arise from U.S.-style negative campaigning; or on NDP leader Mike Harcourt's "low-bridging" refusals to

elaborate on his forty-eight point platform; or, especially, on the latest Socred scandal, such as the revelation of one candidate's neo-Nazi affiliations, or the criminal charges laid against another for theft and breach of trust. In fact, the B.C. Liberals - who had not held a seat in the legislature since 1986, had only received 7 per cent of the popular vote in the previous election, and had asked their leader to resign on four separate occasions in the previous year - could not even get Gordon Wilson invited to the leaders' debate on CBC television. It was only after his party picketed the regional CBC headquarters, threatening a lawsuit, that Wilson was able to claim a podium alongside Harcourt and Johnson.

The event carried live by CBC and CKVU-TV on the evening of October 8 was a debate in name only. Many British Columbians witnessed something resembling a three-party press conference that included name-calling, poorly concealed manipulation of facts, and the constant evasion of direct questions. On two separate occasions, moderator Kevin Evans felt it necessary to remind the participants of debate protocol and of what debates were, hypothetically, for: that a debate was not an occasion for presenting campaign speeches. But all three had been carefully groomed for the event and were not about to change their posturing. Those who could afford it had geared their self-presentation according to information gathered in party-sponsored polls and, as Evans later wrote, "the leaders rehearsed and re-rehearsed their carefully crafted scripts. Some even brought in their own wardrobe and performance specialists"[4].

This likely accounts for Mike Harcourt's bizarre obliviousness to direct questions (an adaptation of his method of ignoring hecklers in the Legislature), and it certainly accounts for his non-sequitous speech which used a Carecard and American Express card as props to parody Socred health care policy. It may account, too, for Rita Johnson's preposterous and oft-repeated claim that the NDP platform would cost each family in British Columbia an extra $314 a month in taxes; however her constant heckling of Harcourt must have been her own idea. To his credit, Gordon Wilson sometimes did give straight answers to questions, but only when they were not asked of himself. He was most eloquent only when restating his party's single greatest strength: that the Liberals were *not* New Democrats and *not* Socreds. As one might expect, these immutable positions wore thin over the hour-long debate, and decorum finally broke down in the three-way confrontation that became the preferred sound-bite for local television stations.

A few days after the debate, a Vancouver Sun/Angus Reid poll of 601 adults indicated that 76 per cent of British Columbians felt that Gordon Wilson had won the debate, even though there was no explicit thesis to refute or defend. Also using the same sample, and asking if they were "feeling better" or "feeling worse" about a candidate, Reid constructed what he called

the relative Momentum Factor (MF) of each party. Subtracting percentages of declining opinions from percentages of improving opinions, he determined that Rita Johnson had a -28 MF, Mike Harcourt a -16 MF, and Gordon Wilson a +56 MF! Reid elaborates, "In the past, momentum numbers like that have usually translated into a substantial increase in popular support". He added that he had never seen such a high Momentum Factor[5].

Ignoring for the moment the fluorescently dubious notion of a Momentum Factor what do such statistical constructions really mean in relation to the final outcome of an election? And, more important, what do these numbers, as news, actually contribute to the understanding of which candidate will best represent a constituency? Do they innocently reflect public opinion or tacitly manipulate it? In their discussions of popular support, many reporters neglect to mention that parliamentary elections in Canada, unlike, say, leadership conventions, proceed by metonymy, not by metaphor: one elects an MLA whose party is represented by a leader, and not directly a leader him or herself. However, political reportage and campaigning in Canada today emphasize the opinions and personality of a party leader who acts as a fetish for the party as a whole. In the days following, Angus Reid did temper his enthusiasm by indicating that, while Gordon Wilson was well liked, the actual support for his party's candidates was still quite "soft"[6]. But the momentum of BCTV's coverage had only just begun to build.

News Hour anchor Tony Parsons, had introduced the Voice of B.C. poll as "the most comprehensive surveys of *your* attitudes in B.C. history"[7]. Adding that, unlike the NDP and Social Credit surveys, which are secretly conducted and used to develop campaign strategy, this poll was not devised for the needs of a special interest group. Although Voice of B.C. spokesman Les Storey would, a few weeks later, refuse to disclose the nature of his polling methodology or data because both were the property of BCTV, Parsons wanted his choice of pronouns to convince his viewers: "This is your poll". Storey, who would become a regular fixture on the evening news, early on stated his ambition "to try and get to the truths of the campaign - the underlying themes of the campaign - to let the voters know what is happening and why it is happening"[8]. But such insight was not forthcoming. If the research company and its sponsoring television station had, for example, studied the biases of major party polling, analysing how their studies effected general party policy and advertising, it could have contributed substantially. Instead, Voice of B.C. produced a parallel body of knowledge that would eventually manufacture its own controversies as much as it would address the few explicit issues raised during the election. Because it had chosen to follow its own logic and system of biases, the Voice of B.C. poll diverged wildly from the actual outcome of the elec-

tion. On election eve, it continued its week-long inference that the Liberals could possibly form a minority government because of their high ratings in popular support - 37 per cent, three points more than the NDP, and twenty points ahead of the Socreds[9]. Final election results found the NDP with 51 seats in the Legislature, the Liberals with 17, and the Social Credit Party down to only 7 - the popular vote giving each party 41, 33, and 24 percentage points, respectively. Since these results were well within the margins of error reported by local newspaper polls, why was the outcome predicted by the Voice of B.C. in the end so different from the choices finally made by B.C. voters?

The phrase "honesty in government", a vague trope for the numerous scandals surrounding past Social Credit governments, became the nearest thing to a campaign issue that the older local parties could agree upon. One hopes that it is because the Voice of B.C. company took this as a cue that it soon began to measure what it called the "trust ratings" of party leaders. Although the company had been calculating voter "trust" throughout the election, after the televised debate, the phrasing of the question, or its placement in the order of other questions, may have radically skewed polling results: after his performance in the leaders' debate, the relatively unknown Gordon Wilson was apparently regarded as being far more trustworthy than the other candidates. NDP pollster Dave Gotthif suggests that questions were asked in an order which led interviewers down a "logic trail" that influenced their penultimate response: Who won the debate? Which leader do you most trust? For which party will you vote?[10] Storey nevertheless maintained that his figures were correct, that it was not his job to predict the election but rather to "hold up a mirror to the public and say, 'This is what's going on today'"[11]. And he would go so far as to announce that his campaign reportage remained an accurate representation of what people in British Columbia *really* thought, in spite of the fact that the Liberals were "not very good at getting their vote out"[12]. Thus, he argued that his analysis of the election was more accurate than its final outcome - perhaps more representative, more *democratic* than the (admittedly tired) democratic process itself. Notwithstanding the contention that BCTV wilfully promoted the provincial Liberals, the station's sensational coverage of the 1991 election was certainly a symptom of the economic malaise that has befallen virtually all major broadcasters in North America. Although it will necessarily do so, it is not the business of a local broadcaster to manipulate popular opinion; rather, it is the business of a commercial television station to make money. And the money that a station will make is directly determined by its popularity among "people using television". In 1991 the network with which BCTV is affiliated, CTV, reported a loss of $2.5 million and liabilities of over $20 million. This deficit was largely attributable to the increasing fragmentation of

the television market combined with expenses incurred since the 1987 Canadian Radio-Television and Telecommunications Commission (CRTC) decree that the network would increase its expenditure on Canadian programming by 75 per cent. In addition to dealing with a recession, BCTV now had to surrender more air time to new network programs. Under the influence of a new owner (Western International Communications Ltd.), BCTV had, during the early 1990s, desperately been trying to cut costs: automating news broadcasts, laying off camera operators, firing senior news staff, all the while expanding its seasonal advertising campaigns in print, electronic, and street-level media [13]. BCTV's sensational coverage of the 1991 provincial election - however interested - was at least in part an attempt to increase its own popularity, station recognition, and all-important ratings share by manufacturing controversies it could later report.

Pipe

The reason for television in North America is advertising. This immutable characteristic has been evident since its prehistory - since the moment radio was introduced on the continent, and immediately distinguished from the state-regulated and publicly funded practices in Western Europe. While the U.S. radio network had, from the first instance, construed its audience as a market to be delivered to advertisers, the BBC (for example) had regarded its listeners as a *public* in need of edification. The former intended to "give them what they wanted", while the latter paternalistically presumed to "give them what they *needed*" - imposing the moral imperatives of a national culture upon audiences, forcing them to "confront the frontiers of (their) own taste" [14].

Radio was introduced in the United States in 1920s after an agreement was reached between AT&T, General Electric, and Westinghouse, who wanted to maintain war-time production levels of wireless sets by selling fully assembled radios to a non-military, non-hobbyist domestic market. Westinghouse's KDKA (Pittsburgh) is generally credited with being the "first" North American broadcaster, beginning transmission in November 1920 - around the same time that the Marconi company's XWA (later CFCF) went on the air in Montreal. Two years later RCA, which was jointly owned by the three U.S. companies, created NBC, whose "Red" and "Blue" networks would provide programming to affiliated radio stations across the continent connected by AT&T's cable telephone technology. Once CBS began operation in 1927, the tripartite system of network competition was firmly established, as NBC-Blue would later become ABC.

In addition to the numerous American radio transmissions that could be received over the 49th Parallel, by 1930, at least four Canadian stations

were affiliated with one or the other U.S. network[15]. In response to the cultural and especially, economic influence of U.S. programming bleeding over the border, the federal government in 1932 established the Canadian Radio Broadcast Corporation (CRBC) amid nationalist rhetoric rivalling that accompanying the creation of the Canadian Pacific Railway. Lacking sufficient capital, the CRBC relied on existing stations to transmit its programs, but in 1936 it was reorganized into the Canadian Broadcasting Corporation, which, by the following decade, had established a nation-wide network of stations connected by microwave transmission relays.

Early radio shows on private stations were more or less program-length advertisements for the manufacturers who paid for production expenses: they would typically incorporate the sponsor's name into their titles, or at least include prominent "plugs" for their benefactor's products. Given the substantial investment in this new promotional tool, advertisers demanded some kind of measure or guarantee that the audiences they were paying for were indeed there. Doubting the statistics provided by NBC (which resembled a copy), they set up their own Association of National Advertisers (ANA) in 1928, using telephone survey methods developed by Archibald Crossley. Only two years later, the ANA methodology was challenged and supplanted by that of C.E. Hooper, who persuasively argued he would not depend upon uncertain accounts of respondents' faltering memories because, instead of asking them what they habitually listened to, he would ask them what station they were tuned to at the moment of contact. Hooper's results were sold to both advertisers *and* broadcasters, making his operation appear to be more impartial, and outside the influence of one or the other interest - and "Hooperatings" became *the* absolute measure of broadcasting success, until 1942[16].

In the 1930s, the company Arthur C. Neilson had founded a decade earlier to conduct consumer market research and performance studies of industrial equipment moved into media research with devices that mechanically measured the habits of radio listeners. In 1942, after six years of preparation, the A.C. Neilson Company entered the audience-measurement market with a device called the "Audimeter". Because the Audimeter could record the tuning of a radio at various times of the day without the active participation of a listener, it had, for broadcasters, a greater aura of scientific objectivity than the telephone survey method. And because patents for the Audimeter were written to prevent other companies from developing similar devices, Neilson was by 1950 able to achieve an incontestable monopoly in the United States. Audimeter-like recorders were soon applied to the new medium of television; since new "Setmeters" could be used to generate quantities of detailed *temporal* data, they enabled the transition from program sponsorship to spot advertising, hastening the end of the so-called Golden Age of Television.

In Canada today, A.C. Neilson shares a portion of the TV ratings market with the BBM (Bureau of Broadcast Measurement) a co-operative established by advertisers and broadcasters in 1944. But, in the United States, media study is dominated by Neilson alone, where its measurement of audience levels directly determines the commercial value of air time. In spite of its enormous influence on network policy and programming, the ratings information issued by the Neilson Media Research Group is surprisingly limited. Until the 1980s, the majority of all Neilson television data were collected by way of Setmeters used in conjunction with written diaries. Households equipped with meters would also be sent diaries in which they were expected to make detailed daily records of their viewing habits [17]. This information was used to compile that statistical construct known as the "Neilson Family", in which each household surveyed represents something in the order of 100,000 U.S. television viewers. The diaries were of critical importance because the Setmeter could register only a television set being on or off and the station to which it is tuned, not whether or not there is anyone watching. The combined methods nevertheless left broad margins of error because they depended heavily upon the cooperation of viewers: some could simply forget to keep track of what they watched on a daily basis and later guess; others might record what they thought they *should* have been watching rather than what they had actually watched despite these uncertainties, the habits and preferences of an audience constructed in this manner determined the value of the advertising envelope surrounding a network program - precisely because it was measurable. However the commodity theoretically exchanged - all television viewers - remained an enumerated yet unknown quantity.

Heat

In 1987 following the first failure of AGB Television Research to break Neilson's information-collecting monopoly in the United States [18], the former company's innovation known as the "People Meter" was appropriated by Neilson as the supposed solution to its potentially contestable methods. On a small contrivance resembling a remote control are set a series of buttons representing each television viewer in a room. Each viewer is supposed to press his or her own button when watching TV, and then press it again when stopping. This apparatus combined with a type of Setmeter and a VTR meter, provides Neilson with theoretically more precise data registered in thirty-second intervals and relayed to research centres by modem at the end of each day. But as networks got to get to know their audiences in more detail, they began to learn things that they did not want to know: that zapping ads with a remote or zipping through them on home-recorded tapes was a common practice, and that when

television sets were used at all, they were very often used to watch new media sources such as superstations, rental film-on-video, and cable.

In the first quarter of 1990, the new measurement system precipitated a crisis. People Meter data had already been recording a decline in network audiences for the past three years but, beyond the more gradual evening of interest in TV that had begun in 1982, Neilson now reported a sudden and, according to the networks, "unexplained" 7 per cent drop in people watching television. This single digit sounds like a small amount, but in a market where thirty seconds of prime time was worth an average of $120,000, and given that seven percentage points could mean the loss of $308 million in Up-Front sales, this glitch amounted to a minor catastrophe. Each July is the time of the annual network Up-Front buying spree, which typically involves three or four days of intense negotiating between network executives and media buyers over the fall broadcast season. Networks guarantee advertisers that the rating of a particular show will not fall below a projected level and, if it does, they will make good on their promise of audience levels with free air time. The Neilson-reported drop already represented $200 million in Make-Goods and, combined with a possible 7 per cent devaluation of air time for the 1990/91 season, it meant a potential network loss of half a billion dollars.

Predictably, the "Big Three" networks (NBC, ABC, and CBS) vehemently argued that A.C. Neilson was unable to explain adequately the drop in viewership, even though consumer VCRs were no longer the high-priced luxury items they were when first introduced in 1975; since the 1987 deregulation of cablecasting in the United States, there were now 65 cable networks on 9,000 cable delivery systems offering as many as 38 channels to 59 per cent of all American TV viewers; and the networks' nearest competition, the Fox Network, was getting nearer to a complete schedule, with three full days of programming which it sold to 126 affiliates and 7 wholly owned stations. The first reaction was from the second-rated Capital Cities/ABC network. On May 31, ABC vice-president John Abbattista announced that his company had devised its own system of calculating ratings standings, because there was a "bug" in Neilson's People Meter, and ABC "shouldn't be held responsible for their measurement problem"[19]. Less than two weeks later the top-rated network, General Electric's NBC, announced its own plan to restructure Neilson numbers - one found to be more palatable by advertisers and which was eventually accepted by both CBS and ABC. As opposed to the ABC method, based on average viewing levels over the previous three years, and which had effectively disguised the People Meter-reported decline, NBC took as its starting-point 1982, the year that television viewing stopped its annual increase since the introduction of the medium, and had began to level off. As NBC Research Vice-President Robert Niles explained with unusual

candour, "We just decided to throw it all into a pot and trend it all Out" [20].
The ratings recalculation was, surprisingly, a huge success with advertisers,
and the networks reported their largest Up-Front season ever, with com-
bined sales of $4.3 billion. But in spite of the new calculation method,
recorded audiences continued to disappear during the fourth quarter of
1990. Make-Good commitments for one network had reached 20 per
cent, and the Big Three were all forced to open a huge "scatter market"
(the discounted sale of unsold air time). Bowing to pressure from media
buyers who felt cheated by the inflated prices of 1990, NBC announced
in March of the following year that they would return to the old system
of ratings calculation [21]. The other networks soon followed suit, but this
belated admission of a disappearing public has obviously done little to re-
vive the reputation of network television. Desperate attempts to make up
the difference - the "split-thirty" or fifteen-second ad and increases in
"clutter" or commercial density - have only been able to hide the prob-
lem and not eliminate it. Today, network audience numbers and advertis-
ing revenues continue to drop.

Topspin

In 1950, the A.C. Neilson Company represented the totality of television
viewers in the United States, using a sample of 1,200 households (some
of which had been polled since early the radio studies of 1938). Pressure
from the Federal Trade Commission (FTC), Federal Communications
Commission (FCC), advertisers, and networks eventually got Neilson to
completely turn over its sample and to expand it in number to 1,700 by
the end of 1969. It was by no means a coincidence that 1970 was termed
the "year of relevance" for network television. This year witnessed the
sudden disappearance of the retinue of ageing radio and vaudeville stars
who had dominated programming for so long. The interests and opinions
of the older radio listeners had been supplanted by those of a new audi-
ence sample. And, in stark contrast to the "Happy Talk" news formats in-
troduced by the networks around the same time, their entertainment di-
visions began to develop new television shows with younger performers
in more "socially relevant" situations [22]. But for whom was this program-
ming invented? Happy Talk news was meant to assuage an audience fa-
tigued by increasingly graphic representations of the United States' ongo-
ing war with Vietnam and the country's apparently immanent internal dis-
solution. And the relevant entertainment programs wanted to suggest to
the Neilson family that, in spite of it all, the American Dream could still
be realized, and that "tolerance" (tolerance of what?) was a virtue.
The Neilson family was composed of those who could buy what adver-
tisers had to sell. Ethnographic details, and vague ones at that, were not

given consideration in research and programming until well after a decade of civil rights activism - and probably only because of the suggestion by advertisers that Blacks in the United States, might constitute a productive market. The 1970s did see the appearance of a number of programs featuring working class black families marginally less stereotyped than in media representations of previous years; but to be "average" on network television was to be upper-middle class, and these programs continued to place images of Afro-Americans well outside of the American mainstream. Ironically, the supposedly "positive images" of upper-middle-class Blacks who have since populated programming and advertising during the 1980s, which present the deepening economic disparity in the United States as being magically "solved" by individual achievement, systematically reinforce racist preconceptions. Even if one ignores the illusory realization of the "American Dream" embodied in such sitcoms as the now-defunct *Cosby Show*, there remains the supposedly disinterested, yet clearly biased, reportage of network news. Consider the representation of drug abuse: whereas surveys indicate that 15 per cent of drug abusers in the United States are black, and 70 per cent white, 50 per cent of all drug abuse reported on network news shows is attributed to Afro-Americans[23]. (This distortion is even higher in the pseudo-documentary cop/crime shows of the early 1990s.) Consider, also, the Canadian media's reportage on the subject of "Asian gangs". At a time when immigration policy is hotly debated by federal and provincial governments, it is typically suggested that there are criminals among recent immigrants to Canada, and their presence is far more significant than the activities of Anglo-Saxon and European "suspects", who are presumably now a part of Canadian tradition. Systemic racism is most effective when it is no longer openly ideological - when presumably indifferent mechanisms, and especially economic ones, maintain racist divisions disguised or contained as class distinction.

The Neilson family was composed of those whose (real or imagined) existence could be the most instrumental to commerce. Based on the assumption of the U.S. myth of a nuclear family in which women are "homemakers" and responsible for the majority of daily purchases, white, middle-class, heterosexual women between the ages of 18 and 49 had for years been the favoured demographic category for media buyers, and so this construct became an important member of the family. People Meter surveys, however, allowed the Neilson company to generate reports with increasing detail. As Charles Kennedy, director of program development for the Fox Network, explains, "The People Meter came along and allowed advertisers to break down demographics more finely. Before, in the 18-to-49 age group, the networks had placed their programming emphasis on those viewers 35 and older, because that's what the diaries - compiled mainly by parents - were telling them. But the

People Meter showed where the younger people were and what they were watching"[24].

The Fox network, which began broadcasting around the time that the People Meter was introduced, geared the majority of its programming to this audience. And the now-measurable presence of younger viewers even inspired the older networks to develop a number of youth-oriented shows in the early 1990s. But what do broadcasters really know about their audiences, even now that the 18-to-49 category can be "refined" to 18-to-34? The People Meter's "Description Controlled Data Base" for each sample household gives. Neilson subscribers demographic information in only two categories, "1) Sets: type, available channels and set arrangement; 2) Audience information: age, sex, education, profession, pets and income"[25]. A Neilson document admits that the majority of homes that decline to participate in the ratings calculation are those where non-official languages are spoken. But in the "recruitment" of alternative "basic homes" randomly chosen in a census strata, or "cells", the only demographics regarded as significant are the age of the head of the household and the presence or absence of cable and children - not cultural background or relative income[26]. Determining the cultural interests of an audience is left to the discretion of programmers, because the Neilson Family is, literally, speechless.

The grounds upon which ABC had originally contested the People Meter's accuracy - that viewers simply tired of punching buttons - may have been well founded, but it was not in their interest to consider all of its possible flaws. By the middle of this decade, European and American research companies are expected to introduce further technological "solutions" to these defects: passive People Meters that will be able to detect a viewer's presence without his or her involvement; the possibility of continuous on-line access to data on viewer activity, and the integration of viewing level surveys with information on barcode registered purchases in supermarkets and department stores. If these new sources of audience information are used in good faith, the results could be devastating for network broadcasters. But because they will likely continue to develop their programming and advertising strategies solely in relation to their own presumptions and the responses of trial audiences who fit their demographic preferences, the new technology will only prolong the existence of a tautological system of knowledge and its phantom progeny: an audience commodity which has only slight reference to the social world.

With the widespread union of polling and politics - not only within political parties, but also among those who are supposed to monitor political activities - the process of politicking has become hardly distinguishable from that of marketing[27]. When researchers working for political

parties begin (as they already have) to use industrial methods to determine election strategy and state policy, they will learn as little from their publics as the U.S. networks did from their moment of relevance in the 1970s or from their minor stroke twenty years later. A palpable, yet still-absent subject haunts this system, and it is the very one which gives television its meaning: the television audience. But to simply measure their number and then divide that sum by demographic clichés only confirms the sovereign imagination that invented those stereotypes. Similarly, for critics of television to speak only of the "preferred meanings" of a television "text" is to speak sadistically, from the side of advertisers and broadcasters, much like the structural analysis of network narrative which served as an epigraph for this essay. Television ratings and democratic elections create similar public spaces. Both depend upon participation and consent in order to legitimate their prerogatives. A public is measured, but its enumeration creates a body of knowledge under private control: A public space is presented to us and, with the same breath, withdrawn from view[28].

The text is reprinted from Stan Douglas, "Television Talk", Little Cockroach Press 1, Art Metropole, Toronto, 1996.

[1] NBC producer Gary David Goldberg in the television documentary *Don't Touch That Dial* (CBS: 1982). Quoted by Sut Jhally in *The Codes of Advertising* (London: Routledge 1990). 104-105. Punctuation added.

[2] The terms, "socialist" and "free enterprise" are used in accordance with their vernacular meanings in B.C. politics. The Social Credit Party's wild free-enterprise initiatives were typically checked by federal policies and the threat of withheld transfer payments, and the New Democratic Party's version of social democracy will, by this late date, hesitate long before infringing upon the interests of local capital. During and since the 1991 election, the provincial Liberal Party has more or less become a refuge from the Socreds disenchanted with the Social Credit party has impertinent populism and no-longer-charismatic leadership.

[3] *News Hour,* Vancouver: BCTV(CHAN), 19 September 1991.

[4] *Vancouver Sun,* 11 October 1991, A21.

[5] Although it did remind him of David Peterson's Ontario win in 1985. Ibid., B3.

[6] *Vancouver Sun,* 12 October 1991, A1.

[7] News Hour, 20 September 1991; emphasis added.

[8] Ibid.

[9] *News Hour,* 16 October 1991.

[10] *News Hour,* 15 October 1991.

[11] *News Hour,* 16 October 1991.

[12] *News Hour*, 18 October 1991. More modestly, BCTV Assistant News Director, Keith Bradbury, admitted that "the station did not do a very good job of explaining to viewers that the Liberals could come out far behind the NDP, even if the poll showed them leading in the popular vote". *News Hour*, 19 October 1991.

[13] One of the reasons for this increase in advertising is to engender station recognition, because it is crucial that a station be properly identified in ratings surveys. As Gerard Malo, Quebec vicepresident of the BBM Bureau of Broadcast Measurement says, "Some people who forget to mark down a show or viewing time will return to the form later and guess a reply... People find (the recent variety of channels) more and more confusing. For instance, does a viewer know he is watching on the CTV station in Victoria or the one in Vancouver? This has an impact on advertisers. They no longer believe in the ratings service". *Vancouver Sun*, 30 July 1990, D4. More about the requisite "belief" in ratings below.

[14] Past BFI director Anthony Smith quoted by Len Ang in *Desperately Seeking the Audience* (London: Routledge, 1991), 26. Ang's book compares the distinct broadcasting traditions in Britain, Holland, and North America.

[15] In Toronto, CFRB (CBS) and CKGW (NBC); and in Montreal, CKAC (CBS) and CFCF (NBC): Mary Vipond, *The Mass Media in Canada* (Toronto: James Lorimer & Company, 1989), 39.

[16] For a concise overview and archaeology of television ratings in radio surveys, see Eileen R Meehan, 'Why We Don't Count: The Commodity Audience", *Logics of Television*, ed. by Patricia Meilencamp (London/Bloomington: British Film Institute/Indiana University Press, 1990), 117.

[17] The Bureau of Broadcast Measurement uses diaries exclusively. The Canadian branch of Neilson Media Research Group entered the Canadian market relatively recently, but its People Meter-driven methods are currently the standard for network ratings. Heeding the call of advertisers, there have been three attempts to merge the two services since 1989, in order to place People Meters in regional markets as well (80 per cent of the annual $1.5 billion television advertising revenue), but broadcasters still refuse to pay the additional costs.

[18] AGB's most recent attempt to enter the US market coincided with the network contestation of Neilson figures described below.

[19] *The Wall Street Journal*, 1 June 1990, B6.

[20] *The New York Times*, 13 June 1990, D1.

[21] *The Wall Street Journal*, 1 March 1991, B4. Up-front markets have continued to decline for the past two seasons. Even General Motors which, for example, usually pre-buys as much as $200 million in network air time, in 1992 chose to wait for the scatter market which began in September.

[22] Meehan, "Why We Don't Count", 129.

[23] Thirty two percent are white. Figures from a *USA Today* survey cited by Ishmael Reed, "Tuning Out Networks", *The New York Times*, 9 April 1991, A25.

[24] *The Globe and Mail*, 14 November 1992, C2.

[25] Neilson Media Research Group, "People Meter Technical Specifications".

[26] Neilson Media Research Group. "The Neilson 'People Meter' Sample".

[27] Excellent examples of this are the recent (1992) Canadian Constitutional Referendum in which citizens were invited to vote "Yes" or "No" to a complex legal document that was not even available to be read, and the 1992 US presidential election in which one candidate bought television air time to broadcast numerous half-hour "infomercials" and another dramatically increased his visibility through his command of night-and day-time talk-show formats.

[28] A *button*: Given the contradictions outlined above with regard to one of the most "public" forms of communication in human history, one might wonder about efficacy contem-

porary public art. Specifically, one wonders what constitutes its *de facto* audience. Do public projects which don't address the local vernacular really ask a public (in that old avant-garde fashion) to "confront the frontiers of its own taste"? Or do they merely appropriate new venues for and expand the formal vocabulary of contemporary art without reciprocity? Is the practice really a reclamation of public space, or is it rather, a novel kind of trickle-down aesthetics?

Luciano Fabro regards unity as the essence of reality. Making that unity perceptible with the resources of art means expanding the field of references. Luciano Fabro's art is much like a stretch of road intersected by paradigms and insights from a variety of disciplines, such as philosophy, literature, geometry, alchemy. Art becomes an intellectual accomplishment whose reflections circle about the human being, for unity reveals itself in art, as Fabro notes, as the body of a person. Luciano Fabro's artworks and installations create fields of interaction dominated by expansion, motion and the interrelationships of complex lines of connection. The viewer who enters and interacts with such a field of tension can experience a wide range of visual, mental and spiritual interconnections. Fabro embraces a humanist point of view devoted to reconciliation between humanity and nature and to the integration of theory and practice. Viewed from this perspective, the acts of creating and writing about art unite in an intellectual activity whose object is the quest for statements of universal validity. (G.D.)*

Luciano Fabro
I would like to leave a message

The idea of approaching these matters in lectures derives from a basic idea of mine which I may summarize as follows: our civilization has its origins in three rapacious civilizations: Roman, English and Spanish. We cannot include for example the Egyptian and Greek civilizations. Roman civilization lived off the ideal, artistic and economic riches of other civilizations and when these ran out it fell into ruin. A thousand years were to pass before a creative civilization was born, the one we call Humanism, Renaissance. But the discovery of America interrupted the Renaissance and marked the beginning of a new rapacious civilization.

It is commonly thought that we are exhausting all the ideal, artistic and economic riches of both the western Renaissance and of other civilizations. The Roman civilization was strong, not so much for its army as for its ability to give an international legal order to this exploitation. Our civilization's strength has been its constant ability to direct the problem of exploitation towards some technical solution, be it democracy, economics or industrialization. We have called these ways of thinking pragmatism. Given that this impression is neither mine alone nor of recent date, at the beginning one thought of facing the problem by creating new energy sources and bartering these with the riches of other civilizations. Now the

* 1936 Turin / lives in Milan.

exchange material has become progressively less and in certain senses more dangerous (pollution, atomic energy...). Control of the situation is carried on exactly as at the Fall of the Roman Empire, progressively more monetary. But we can already see the disastrous consequences of this mentality in a large part of the world and in society.

Also in the case of art, the avant-garde movements first tried to exploit all the old and new sources of energy: oriental and African art, technology, economics etc... and then to China, Africa and South America: their art recycled and homogenized in accordance with European and North American recipes.

Now that these exchanges are less and sometimes even dangerous... think of the crisis of the communist economy and, like today in Italy, that of the capitalist economy... and of the mistrust of technology. Now, just like at the end of the Roman Empire, art tends to be decorative and uniform. I think an inversion of tendency is required. This would be possible if we began to feel responsible for what there is at the beginning and not only for what there is when things turn out disastrous. This initial ontological responsibility, also called creativity, must, I believe, come under the artistic spirit, an artistic spirit which finds its explication in the artistic act. What I believe is as follows: the artistic act is at the origins of natural becoming. The artistic act manifests itself in the activity of human intelligence in two forms: the artistic and the scientific. The consequences of this act are the argument of scientific discovery. The testimony of the artistic act stimulates the act itself. Works of art are the heritage and stimulus of natural becoming. If I may be permitted to point out a correspondence between this thesis and my works I may say that they should have the following qualities: create vitality, excitement, liberate curiosity, sensations, observations, they should have the quality of simplicity, each one should speak in its own manner, different from all the others, and things very different among themselves should lead to the discovery of a harmony.

All this should end up with the desire for dialogue, with the faith that from that moment on things become a little different, more optimistic and with more sense of responsibility. Art is that attitude within natural phenomena, be it physical or spiritual, which modifies the process, augmenting its definition: after the artistic art the phenomenon can no longer be defined as before.

All of our senses are set in motion; our entire body reacts when we are interested in something, when we come into contact with something or someone. There is no great difference between two things and two people which come into contact. When the wind meets leaves, it makes them react at a deep level and not only in the surface, to the point when, with time, they will better adapt to the wind, at the moment and at the time

when the wind changes its course, its heat, its smell. Thus everything interacts with everything else and this interaction tends toward the harmonization of things among themselves, or rather, toward the placement of one thing next to another so that the result is art. This disposition within natural phenomena includes adaptation, defines selection, establishes new processes. If cacti have thorns and are barrels of water, it is due to an act of some individual cactus, in some moment, which permitted it to survive and at the same time to create its aesthetic; that is, to become in harmony with the context. At the moment in which it harmonized, it defined its function: it will be visual, olfactory, gustatory, spatial, sensitive and intellective nutrition of the context. These acts become related to other acts, and together they create an aesthetic. This aesthetic will permit a definition of a series of phenomena and functions.

These acts give us the elements of difference and harmony. I mean that only through a harmonic comparison can we differentiate; I also mean that the elements, by interacting, left chaos and ended the cosmos.

The harmonic interaction determines pleasure, order, and action. Action includes more and more varied elements and creates harmony in continuous modification. The motor of the action is harmony itself.

I call this process of locomotive harmony the artistic act. The artistic act would be the spark which precedes the moment of the realization of phenomena, changes, discoveries, inventions, and the birth of systems. Even if I do not know a bird or a stone reflected on this, I think that some form of reflection is common along all elements.

I call this common reflection "aesthetic reflection", and it is that which moves me when I see a sunset or the pattern of a butterfly, but also it is my own capacity to metabolize a fruit both by eating it and by drawing it by formulating a geometry through it.

We generally pay more attention to the moments following the artistic act because they seem more concrete to us. But, I repeat, at this point everything has already happened, and we are not able to do anything but evaluate the consequences, in one field or another, in what is more convenient for us at that moment. It is for this reason that for the scientist the artistic act becomes scientific, for the religious man it becomes religious, for the person who puts all his energy into daily things it becomes quotidian.

By this I do not mean that everyone is busy doing artistic acts in equal measure. I am only saying that the artistic act is natural and is distributed naturally. I also would like to repeat that, since it is the origin of other acts, it precedes them and distinguishes among them. And thus I have arrived at my point, which I think is clear enough to say that the artistic act distinguishes itself from the work of art as such. Hence, to make works of art does not mean in itself to live artistic acts, but rather to undertake

the responsibility of transmitting the artistic act frequently. The artist is the person who realizes the artistic act in an image, in that which the masters of art - the Greeks - called "Idea".

I can testify that the Idea manifests itself as an image. I can testify that the mark of the artist consists of two basic elements: one is that the image presents itself to him absolutely clearly and distinctly, the other is that he must have the obsession to give consistency to this image.

Now let's try to give a time to the work of art. I place this time at the moment in which the artist has the revelation of things, he sees things as if for the first time, as if it were the day of creation; he sees them with enthusiasm, as when we discover a splendid view. He sees things emerge brilliantly from the chaos that is customs and prejudices, from the ruins of what was harmonious beforehand.

What does the artist do? Having determined a creative moment, he abstracts it from its context and from its natural consequences. Like the scientist, he determines a law out of a series of phenomena. Thus the artist determines the artistic act that is the origin of a phenomenon. In order to isolate it to give it form, in order to highlight it, he transfers it onto some sort of screen or support. Just as the light of bodies is fixed onto the cinematographic film, once in a while the artistic act is fixed with words, sound, material, space, and thousands of other ways which are more or less familiar to us. Those which are more familiar to us are the ones we call music, poetry, painting, architecture, sculpture. These are nothing but screens, supports whose adherence to the artistic act must be checked on and modified from time to time. I repeat that the artistic act in itself is not identifiable in nature by its effects, nor by its determination of the development of the natural bodies and it determines upon the natural bodies.

When artistic act and support adhere we have the work of art, or the artistic act takes on a body of its own. The work of art gives us the artistic act isolated from the consequences on the natural bodies. One of the ways to define this difference is to use very basic supports in the work of art, such as stone in sculpture, colored mixtures in painting, and also to use very rudimentary techniques. Think of the technology of the artistic act which corresponds in nature to the colors of a flower, and compare it with that which was used in a work of art by Matisse in order to paint the same flower: in the case of nature, the artistic act has arranged all the possible and imaginable elements of our imagination and intelligence. In the case of the work of art by Matisse, it was more a matter of arranging the colored pigments onto a piece of canvas.

But here is where the miracle occurs: if that arrangement of spots of colors had fallen on your shoes you'd have to throw them away, but if you organize them on that poor support they must yield the same artistic act

which contributed to the birth of that flower. But one would think that the relation of the two artistic acts is a formal one, since there is a resemblance between the two flowers, the one in nature and the one painted by Matisse. But instead, the resemblances is only passing: I could say that what makes the work of art and images in nature resemble one another is a pentagram which artists adopt in order to better make the artistic acts of the work of art in tune with the artistic act of the work of nature.

From this discussion, one would think that all the effectiveness lies in the artistic act, in the work of art. In the economy of the species, then, one cannot understand why some people insisted on constructing colored surfaces from the beginning of humanity, by engraving stones and collecting them, on organizing sounds, words, images, sensations. Since the beginning, man has reflected both on death by disharmony, as well as on death by regression. Some dedicated themselves to combat regression by knowledge, and that is how religious, civil, and natural knowledge came about. Others, in order to combat death by disharmony, dedicated themselves to that which I call the artistic act. These people called themselves artists.

Elements which die lose the complex experience acquired in the vital processes. An abandoned field, or one in which growth is destroyed, is transformed into a desert, and as a dead zone it becomes a danger of death for other beings.

This artistic act is common, then, to all beings and also to man; about man we even know something further: we know that he senses when the order of things is in a state of crisis, when aesthetics, or the order of things, are going into a state of crisis. When I say that the aesthetics of things can go into a state of crisis, I include also the aesthetics of thought, the aesthetics of conscience: I mean any kind of harmonious activity. The understanding of an artistic act is not arbitrary but rather it answers the state of necessity. It happens only when it is necessary. If, however, it didn't happen when it was necessary, we would have the end of that being.

I believe that when artistic acts happen we should be happy. But once one understands that the manifestation of a phenomenon is a question of art, a sense of responsibility arises which doesn't make one very happy.

In practice, when things are dying, they wither, they protract beyond their size; this depends on the fact that the necessary artistic facts do not happen. If one does not listen to music, one loses one's ear for music; if one does not pay attention to plants, they all end up in the same state, if one is not careful to treat people with interest, or better, with love, they become unbearable. In each of these cases we have death by disharmony. I think of man's terror when he discovered this, and I think

that he was obligated to find a solution by writing his memories of the artistic acts and the works of art in the form of a diary. These works are a memory of harmonious solutions, harmonies by which the ear can remain exercised, the eye attentive, and the feeling awake. This is an intelligence ready for the continual future of artistic acts, so that our senses remain in motion in a way that they can adequately interact with everything and this interaction can tend toward the harmonization of things among themselves, to the placement of one thing next to another so that the result is art.

Speech at the San Francisco Museum of Modern Art, 30 September 1992.

Simply following the course of events can be an exciting adventure. There is so much waiting to be discovered. The video production entitled "Der Lauf der Dinge" (The Way of the World, 1986-87) stands as a paradigm for the art of Fischli and Weiss. The conjunction of different factors generates a sudden reaction, creating a new situation and bringing about an unexpected turn of events. Are the viewers to direct their attention to the continuous process of transformation or to the interim products themselves, which consistently take on new forms?

The product is not the focus of concern in the work of Fischli and Weiss*; instead they are concerned with the methods and mechanisms of art in a world overflowing with material things. The two artists explore the enormous quantity of objects and images, constituting the systems of order that give life the appearance of stability. With humor and playful nonsense, they shift these cumbersome systems of order out of kilter. The more materials and objects they enter into the equation, the less predictable the outcome. (G.D.)*

Peter Fischli & David Weiss
Real Time Travel

INTERVIEW BY RIRKRIT TIRAVANIJA

Spending time looking for a tiny miracle at the end of the day, it suddenly all makes sense, the way things go.

With Peter Fischli and David Weiss, the way things go is that they take time: not necessarily "actual" time, but possibly the contemplative relation one could have with time. Their most recent video work - accumulated footage from various trips, both planned and spontaneous, encompassing experiences ranging from daily activities to an event that might occur once in a blue moon - was a year and a half in the making. In their work the camera takes in a "handheld reality", fragments of events within the parameters of the artist's reach - encounters occurring during an afternoon drive, a day trip, or a journey across the continent.

I arrived in Zurich to spend a couple of days (two and a half, to be precise) with Peter and David as they prepared for their show "Peter Fischli and David Weiss: In a Restless World", on view at the Walker Art Center in Minneapolis until August 11. In addition to works of sculp-

* 1952 Fischli / * 1946 Weiss / live in Zurich.

ture, film, and photography, the exhibition features their videos, shown
for the first time since their debut at the Swiss Pavilion in the 1995
Venice Biennale. Dubbing all the tapes for the Walker exhibition will take
10 hours a day over a 12-day period. Between the taping and the work
arranged for the three of us (and a friend) to take a guided tour of the
"Hölloch" (hell hole), the largest cave in Europe and one of the biggest
in the world. The fragment below is an excerpt from an attempt to con-
duct an interview in real time (comprising 15 hours of recording); as
with reality, many things worked, and many failed, but in spending time
with Peter Fischli and David Weiss, a small event can answer all the big
questions.

The taping begins in the car with David on the way from the airport to one
of Fischli and Weiss' studios. David and I discuss the idea for the interview
and agree I will tape our conversation in real time (or close to real time) -
that is, turning the recorder on and letting it go for the two and a half days
I will be spending with them. David says that they haven't done an interview
in a while and that in the past it has never been quite satisfying.

DAVID WEISS: Did you go to the Biennale in Venice last year?
RIRKRIT TIRAVANIJA: No, I didn't get to see the project.
WEISS: It's quite similar to the idea of having the tape recorder running
in real time during our conversation. Did you hear about it? It's not
exactly real time but it is close to real time.
TIRAVANIJA: The exhibition in the U.S. will start at the Walker Art Cen-
ter, in Minneapolis?
WEISS: Yes. We will show older works as well, though it is not quite a
retrospective. Not everything we have made will be in the exhibition.
At the Walker it'll be shown in the room downstairs. Do you know this
space? We'll try to show the works in a mellow light or spotlit. We'll
have some works on the walls, of course, but we'll also have two videos
which will be projected. For the piece we did in Venice we'll have ten
TV monitors. A slide projection and a smaller piece with light, plus two
sculptures. All in the dark!
TIRAVANIJA: Like in the Hölloch. When you made the videos for the piece
in Venice, was there a specific situation you went around trying to tape?
WEISS: Well, it took us about a year or a year and a half to make it all.
It started with one video, shot on the road we're driving on now, going
back and forth, to and from the studio, in addition to footage shot of
us in our studio. We took the bus. When we were asked to present a
project in Venice, we felt there was more to this activity, more in real-
ity, more in a place where there is no art. When the camera is on, you
decide that this is a good situation. Like now (looking out the car win-

dow), there's something special about this moment. Sometimes we would take small trips, sometimes together, sometimes alone, without any destination, just driving and going out in the woods. Perhaps we found something, or not, while driving around. Sometimes we called ahead and asked if we could come and visit. For instance, we went to this factory where they make things like yogurt and milk. Somehow, the footage didn't turn - it just looks like any other factory.

TIRAVANIJA: Does each segment have a specific running time?

WEISS: I think they're from ten or fifteen minutes to two and a half, even three hours. One of the sequences is a train ride somewhere around Zurich in the winter. This is simply very beautiful. There isn't much editing on this tape, but after three hours we had enough footage. In Venice we had 12 monitors in one room, so you wander around and you always see at least two to three monitors at the same time. Sometimes you could see five to six in the distance.

As we continue to drive through industrial parts of Zurich, I ask about Los Angeles, where David lived for a few years, and how he and Peter started working together.

WEISS: I lived in L.A. in 1979-81, about fifteen years ago.

TIRAVANIJA: And this is around the time you started to work together?

WEISS: Yes, we made a series of photographs together here in Zurich. Then Peter came to L.A. and we made a short film, with rented costumes.

TIRAVANIJA: The Rat and the Bear.

WEISS: We didn't have money. We lived in Hollywood, we couldn't act, and we didn't have any actors. So we decided that we could hide in those costumes - of course, you can't. Then we were invited back to Zurich and Peter and I made the exhibition with the clay figures. One show after another came, and I didn't think I could live in L.A. any longer. Once you've lived in L.A. for a year or two, you come to a point where you have to decide, "Am I a visitor still or am I going to live here?" L.A. is the kind of place where you can become a "Californian", because they don't care there! I couldn't just go to Italy and pretend to be an Italian!

We reach the studio, a modest-size room that once housed gas utility laborers who worked in the area. This is Fischli and Weiss' "clean" studio, the one they use for their photography and video work. There we exchange greetings with Peter.

TIRAVANIJA: You are dubbing?

PETER FISCHLI: This is the work of art in the age of mechanic production.

WEISS: For about half of this year we have watched on two side everything we shot. It usually takes about two to three hours, but it's nice to sit down and just watch this "everyday life", what's going on outside, useless things.

FISCHLI: It's not real time, it is edited.

WEISS: But not rearranged.

FISCHLI: It's a one-day trip which becomes an hour of film. We have long sequences in real time. It's an important aspect that using or spending time is "something". To spend time, to go to a place, to watch people, and then also to spend the time watching the video. It slows everything down a little bit.

WEISS: In editing we had to spend more time. Going through it again, you can't speed up.

FISCHLI: In the final installation in Venice, we had the piece on 12 monitors. You really had to watch one tape after another. But in fact we really didn't want this. Because we had a very large space, you couldn't watch all the monitors at once but you could watch maybe two at the same time. When we were sitting here in the studio we could have something to drink and cigarettes to smoke. In Venice, the minimum comfort you could offer somebody was a glass of water and a chair - it is a little bit more than nothing.

WEISS: The water was a big success. Many people came for the water, and they may have even seen the show as well.

FISCHLI: The themes of the films we chose - you could describe them as an encyclopedia of personal interest. We just filmed things that we thought we would like to go and see - what everyone is doing, the whole day. It more or less breaks down into three sections: people at work, sport and fun activities, and nature and daydreaming. Some of the things were chosen in a passive way. Because David had to go to the dentist, I said, okay, I'll come with you. It wasn't an artistic decision. Other segments are of places we had been before and wanted to go back to. And others were about going without any kind of ideas beforehand. Like our trips to the Egelsee, a little lake where David and I have made a couple of films.

WEISS: Nothing happens there! Or close to nothing. It's so cheap to make these videos; you don't hesitate to shoot anything you see. If you see some kind of small or large animal or a farmer working, you can just sit there and watch him work.

TIRAVANIJA: You each had a camera to shoot with?

FISCHLI: Yes, and for most of the videos, we were alone. David went somewhere, and I went to another place. But on some of the films, we

made a special trip together. In the end we realized we had ended up with esthetically pleasing things - like "Oh... the light was so beautiful". When you are taping so much, then something like a wonderful light can just happen. There's a moment of marvel in it, because this is the other side of a conceptual work. The conceptual work would be, for example, an artist who is following a cat for the whole day. But when you have a beautiful image of a cat, and the cat looks really wonderful, it's something marvellous. I like this moment, when you forget that an artist had thought of the idea to make a video about a cat, because it's just a wonderful cat in the end. (Looking at footage of a rat in an animal hospital being operated on for a tumor.) These could be educational movies, but they are not because no one is explaining anything. So it's wasting time, in another way. In the end you are not able to operate on your rat.

TIRAVANIJA: It is like learning through observation. The viewer has to pay attention in order to learn something.

WEISS: The viewer is completely left alone; there is no explanation.

FISCHLI: It has this aspect of an encyclopedia, but it is not really an encyclopedia. An encyclopedia explains, and we don't explain anything. In many ways the camera is observing us, what we've been taping for the past year and a half. The camera is also pointing back at us, in a way.

WEISS: With the camera you don't force your way. You just wait there.

FISCHLI: The handheld camera is a very important aspect to the videos, because you have this effort of the body trying to keep the camera in place.

David drives me to visit the permanent installation, a little room that can be viewed through a small window from the street across from the Kunsthalle in Zurich.

TIRAVANIJA: How do you feel when you watch the footage together at the end of the day? Do you have certain anticipations or expectations?

WEISS: First you're excited, especially if you've made a good trip or had a good day - you look forward to seeing the footage. Sometimes you're surprised at how bad the footage is, or that it was nothing special. In other cases you really have good moments.

We go to the red-light district to have dinner at a Thai restaurant; we're early, so we go to the bar, and Peter is already there. We look over brochures for the guided tour of the Hölloch.

TIRAVANIJA: Do the two of you have a lot of discussions about what you do and how it works?

FISCHLI: For the work in Venice we were always discussing how it worked as art. You can get lost because it has nothing to do with art in a certain way. But when you watch it, you can also see that there is an attitude of two artists within the piece of work. When you see this rat and his operation you are touched by what you see, by what it is in real life. For that reason we didn't want it to look artistic or like an art video. The footage should have a "normal" quality. No special gimmicks with the color.

WEISS: Sometimes you reach normality on the level.

TIRAVANIJA: The level of quality?

FISCHLI: Yes. Carefully, not too shaky. Just "the best we could do".

TIRAVANIJA: Do you feel this is a kind of attitude you have in all your works? When you are carving the polyurethane objects, in the end do they have to become normal?

WEISS: Yes. Taking pictures, for instance, one shouldn't talk about the grains or the photographic style. Formal aspects should not be the content. Things should be in the middle of the frame, and the weather should be nice!

TIRAVANIJA: Perhaps this is a balance of reality?

WEISS: Balance?

TIRAVANIJA: Well, that the way it is made returns it to reality?

WEISS: It should never leave reality.

FISCHLI: With the ("Bilderansichten" (Monument), 1991) photographs something interesting happens. We took photographs of images of marvellous places. We were asked by a company if we would like to make art for their offices. So we thought it would be interesting to make these photographs for the hallways. We hung them all over the building, and they looked quite normal, like photographs and postcards or posters of wonderful places that the workers would have put up.
It didn't look like art anymore but rather like the places they would have liked to travel.

WEISS: The only criticism from the workers was that the photographs were too small.

FISCHLI: So they can switch from art to life - back and forth. Most of the time they're in real life. Only if we would take you or someone from the art world to see the photographs would you realize that this is about an attitude. But it doesn't have to work on the level of art only.

TIRAVANIJA: I am interested in this idea.

FISCHLI: It depends on the attitude. They can be on both sides. For sure, when things are handmade like sculpture, it is much clearer that they belong to a maker. David showed you the little room? We did other similar rooms. In the museum room in Frankfurt the objects look more realistic. In the room here in Zurich, you can see how some things are

a little off. In the Frankfurt room, you look through a window and see this room, which seems to belong to a museum custodian. But it is also an illusion: you think you're looking out of the museum.
WEISS: Out of the art world into a private space.
FISCHLI: But in fact it's probably the most artificial thing in the whole museum.
This switch is always very nice. Or it is the point of interest, part of everything we do.

We all leave the bar and walk over to the restaurant.

WEISS: Shall we not work? Just eat?
TIRAVANIJA: We should never work and only eat. (We have an excellent dinner, but the restaurant/bar is too loud to continue with our topic, so we discuss our upcoming trip to the Hölloch.)
WEISS: Do you think that you now know more about the Hölloch, or less? Because now you know how much you don't know.
FISCHLI: But if you know how much you don't know, you know more, in a way. Because you know that! That's something! I also think the experience of physically feeling something is important. The corner we saw, less than 1 percent, lets us imagine the rest of the cave. Just to have someone tell you the cave is almost 170 kilometers long is too abstract.

We drive past the Swiss Army Knife factory and the outer parts of Schwyz. Peter puts on a tape of international-style easy-listenig music. The sun is going down and there are lakes and mountains rising from the background. It's a film, possibly.

TIRAVANIJA: For your sculpture, do you just pick out objects that are lying around the studio? I mean, are you carving particular things from the studio which have personal references, like "here is my knife".
WEISS: Yes. It comes down to that.
FISCHLI: Mostly things that would be around the studio - tools and objects we would need to make a carving - we carved. The working process itself is very close to what we are talking about. With these objects, we're talking about "something else" in a way. Then we also realized that the tools we use around our studio are similar to the kinds of objects that museums and galleries use. These are the studio objects, but they are also objects in the cabinets in a gallery.
WEISS: This is a nice coincidence, because all the objects are known to everyone. Somehow everybody has had an experience with those objects. Sooner or later they need this kind of knife or glue or wallpaper. They are extremely common objects. Everybody knows how to paint walls.

FISCHLI: In the exhibition we had at Sonnabend (in New York), we went to the gallery ahead of time and took a close look in the cabinet and storage rooms to check and see what kinds of objects they contained. We brought many of them back to Zurich, where we chose some of them.

WEISS: The small room I showed you yesterday has travelled to England and to Germany, so we had to remake the milk bottle, because we didn't want people to be surprised by looking at a Swiss milk bottle. It shouldn't be exotic, it should be.

TIRAVANIJA: Normal.

WEISS: Yes, as normal as possible - straightforward.

FISCHLI: The gallery told us that when the elevator doors opened and the visitors looked into the exhibition space, they thought that there was no show to visit. People thought that the objects belonged to real life, so they weren't interesting to them.

TIRAVANIJA: I like this idea of "spending time" we talked about earlier.

FISCHLI: Yes, it is very important.

WEISS: Perhaps there is even an aggressive aspect to the idea.

FISCHLI: We made one photograph in the series of balanced objects ("Stiller nachmittag" (Quiet afternoon) series, 1984-85) called "Time Abused".

TIRAVANIJA: Do you see this abuse of time as related to the notion of making art?

FISCHLI: I see it when you spend time with something. It is like the cave we were in today. We spent time in the cavities and holes.

WEISS: Well, it's the basic question of the value of the time.

FISCHLI: It really depends on how much you can see in it, or how much you can take out of it. It is like Max (a man we met as we exited the Hölloch, whom our guide described as obsessed with spending time in the cave) spending forty years of his life in this cave. Max was bringing value to the cave, by spending so much time in it.

TIRAVANIJA: You were talking about curiosity before and the way it drives humans to enter and explore places like the Hölloch. I was just thinking that in your works this idea of curiosity would create a space for spending some time. One has to look closer and spend time. Is that well-spent time?

FISCHLI: By spending time with something, even when you don't have a relationship with it, something changes.

WEISS: Relationships can start, or even the knowledge that your lack of interest in "this" or "that" can cave in. For example, when you go around with the video camera you know exactly how much time you spend with something, and how long you are interested.

FISCHLI: When you spend time with something you can also have an experience which you get tired of after a while. You could get tired or you could want to spend more time.

WEISS: For me the main focus with the objects is that you "see something" that you also know is not there. Of course, it is there, but the chair is not a chair, the table is not a table. Or it's not there as what we usually know about these objects. You can't use them, because their functions are lost.

FISCHLI: It is just the surface of these things that you make believe is there.

WEISS: Perhaps it helps that we choose such low-key, low-value objects to carve because it helps underline the value of the object.

TIRAVANIJA: So it's like the "big questions" and the town in the mountains where everyone has the name Fischli?, I said: "No, I am not from this village", and they replied: "Sorry, wrong number".

The techno music begins to grow louder.

WEISS: The sound quality is really good, considering, you're sitting in the car with the engine on.

FISCHLI: We taped it off the radio.

WEISS It isn't mixed in later.

TIRAVANIJA: It's recorded directly through the camera? That's very good sound quality - especially the techno music.

We are still watching footage of the car trip from the dam to Zurich.

FISCHLI: Well, this is a nice piece of music.

WEISS Yes, it is. The last piece of music that came on before this was a little bit stupid. But what can you do?

FISCHLI: What can we do? That techno music is the fashionable thing. It's nice that the sky is still a little bit lit.

The videotape ends.

WEISS: Can I have a cigarette? Oh, you are out.

FISCHLI: Next tape. We cut in the black for 20 seconds in between each segment 10 seconds of black from the first tape and 10 seconds of black from the second, and it.

WEISS: It starts again with the rain and snow.

We watch the beginning of the next tape, another drive with heavy wet snow hitting the windshield.

FISCHLI: My mother went to Venice to see the exhibition and said this is the one video she always watches. This windshield and the rain and...

TIRAVANIJA: I like looking at this image. Have you seen the German television program with the POV camera from the train? It's shown very late at night, and the ambience of the train tracks and all the scenery going by is very meditative and relaxing.

. FISCHLI: Look, this is the special effect we told you about, the "little miracle in everyday life".

In the distance through the heavy snow, a snowplow is approaching from the opposite lane. As the plow passes by, the car swerves into the opposite lane, the road is clear of snow.

Rirkrit Tiravanija is an artist based in New York.

The interview originally appeared in *Art Forum*, no. 10, Summer 1996.

The mirror image does not lie, but in duplicating the obvious it tells only half of the truth. Dan Graham constructs accessible pavilions out of transparent and mirrored walls. The mirrors structure space and provide a framework for the perception of the surroundings and of one's own physical presence. The experience of the body as a mirror image is intensified by the video cameras that record the viewer's movements while he is within the structure. The glass pavilions represent a dialectical antithesis to the use of such materials in city architecture.*

"Model for Skateboard Pavilion" (1989), done as a model for a skateboarding course, and "Rooftop Urban Park Project" (1991), developed for the roof of the New York Dia Foundation, point to the significance of urban space as a sociological category. Photo-text collages explore the relationship of art to the gridwork patterns of urban structures. This subject is a constant in Graham's art, having been treated in earlier works such as "Homes for America" (1966-67), and expresses the artist's interest in the visual aesthetics and dialectics of urban and suburban living areas, of public and private space. (G.D.)

Dan Graham
An Interview

BY MIKE METZ

MIKE METZ: It's been almost thirty years since you first put together a battery of works that were projects specifically for various slick publications. What was on your mind then? They're so prophetic now.

DAN GRAHAM: They were published because I had contacts through art magazine publishing. People who had been doing art magazines moved on to other magazines like Harper's Bazaar. I also did a series of advertisements in The New York Review of Sex, National Tattler... many of the advertisements were done gratis. The intention was to go for the slick magazine because that's what was on everybody's coffee table.

METZ: This move into such a radically altered context as a focal point of your art predated so much work in terms of artists who were finding gallery space constricting.

GRAHAM: Well, it began with my being an accidental director of this short-lived gallery, the John Daniels Gallery. One thing I learned at the gallery was that the basis for getting attention was having reproductions

* 1942 Urbana, Illinois / lives in New York.

of the work written about in magazines. I realized how dependent the art world was on publicity and information. It also was the golden period of artists like Lichtenstein and Warhol. Lichtenstein interested me because he was taking things out of magazines, blowing them up on canvases, and showing them in galleries. Thus making a connection to the information system. I was also interested in the early works of Flavin which were more pop art than minimal. He used fluorescent lighting from hardware stores to make temporary installations. The work was never deemed for sale, it would be dismantled and go back to the hardware store afterwards. But this idea of devaluing things so that they would be common currency and common decoration was being undermined because even these temporary installations were being bought by collectors. I thought it would be much more interesting to short circuit all of these areas and put things directly into magazines. There was a period in pop art when you began to realize that New York was basically about advertising, printed matter and design.

METZ: The critical difference in your work was the structure of information. What makes those early pieces seem prophetic is the fact that they are structures on which one sees the possibilities of specific information about the real world circumstances that was positive in intent.
GRAHAM: Minimal art, which seemed to be abstract, took from suburban environments like hardware stores. The content was taken out, making things very abstract. In and around New York, you could see similar things as in a Godard film, housing projects, suburban life. Godard was also focusing on media as an information form. Mass circulation magazines. What I was trying to do with very minimal means was to simplify, reduce and to have work that could be done with no money. I saw information as a way of linking together both criticism, philosophical issues, the films of Godard and this installation art that was being done inside galleries. So it was a reduction of a kind of work that was tending toward reduction to begin with. People were attentive to information systems. It was vaguely in the air. Cybernetics was vaguely in the air.

METZ: The early work "Schema" identifies the number of nouns, adverbs, adjectives; the area occupied by the text, the typeface, and so on in the magazine itself. The work is a media-generated text. "Schema" seems to be the first of many works that were mediations in that fashion.
GRAHAM: Well, in the first pieces, each form usually illustrated a particular approach to the media. In a material fashion for instance, it was the name of the typeface, the type of the paper, the depression of the typeface into the surface of the page. "Schema" was also a very early computer piece, because a computer can generate many different possibili-

ties for a hypothetical future that either existed or didn't exist. And there was a fictional element because even though information was self-referring, it had not to be interpreted. The idea was to build in as many different meanings as possible in a very simplified, available situation. While Lichtenstein and Flavin were big influences, I wanted to make a further reduction and make non-gallery art.

METZ: Sort of an influence in the reverse. You were heading in exactly the opposite direction.

GRAHAM: Yes. As much as I admired the work, I saw contradictions in it. In the case of pop art, instead of taking things out of media, I decided to put them back into media. Instead of having a show that had a photograph and a critical piece of writing about the show to validate its meaning, the idea was to stage the entire thing directly in a magazine. In a way it was absolute and problematic because the work would never take on value. But they weren't conceptual. They weren't for a hypothetical art "in the mind", they were about the "physicality" of printed matter. Which would be equivalent to the physicality that you had in reproductions. In other words, the reproduction has its own kind of physicality as reproduction of a reproduction. And then you have the fact that this physicality would only have a short life. It would fade away as the magazines were discarded, and go back into time and place. But they were geared to that present time publication situation.

METZ: "Homes for America" moves into suburbia, with the diagramming, and schematizing of specific social circumstances. At the same time the perspective shifts from yourself to that of the suburban spectator.

GRAHAM: "Homes for America" was done intuitively, but I was also interested in the relationship between serial music and minimal art. At the time, Esquire magazine was publishing sociological exposes like David Riesman's, "The Lonely Crowd". They used photographers in the school of Walker Evans, photographers who were showing vernacular workers' housing, suburban housing, but usually from a humanistic negative viewpoint. I wanted to keep all of those meanings but empty out to the pejorative expressionistic meanings. On the other hand, I didn't want to go as far as minimal. I wanted to show that minimal art was related to a real social situation that could be documented.

METZ: You referred to the minimal pieces of the time. Those pieces were, if nothing else, hermetic. They were complete, in and of themselves. Whereas in "Homes for America", or the article that appeared almost six months later called "Information", I took to be a code or description for how to look at "Homes for America". This was the

reverse of the minimalis tendencies at the time. Even though there are certain visual similarities in the structure.

GRAHAM: If you put pop art together with minimal art together with Godard together with sociology together with serial music, you might come up with something like that (Laughter) I was not working out of an art history, or even a philosophical tradition. I was working with what everyone had in front of them.

METZ: The "Income Outflow" piece. Where was that placed? Did you ever actually run that anywhere, and did anyone ever buy any stock?

GRAHAM: My initial interest was the fact that to raise money and begin the process, you had to start with an advertisement. After a while, I realized that the main focus of my work was the artist buying an advertisement in a magazine. In other words, "Homes for America" was both an art essay by a critic, and a work of art in the sense that a Godard film was both an essay, a narrative, and a quasi-documentary. Sociological at was a very late piece, it was 1969. After 1969 I did not do anything else for magazines.

METZ: Was your first use of architectonic elements "Body Press", the two people inside a mirrored cylinder?

GRAHAM: I thought it would be more interesting to make the piece optical and interior, and also to be about the skin of the performers. So I constructed a large interior mural size cylinder, which was like a huge anamorphic lens surrounding two performers. The performers were a man and a woman, naked. And the cameras, instead of mapping out the surface of the area they walked outside, were actually mapping the surface of their bodies. So the cameras were pressed against their bodies. You would be able to see the camera and the spectator by the reflection on the surrounding cylinder mirror. The camera's angle changed as it pressed against different parts of the body. You might see a lower part of the body on the anarnorphic mirror, thus the camera would be filming itself and that part of the body that was next to it. Or it might be oriented somewhat upward, so you'd be seeing, reflected on the mirror, the eyes, the head of the camera person. The cameras were rotated and since they were more or less synchronous, when they were rotated, each camera would be filming the other camera and the other spectator. Then they were handed between the two performers and the exchange continues onto the body of the person they were handed to.

METZ: It seems that here the two cameras in relation to the anamorphic mirrored cylinder, as lens, deflect meaning. The cylinder itself seems to be attacking the information. People see what's going on, yet the film doesn't seem to add up.

GRAHAM: Here you see both the camera and the objects. Also, you have the fact that each of the performers is handling the cameras. So you become part of the camera, you identify with the camera that you can physically see. You also identify with the performer and their body. You can feel the body through the way in which the camera is pressed against it. You have a multiplicity of different viewpoints. Plus you have two people and two different cameras at the same time. And I think the complexity comes with the two people.

METZ: Nor to mention the fact that they're a man and a woman.
GRAHAM: It sets up a relationship whether you're identifying voyeuristically with yourself or with a sexualized, heterosexual image outside of yourself. Or maybe putting the two on the same narcissistic optical level that Lacan's mirror stage begins with.

METZ: But there is that unequal footing of the nude female body and the nude male body and the difference between those gazes.
GRAHAM: We have very conventionalized, cliched ideas of both.

METZ: Yes, exactly. And also the inability to truly read either due to the nature of the cylinder itself.
GRAHAM: Well, I think the distortion varies. If you move very close to the image, extremely close, there's very little distortion.

METZ: Another type of distortion you have used is time distortions as recorded on video tape.
GRAHAM: You can get delays from between five seconds and nine seconds so that the image you're seeing on the monitor from the playback machine is slightly delayed from the present time image. In other pieces, I used a delay of 24 hours. In "Yesterday, Today", one space had a live camera with the monitor in a nearby space where you heard a 24-hour continuous audio tape of what had happened in the space with the live camera that you're seeing on the monitor, 24 hours ago. All of this was a property of the very simple video technology available at that moment. All of it was in juxtaposition to the older film situation which showed past time, edited.

METZ: The objects of the technology seem to be a governing element. I'm thinking of the first pavilion pieces, where in effect you end up with a formal architectural structure. What predicated this move?
GRAHAM: It had a lot of stages. There were video projects which took place within showcase windows that were between two glass office buildings and displayed picture windows of houses. So you have all the possi-

bilities using real, urban and suburban architecture, consumer-oriented, showcase window architecture, office buildings - all of the elements that actually I later did with pavilions because the pavilions are mediating between traditional park/garden historical references to references of the city and urbanism. The change, if anything, was a change between making pieces that were camera obscuras which placed you almost inside the camera, and were referring to the optical system per se, to one's showing the spectator, in terms of the perceptual process, as an audience, as a spectator, rather than as a work of art the principles were the same, but these were the spectators in relation to materials commonly used in the city that had psychological and physiological properties.

METZ: "Two Way Mirror Cylinder Inside Cube and a Video Salon" is your most visible piece here in New York. What did you see as the relationship between the two parts, the video salon and the two-way mirror?

GRAHAM: Heiner Friedrich's original idea was to take one of the spaces downstairs and have a self-enclosed, discrete space, not framed by the city and outside distractions and definitely a non-museum type of space. Something like a church. A meditational space for the ideal work of art. My idea, obviously, was the opposite. I needed a public social space, a space that would be quasi-functional. So one aspect of the piece is both a coffee bar and a video salon. Six curators were hired to buy a library archive of videos in the areas of cartoon animation, music, architecture, performance and artist performance which would be permanently installed as a library. The piece and the space around it were designed to be a kind of bar or lounge area, a space for openings and social gatherings, and a space for performances.

METZ: So you really mean for the piece to be used.

GRAHAM: Well, it's part of the section of museums which are the most interesting architecturally the bookshop, the coffee bar, social lounge area, romantic rendezvous area. It's all to be a part of that.

METZ: A great Friday night pick up spot. I had heard that people were sleeping in "Two Adjacent Pavilions" during Documenta.

GRAHAM: My students would sleep inside the pavilions with their sleeping bags. I designed this pavilion to fit about five to ten people inside. So the dimensions are always human. In a park situation, people are often lying down, as well as standing up and looking around. There's always a reflection in my work between the work as an object in itself and the idea of people seeing themselves as perceiving and being perceived.

METZ: These pieces have the spectator at the center.

GRAHAM: They're designed around the perception of the spectator and the idea of the public in relation to the private person. The relationship of the spectator to a private artwork in a museum or gallery as somehow the subject of the art, which was the case in minimal and conceptual art.

METZ: So it's moving the subject to the spectator and away from the object?

GRAHAM: Well, my work became more involved with large public spaces, it shifted from one spectator to many spectators and not one public, but often two aspects of the same public.

METZ: "Two-Way Mirror Cylinder Inside Cube and a Video Salon", uses mirrored surface as a device to move the spectator away from the object. How long have you used this surface as a means of perception?

GRAHAM: We were speaking about the "Body Press", which was the last of the double projections. That was related specifically to the body. But there's also always a relationship in the double film pieces, between the outdoor surface of the body and the outdoor surface of the surrounding 360 degree environment, the two are mirroring each other. And the construction of the pieces has always involved a doubling or a mirror relationship. What was a structuralist procedure became first a physical device, and then performance. At that point, it seemed I could use video, including the video delay, in relationship to window glass and mirrors because video was a continuation of the renaissance perspective that was built into the mirror and the window, but extended it in many ways.

METZ: With the window comes the notion of the "view in" and "view out". One individual at a time, one family at a time, it seemed to be separating the family unit, or separating the individual home.

GRAHAM: You're referring to one piece, "Alteration of a Suburban House", where I'm extending the picture window, I'm making it larger. So the view you get works less as a voyeuristic piece and more as a piece where people on the outside see themselves in a so-called public space outside the so-called private space. It's revealing the outside environment around the inside. What happens inside isn't that important because it's only the living. It's often covered up, so it's really a trap for people on the outside to reveal their own situation.

METZ: What kind of a house did you grow up in?

GRAHAM: Until age 13, a public, government housing project in a rural area on the edge of a New Yersey suburb - basically, army barracks. Most of the

people were upper-lower class, but we were surrounded by the growth of middle class and upper-middle class suburbs. When I was 13, my family moved only a few miles away to a very upper-middle-class suburb.

METZ: Do you always envision a picture window in a suburban house?
GRAHAM: A picture window, that was definitely the name of the game. Two styles were rampant. We had a Cape Cod, but the other style was the ranch house. I guess picture windows were important in Holland and American suburbs after the war. So I was simply extending that convention. It's also, in terms of architecture, related to Philip Johnson's "Glass House", which derived from "Farnesworth House". On the other hand, the composition of many of the Venturi houses was delivered from the composition of the adjacent house or the one across the street. So, the facade of the house has been destroyed, but what you see in the mirror are people outside, people on the inside, and the houses across the street. I'm doing the same thing, I'm imploding it all onto one surface. The surface of the mirror behind and also the semisurface of the glass window in front.

METZ: In a curious way, the two-way mirror is quite aggressive. What led to this?
GRAHAM: They come out of work that came before. The first time I used two-way mirror glass was in a very simple video installation, and it attracted itself to me because this material had been used in psychological laboratories and was also used for surveillance. It was replacing, in many of the urban contexts, let's say Toronto or Los Angeles, the sheer glass of the International style office building. The illusion of openness that the International style glass office building wanted to maintain was falling apart. The inner core of the city was becoming more dangerous, people were moving out of the city. The two-way mirror glass gave a certain amount of security in that people couldn't look in during the day, but people inside could look out. And the opposite at night. Plus it was ecologically efficient, and it was definitely the new cliché of mediated social space on the inside of the city. For Documenta 7, I came up with the idea of doing an outdoor piece, but I wanted it to relate to the city, the suburbs, as well as the traditional park situation. It was to be used the way garden architecture and garden pavilions function in a normal large park. So I was picking up all of those things at the same time.

METZ: How do you see the difference in function between the pavilions and the pergolas? The pergolas seem to be much more relative to a planned garden environment.

GRAHAM: You haven't seen pavilions in the United States. In fact, they were just as garden oriented. The one from Muenster had a wooden roof, and a wood pole... it was in relation to an octagon, an 18th century place. The layout for the grounds around the palace were octagonal. I was trying to coalesce different time periods.

METZ: This pavilion was made with mirrored glass.
GRAHAM: Mirrored glass made it into a photo opportunity. And the idea of an amusement park, a funhouse situation creating kaleidoscopic space. And also a kind of fun division between parents and kids on the inside, and photographing parents and kids on the outside. It was very similar to these half-open music pavilions of the late 19th century, where there would be a bandshell on the inside of a large estate gazebo.

METZ: Psychologically more playful, less aggressive.
GRAHAM: But the shows are normally in the summer, and based on tourism, which means families travelling in their automobiles, to specific locations where people go to see modern art in a country setting. And also they need to relax. And if they remain - let's say in Muenster, most of the city is a large university city - so, these temporary buildings have to be used as young people would use them.

METZ: Speaking of young people, you've done two children's pavilions.
GRAHAM: Well, let's see, the first one was circumstantial and was part of this very large exhibition in Ghent called "Chambres d'Amis" which had as its theme artists using interior private spaces of people who lived in Ghent. People responded to advertisements to allow their spaces to be used. This included doctors, lawyers, architects, social workers, teachers... People who were interested in the educational aspect of being temporary curators and guides, and also what would happen if their home and their private life became the subject of the artwork. I chose an architect because I liked the idea of doing work that was quasi-architecture for an architect. What turned out to be important was that I couldn't do a work in the large-scale size that I had normally worked in, because it would have dwarfed his own architecture, Secondly, the area we chose in the back was a very rough area used by his kids as a playground. There was also a playground across the street used by neighborhood children. I wanted to keep that relationship to the playground across the street and build that into the piece. So what was originally going to be a small botanical garden finally became something more of a dollhouse, a children's size pavilion.

METZ: Was street traffic allowed through the property?

GRAHAM: Well sure, that was the idea. In other words, the property itself became part of the museum show or, let's say, it was related to these shows in public spaces inside the city. When I showed this video tape to Jeff Wall, he had the idea of designing a large scale playground piece where he would do images of children very similar to the images of children he saw in the videotape. This became "the Childrens' Pavilion", and it was a completely different proposal which came about not because Jeff saw the original piece, but because he saw the television replication of the work. And of course, psychologically his identification with his children, his childhood. So I was operating from his interests and my own. At that time I was interested in underground architecture. For instance, one of the most salient playthings used by kids are these earth-mound mountains, that often have a hole in the top for kids to dive down into. The game has become a king of the mountain type thing except that they dive into the space. So my children's pavilion was based around those conventions, and the conventions of the worship of children. The panteon has an atrium hole in the top for the worship of the different gods whose images would be along the inside wall and illuminated by the sun overhead.

METZ: Virtually all your work deals with the spectator becoming aware of their own consciousness, a mediated view of themselves. That particular children's pavilion is very much a media representation of how children are seen. It's the establishment of stereotypes of children.

GRAHAM: In "Alteration of a Suburban House", you're also dealing with the stereotyped idea of the suburban house after World War II as shown in magazines, the cliched prototype of a desirable, model house. The stereotype of a child probably comes from films; I think Jeff derived it from Spielberg films. We are both interested in Baroque paintings, the angels that appear on the ceilings in Baroque paintings. At the time I was doing "Rock My Religion", where a teenager appears as an androgynous angel figure. The idea of children as angels comes from that sentimental idea of children that Jeff and I probably had concurrently. I also like the idea that on the outside, when you look down through the oculus you're looking through a concave mirror image of yourself vastly enlarged, against the sky, the real sky on the outside opposed to the idealized sky in the photograph. As that sky changes, your image of yourself is changing. With a two-way mirror you're seeing the idealized is changing. With a two-way mirror you're seeing the idealized children below but you're also seeing real children with their parents looking up through the oculus.

METZ: In your reading, what kind of affinities do you have to any philosophical or religious outlook?

GRAHAM: At the time of "the Childrens' Pavilion" it was a break with the anti-humanist liberalism of the minimal period and a return to, if you want, the United Nations of Humanism. It was the beginning of the ecology period and I was looking for an underground, earth oriented architecture.

METZ: I wanted to talk about those pieces that involve both indoors and outdoors. I'm thinking about "Altered Two-Way Revolving Door and Chamber with Sliding Door".

GRAHAM: Again, these are all projects that were given to me. I designed that for an inaugurating exhibition to celebrate the World Financial Center. It was on the outside of a large lobby of the office building. There was an L-shaped corner in the building which was itself made out of two-way mirror glass. I filled it into make a triangle, which was a natural extension to the architecture which allowed for a viewing area for the people on the inside.

METZ: The general passerby coming across the door would have thought it was a doorway.

GRAHAM: Well, I don't think after the opening of the exhibition, people went there for the work. The work blended into other semi-functional, semi-landscape, semi-artistic things that were part of the exhibit.

METZ: The fact that it wasn't functional but looked like a doorway into the space...

GRAHAM: But it did have a door that you could close and most people closed it. By closing the door you are creating a shelter for yourself. And you're implicated in all the relationships. I think as soon as you close it off, you're creating an architectural situation for yourself.

METZ: It's curious. I was over there a couple of times after it was set up. Anyone who went in, closed the door and after a few moments, would come out looking sheepish.

GRAHAM: It was small enough that generally it was for one person not a large group of people. And because it wasn't labeled as art you didn't have to look at it aesthetically.

METZ: More adventure some but not intimidating.

GRAHAM: You have to make a commitment in terms of taking time out. Most of the public/private places are to be walked past and not thought about. You're not really stopped in your tracks. They're really designed for semi-distracted observation.

METZ: You seem to be a move away from urban/corporate type works, with the use of the pergola, with its various plants, in a garden setting.

GRAHAM: They're public/private spaces for people to stroll through. The large, two-way mirror, hedge labyrinth piece has been built for a private collector as an extension of his garden and his hedge system. Another version of it was constructed for a gallery in London, in the center of Hyde Park. People stroll through it. You can see it if you're driving trough Hyde Park. It functions as garden space, as Renaissance, Baroque theme park.

METZ: Do you specify what plants are meant to go in those works. In other words, how much of a botanist are you?

GRAHAM: Well, it depends on the actual situation. For example, when I was doing something in La Jolla, I was trying to match the plants they actually use as hedges. In fact, in La Jolla, I had to switch because there was a plant plague.

METZ: In La Jolla, a lot of people have hedges made out of jasmine which is fragrant and is associated with erotic gardens. Would you make a choice like that?

GRAHAM: I was looking for something that was opaque when you looked at it from a distance but when you got close, had a lot of space between the flowers and the leaves. I wanted it to become more transparent as you got closer. Very similar to the mirror glass. There was a vacillation between it being opaque, translucent and transparent.

METZ: As with your other work, you are looking for a certain degree of anonymity.

GRAHAM: I was looking for a contextual match. In other words, it's related by context to a surrounding architecture or a plant. But it's a hybrid between it and something else. It's also emblematic of something that isn't there but allegorically is suggested.

METZ: You said a number of years ago that you really wanted your work to leave out both the artist and the notion of artistic vision.

GRAHAM: Well, I don't know if there's been the elimination of the aesthetic vision. These pieces are inherently aesthetic. It's just that the aesthetic ideas are contained inside people's perception of the piece, not the environment and the architecture.

Mike Metz is an artist and writer; he lives in Brooklyn.

The interview originally appeared in *Bomb*, Winter 1994.

Art that makes use of the mechanisms of popular media culture and exploits the evocative power of sensationalism proceeds along a narrow path between art and kitsch, perversion and bluff. Damien Hirst attracted media attention and public interest in the early nineties with spectacular presentations. The installation "Mother and child divided", a bisected cow and calf preserved in formaldehyde (1993), intensifies the shock effect produced by confrontation with death, whereas the show "Pharmacy" (1992) focuses on the illusion of prolonging life; the staged presentation of a glistening, immaculate drug cabinet alludes to the meaning and suggestive power of medical logos. Hirst's installations are not intended primarily to represent a break with traditional artistic practises or to generate critical dialogue, instead, they are the vehicle through which the artist responds to the expectations of a broad public, mirroring its interest in rapid consumption of sensations. The manipulated perception of feelings and sensations corresponds to the information strategies of TV, advertising, music and fashion. "Art's about life and it can't really be anything else", says Damien Hirst. The aesthetic strategy incorporates a deliberate styling of the image of the artist, reviving the myth of the artist as an independent entrepreneur who makes his mark in the realm of art through provocation and boldness. (G.D.)*

Damien Hirst
The Exploded View of the Artist

INTERVIEWED BY FRANCESCO BONAMI

FRANCESCO BONAMI: How did you put this show together in New York at Gagosian?
DAMIEN HIRST: This time it was the title that came first. "No Sense of Absolute Corruption". Everybody told me not to do a show with Larry (Gagosian). So I thought the title was funny.

BONAMI: Why did you?
HIRST: In a conversation three years ago he asked me to do a show. I said no. I thought it wouldn't work. I said, If you are interested in my work; as much as you say you are, you still will be in five years time, if not then I shouldn't be doing a show now".

BONAMI: But you did it after three years...

* 1965 Bristol / lives in London.

HIRST: It took me a long time to be able to deal with that space. I was intimidated. I did the show when I got to the point that I didn't care.

BONAMI: But going back to the title...
HIRST: The idea came quite a long time ago - "No sense of absolute corruption" - because as I said a lot of people think Larry is absolutely corrupt. Which I don't think he is. I imagined what all the other gallerists would be like in his position and figured most of them would be a hell of a lot worse, more difficult to deal with, I wanted to make a show where every piece somehow undermined every other piece, but not in a negative way. It became a kind of celebration. It looks more like a group show, with the individual artists being aspects of myself, like an exploded view of an artist.
I thought about all the different kinds of corruption that exist in art.
The billboard is where advertising is corrupt, the smoking is corruption into yourself, and big business. The way the spin paintings are made is very easy, they look cheap. How not to make my own painting. I made a machine to make them, which is a quite corrupt idea... maybe.

BONAMI: What about the pig?
HIRST: It was the last thing to go in the show. Ignorance, explored, explained and exploded, at the last minute I changed it to "This Little Piggy went to Market. This Little Piggy Stayed at Home". I like the stupid idea of the pig moving like a bacon slicer, which is logical, but twisted.

BONAMI: What about corruption of the beach ball floating in the air?
HIRST: The title is "Loving in a World of Desire" it's my favorite piece. It's so cheap and empty looking, but the floating is amazing. But even if it's cheap and empty and nothing you can have, it's out of reach.

BONAMI: "The billhoard" The Problems with Relationships...
HIRST: Sex and violence isn't it? Originally it was a sculpture, a table with the hammer in one corner, the peach in another corner, the jar of Vaseline in the other corner and the cucumber in the last corner.

BONAMI: The cow...
HIRST: "Some Comfort Gained from the Acceptance of the Inherent Lies in Everything". When you accept that failure is unavoidable, rather than trying to be perfect you say "OK I'm shit." you can move forward.
You get some "comfort" if you accept that "lies" are a part of life.

BONAMI: So your work is corrupt?
HIRST: Not now that I have done the show, at least for a while. There are

a hell of a lot of things that you have to think about when you are an artist, and some of them are really dangerous. Sometimes it's easier to avoid thinking about them. You have a desire to make art, to have integrity, and to be truthful. But you also have the desire to be famous, and to live for ever, which you are not allowed to talk about. It's hard to get hold of all that stuff, get your head out in the open, admit "I want to be famous". I don't want to become my own idea of myself. I could have very easily gone into Gagosian, just put a cow chopped in pieces and been Damien Hirst. I could have an art plan for the next ten years: have the spin paintings show, and then two years later the beach ball and the pig, and so on, and two years later... blah, blah. blah. I could have known what I was going to do for ten years. Now I don't know what I'm going to do next, which is fantastic. It's a good position, it's my position from the beginning.

BONAMI: Could you stop being an artist?
HIRST: I know how to make the perfect artwork, how to be a perfect artist, but I can't do it, I am too arrogant, all artists are. The best way to do it and the most perfect way to do it, is to put what you put into art into other people and not call it art, it becomes not art, it becomes life. You don't ever think about it, it cancels out art. Because art is about life and the best way to live life is not to be an artist. Jeff Koons got the closest to that, but maybe even he is changing, it's difficult to sustain. If you are an artist you spend a lot of your life involved with something which has nothing to do with life, something which is quite weak compared to it. I can't do it. It's very hard to admit.

BONAMI: When you did a video for the music band Blur was it a chance to move away from art?
HIRST: Art is about life and the art world is about money and they are separate things. You can't confuse them. Art is invention, exciting and fantastic. When I was a student I had an ambition: I wanted to show at Anthony d'Offay. I never thought beyond that. Now that I have a show at Gagosian it is in a way where I wanted to be. Is that beyond d'Offay? I don't know where that is. I don't know what to do next. It could be a horrible position but it isn't.
I was watching TV and listening to pop music before I ever went into an art gallery, and I am an artist. I don't know why, so doing a video for a band like Blur is normal but it seems weird to other people. When I curated the exhibition "Freeze" everybody said to me, "Now, you have got to decide whether you are an artist or whether you are a curator". And I said "Why?". There was no reason, "Why?". I spent all my time asking myself "Why?". When someone tells me I can't do something, so far I've always found out that I can. Now people ask me, "What are you doing now? Are

you going into pop videos, films, or are you going to be an artist?" I can't see the difference, I just do the whole thing, it's all art to me, TV has only been around for 60 years, art has been around for ever. The only difference between art and film is that art can be cheap and film is fucking expensive.

BONAMI: Do you believe there is a big difference between the art world and the music world?
HIRST: Yes, the music world is a pile of shit and the art world is fantastically free. Basically in the music world the people who are the furthest away from creativity have the most control which is totally stupid. The people who make the decisions about what we listen to should be the bands, and they are at the bottom. If you look at the contracts they have to sign, it is ridiculous. I was looking at a contract that Blur has to sign, and the bassist, Alex, showed me that in the contract it says "You can't change style". So if the record company is primarily interested in money, why are they so stupid? They don't realize that if the Beatles had signed a contract like that in 1962, they would never have become the Beatles nor made all that money.

BONAMI: So it was not a good experience?
HIRST: Oh no, it was a fantastic experience.

BONAMI: Are you going to do another video?
HIRST: There are four reasons for me to do it: it has to either be a fantastic idea, a fantastic band or a fantastic relationship with that band, a lot of fun or a fantastic amount of money. In that order probably, if it is not one of those things, I'll say no. If it's all four I'll do it.

BONAMI: Why did you do it with Blur?
HIRST: All those reasons. We went to college together. I wanted to be their manager, it didn't work out. It was when nobody liked me in the art world, I was an upstart. Blur was playing at our degree show, but they were called Seymour. Then I forgot about them. One day I saw them in the Groucho Club and I realised that they were the same guys I went to art school with. I didn't connect them with Blur and I was shocked when I found out. We started going out and drinking together again and they asked me if I wanted to do their video. I had a good relationship with them, it was a lot of money and a lot of fun. The only thing I didn't like about doing a music video was the fact that you can't change the soundtrack.

BONAMI: Do you feel you are at another level compared with the other artists of your generation in Britain ?

HIRST: I don't know, I wanted to be stopped, and no one stopped me. I just wanted to find out where the boundaries were. So far I've found out there aren't any. You have to step over the line to find where the lines are. A lot of people go close to it and don't go over it, but I got over and I can't find any. Meanwhile I look around at some of my friends who didn't, and a lot of relationships have changed, the goal posts just keep moving.

BONAMI: Are you still seeing people in the music world?
HIRST: The boundaries are really blurred, it's quite exciting. Like I think Jay Jopling might be working with a record company. In the way that Jay is working as a dealer he is thinking of branching out somehow from the gallery into other things. I think it is a great idea. Angus Fairhurst did a performance when Jarvis let him do it on stage as support for Pulp. People didn't know how to react, they just stared, thousands of people, now that's great, great that Jarvis did it, what a guy. When Jarvis went on after them he went up to Angus and said, "You conceptual artists, I don't know". It's not just me, it's everyone.

BONAMI: Are you looking at ways of making art like doing a job?
HIRST: I want to stop art ever being a job. That's why I didn't just put the cow at Gagosian and then something else two years later, because it would have been like a job, like working in a factory.

BONAMI: Your relationship with Jay Jopling is good, how does it work?
HIRST: In the beginning when I started working with him, we said, "Let's try to not have any preconceptions" and we are still trying even though we know it's impossible.

BONAMI: Are you putting your mouth in Jay's decision ?
HIRST: What do you mean? I put my mouth in everything I do.

BONAMI: Are you arguing about some of the artists he shows that you don't like?
HIRST: Yes, but I admire him because in spite of what I say he does not dump those artists I would rather not be with him if he did. He proves to be loyal and responsible. If he got rid of people because someone else said so then he could get rid of me.

BONAMI: Does he influence your decisions?
HIRST: In this show he disagreed about the small dot painting. I thought about it but I included it. We work well together.

BONAMI: What's wrong with that painting?

HIRST: The small painting was the last decision, definitely. It goes against the scale of everything else, it fucks it up completely, but that's why I like it, that's why Jay didn't but maybe he does now.

BONAMI: You also did a movie?
HIRST: A short film, it's called "Hanging Around". It's about a man and everybody he comes into contact with dies. He starts to realize that every time he leaves a situation the situation doesn't exist anymore, he only exists in the present. He doesn't have memories in the beginning and he starts to develop them and he begins to work out what is happening to him.
He goes to see the doctor and says, "Every time I visit people bad things happen to them" and the doctor says. "That's funny because everybody who comes to visit me dies, so the doctor is the same as him". So they have a kind of tête-à-tête conversation and the doctor dies, and that's the end, sort of.

BONAMI: Is it something that you just did for fun?
HIRST: The good thing about it is that I showed it at the Hayward Gallery. They made the gallery into a cinema and they paid for it.
I am an artist. I put things in art galleries and the film is one of those things, but it's also a film, which is confusing but I like that. People didn't really like it because people expect you, according to your reputation, to be able to make a perfect film, while in reality you have to learn a whole new visual language. People didn't know how to approach it because they couldn't decide whether to treat it as art or film. If it's art, it's great, but if it's a film it's not really as good as "Apocalypse Now".

BONAMI: So the music world is shit, what about the movie world?
HIRST: Same thing with Hollywood. The art world is fantastic, you can have so much fun. I can walk into my gallery with a banana stuck to a dog shit and ask Jay what he thinks about it. He can laugh but he has to think twice about it - especially with a good title - he has to look at it, he has to consider it. There are regular moments in the art world where something has been invented and no one knows if it's good or bad. How fantastic is that?

BONAMI: So, why are people in the world so often depressed if its all about freedom?
HIRST: Because they can't admit to themselves the secret that they want to be famous, and they resent not being famous.

BONAMI: Why has art not got such a big audience as films and music?
HIRST: Maybe art is too threatening. People are incredibly visually educated, they don't even know how well educated they are about films. The

amount of films that people watch is so big, but they don't realize how much they know about it and how it works. If people would see as many art exhibitions as they have seen films, they would know a lot about art. This visual intelligence that everyone has got from films is used in advertising to sell things to us.

BONAMI: You like advertising?
HIRST: I love it. I prefer it to film because it admits its own corruption.

BONAMI: What makes a good film?
HIRST: A film is about different levels, there's no formula to it, it's like art. But Tony Kaye, a friend of mine who is a great commercial director and artist, said to me that sound is over fifty percent of the film. All you have to do to realize that, is sit and watch TV and look at how much space the image fills and how much space the sound fills, sound fills the whole room and the image just the screen. How long can you watch TV without sound, ten seconds without being bored, but you can listen to the radio for an hour and an half.

BONAMI: Did you ever use sound in your work?
HIRST: There is quite a lot of noise in the Gagosian show, all the machines, it's annoying but I like it. Wow! I just thought that in the show I should have had music playing, it would have been fantastic, mental.

BONAMI: You are also doing a book, but it's not a regular one, is it?
HIRST: It's a pop-up book. Art books are art books but I like the idea of something that could work on different levels, on an art historical level but also one a child could go through and love. I was wondering if I could do some art that works on both levels. There are spin paintings that spin in the book, or there is the story where the lamb was vandalized, if you turn the book upside down the sheep fills with ink. It's a serious art book that kids would love. The weird thing is that I got a quite big advance to make it which is considered mad for an art book.

BONAMI: How much is going to cost in the book-stores?
HIRST: Cheap, 35 pounds... I hope.

BONAMI: Do you think your image can sell?
HIRST: Maybe it will if someone is willing to cross some boundaries with me, taking some risks and making something else, something different.

BONAMI: Did you have to give up anything in your life?
HIRST: No. I didn't.

BONAMI: Do you have to play your own role, Damien Hirst?
HIRST: If I hadn't seen Jeff Koons I probably would have done it, but not very successfully. But when I look at what he did, he gave up his own idea of himself for art, which is why he is fantastic, he went the whole way, I realized there was no way I was prepared to give it all up. And if I only give up half, that is not enough. So I have to find another way to do it.

BONAMI: Which is?
HIRST: I don't know yet. Enjoy yourself, not change yourself, drag all your friends and everything with you; do not stop talking with people even when you stop communicating. I don't want to get to the point where I will be turning to my son going "Have you got any idea who you are talking to? I am Damien Hirst!" I keep thinking that everybody is incredibly more famous than me. Everybody secretly thinks that, but they deny it. If you look at David Bowie you say, "He is fucking superfamous", but if you are David Bowie you probably think "I'm just little old David", it's hard to think about.

BONAMI: Is being an artist a way to change your social status?
HIRST: It's not the reason to do it, that is just a bonus. But that's why art is brilliant, it gives the vision of freedom, it's classless.

BONAMI: Are you ever unhappy? Do you have what you want?
HIRST: There is a thing that I want more than anything and that I think I might never be able to have; I would love to live in the present, just to be here, now and not looking behind or into the future.

Francesco Bonami is an art critic and curator based in New York; he heads the *Flash Art* US editorial desk.

The interview originally appeared in *Flash Art International,* no. 189, Summer 1996.

Like billboard slogans in urban areas, Jenny Holzer's art has a chance of being experienced "en passant" - or not at all, since pedestrians are known to have an attention span of only a few seconds when it comes to reading something as they walk along their way. Thus in order to catch the fleeting glance and facilitate a quick reading of the printed message, the artist's texts are short, dry and to the point.*

Jenny Holzer has memorable one-liners printed on posters to be stuck to building facades or displayed on led electronic signs. To ensure wide distribution of the texts, she has them posted wherever people are likely to be - in streets and squares, on telephone booths, in taxi cabs or even on parking meters.

"Protect me from what I want". "Raise boys and girls in the same way". The artist's political or personal slogans penetrate the conventional systems of visual communication and settle in to operate like radio jamming transmitters. Jenny Holzer's art, driven by an impetus of social criticism, intervenes in opposition to the constant visual presence of powerful messages that penetrate our consciousness virtually unnoticed, messages that threaten to become an omnipotent force in our media society. (G.D.)

Jenny Holzer
I Wanted to Do a Portrait of Society

INTERVIEW BY PAUL TAYLOR

PAUL TAYLOR: Were your beginnings in the New York art scene with the Colab group?
JENNY HOLZER: I'd been in New York probably two years before I found Colab. I was a relatively fresh arrival.

TAYLOR: Why did you come to New York?
HOLZER: I was restless or confused or driven. Pick any one of those three. I was an abstract painter, kind of a stripe painter, school of I don't know what. Actually, before I did the stripe paintings, I did some quasi-conceptual things - things about my work. I was working in a hospital once so I took out all the cards I'd typed and made mistakes on and made some art out of all my mistakes. Things like that - in '72 or '73 way back. Then came abstract painting I thought abstract painting were pure and beautiful, so I wanted to make some.

* 1950 Gallipolis, Ohio / lives in New York.

TAYLOR: Do you still think so?

HOLZER: Sure, some of them. Some are rotten. It depends. A good Rothko seems generally spiritual and lovely. At that time I also read a lot of books. I still do - usually literature as opposed to art criticism; promiscuous reading, right across the board though fiction was my bent. I went more for old classics. I don't read too much contemporary fiction. Now I'm maybe more prone to read political journals, still with a heavy dose of literature. I like political theory. I recently read an interesting series of books - the "African Writers" series. Have you run into them? I thought those were interesting. It seems like the novel got life then there was serious subject matter. When people were very earnest and sincere about what they were writing the whole form came alive again. Subject matter helps. I never read too much feminist criticism. I'm aware of it, but it's not a specialty.

TAYLOR: Is there more subject matter in the art world today than, say, five or ten years ago?

HOLZER: Maybe more than five years ago and less than ten years ago. Five years ago, I guess, was at the height of the rediscovery of painting. Ten years ago, going back to Colab, there were a number of people who were trying to put art in public places, to make art for a non-art public and all that kind of thing - to make art about the big issues that would be intelligible to anyone. That was at least one segment of the art world.

TAYLOR: How are politics manifest in art?

HOLZER: They can be there in all kinds of ways - from overtly political subject matter with not much art attached, to how the work is displayed, to whom it's displayed. There are all kinds of ways to approach it. That people are more willing to entertain troublesome topics signals end of the Reagan era - as opposed to assiduously not thinking about them.

TAYLOR: What are the troublesome topics?

HOLZER: Dying in a war, dying in a prison camp, dying because you drink something bad in your water if a little plutonium floats by. These sorts of things.

TAYLOR: Was it as a result of conceptual art that you started using words?

HOLZER: No, my art history background was so bad that I didn't really know about conceptual art. I had some vague idea that conceptual art was art by people who didn't make things for sale. I didn't know about language as art or that kind of thing. I didn't want to grow up and be Kosuth. I didn't know who he was I was ignorant.

TAYLOR: When did you start writing?

HOLZER: Shortly after moving to New York, after flopping through a number of failures, I had started the writing and done the first street posters. I think it was 1979 and I was in my second series of street posters when "Jenny meets Colab". I just heard someone talking about a group that organised shows on its own, that didn't try to get into museums. They would have these shows in peculiar non-art places and try to make art that would make sense to someone in the Bronx and to people who don't go to the Metropolitan Museum every day. I thought, "Mmm, sounds like a good idea, more or less like what I'm trying to do". The context of an art museum was not so much "the enemy" as just out of the question. My first writings were the "Truisms", the one-liners. I figured out that they had to go back in the world and had the idea of doing the posters.

TAYLOR: Why did your "Truisms" appear in the art context instead of in, say, magazines or a literary context?

HOLZER: To tell you the truth, I didn't put them in an art context I put them in the street. I somehow thought that maybe I could be an artist and at the same time get this work that I was thinking about out to the public. I was dying to get this information out where maybe it would be useful to somebody. It was really the art world that put it into art eventually. I tried to put it outside. I did a couple of shows after having the stuff in the street for maybe two years, in places like the window of Franklin Furnace, in Printed Matter and at Fashion Moda in the Bronx... I thought Colab was absolutely wonderful. Here were a couple dozen people trying the same kind of thing I was, and because there were so many different people, there were that many different ways of going about it. For instance, John Ahearn's stab at making something relevant to a non-art audience was going to Fashion Moda and sculpting portrait busts of everyone on sight as an ongoing activity. That worked very well because it grew. Every weekend there'd be more and more people. That was a nice thing. His brother Charlie did it in a different way, he did a film about graffiti writers and rap music. It's called "Wild Style". They're identical twins.

TAYLOR: It's a dreadful film.

HOLZER: Robin Winters, Tom Otterness, Colen Fitzgerald, Alan Moore, Peter Nadin, Diego Cortez and Betsy Sussler were other Colab-ers, and in the beginning, everyone was pretty sincere. The career thing wasn't alive the way it is now because it just seemed impossible. Even if you were so oriented, an art career just seemed so far away that you might as well do what you were interested in. Our major involvement lasted probably two or three years and then we all just drifted away or whatever. All of us got older. Fashion Moda was in gear for many years and I think Stefan Eins just

got exhausted because he had more or less kept it afloat for years single-handedly. He handed it over to somebody, and I don't know the current status, to tell you the truth. I think it's a moment waiting to be rediscovered. Although I'm prejudiced, I think some of the more interesting stuff was done there, like Justin Ladda's piece, "The Thing", which was one of the better things done for a number of years, of any description, in any mode. He was a member, it was done under the auspices of Fashion Moda in the Bronx, and it also was a part of the trend to put something someplace unusual.

TAYLOR: When did you start working with electronic media?

HOLZER: When I got access to the sign in Times Square, which was in 1982 and part of a public art project. I think Keith Haring did it first, then maybe Crash, and I was the third. It was Jane Dixon's idea. She is an artist and Charlie Ahearn's wife and was working at an advertising company. Colab had used the sign before to advertise the Times Square Show, and maybe Peter Downsbrough had used the sign during an election. But Jane had the idea that artists could routinely have access to the board, and approached the Public Art Fund and started the project that lives on to today. Once a month an artist gets two weeks. I thought this was a perfect way to display writing - the text fit fine and it was interesting to change from the underground connotations that posters have to Big Brother overtones, because the big signs make things seem official. The sign is either for commercial things, which seem very real in the United States, or for genuine public announcements. It switched the emphasis in my things. It was like having the voice of authority say something different from what it would normally say. Sometimes I think something is more effective if you make it seem official, but then use a different content. I don't really want to control people's lives like Big Brother does, or to run people's lives. I wanted to do a portrait of society, if that doesn't sound too pretentious. I tried to put in ostensibly every possible belief. I thought it might be interesting and effective to show a spectrum of all possible beliefs.

TAYLOR: How expensive is your work? Are the posters still for sale?

HOLZER: They were originally $100 for a set. Now they're maybe $200 at Barbara Gladstone's. They've doubled. But you can still get them at Printed Matter for $25. The LEDs (Light Emitting Diode machines) range in price. There's a little guy that's $1500, through to more expensive ones. It also depends on what the hardware costs. For some of the larger ones, just the sign itself from the company costs many thousands of dollars. I like a good sign. I still want to get the work out there, and these signs display the work very well. They have huge memories, so you can put a lot of things on them. It's good if I want to display a whole series and pack the

whole thing in. The sign will regurgitate it. I have to say too that I like the way they look. They push me in the right places.

TAYLOR: Of course you have also had your words set in stone lately.
HOLZER: I went from stone bench to coffin. Probably the longest things I've written are on the sarcophagus lids. They're in the Dia exhibition. I got into the coffin business because I am occasionally on an apocalyptic bent.

TAYLOR: Has it got anything to do with the origins of sculpture which are, to a large extent, connected to the origins of sarcophagi?
HOLZER: I came to it in a slightly different way.
I'm always looking for functional objects that comfortably hold text, that it's logical to have text on. I always liked whatever it was to have a real purpose in the world. What I am planning for the Venice Biennale is a formal art installation in the U. S. pavillion and to have a number of things in the city as well: benches and signs and sarcophagi and there's a new laser thing that I'm learning about. It's a laser that writes text, a projection basically, that when it hits a wall you can make an animated text. The quality of light is very nice, it can wiggle all over the place and the colors are very otherworldly. The way I'll work it all out is to just walk around the city and talk to people there and find out what are the common ways to put out information, how pronouncements are put out in Venice.

TAYLOR: Marinetti threw leaflets off the clocktower eighty years ago. He got the crowds on their way back from the Lido.
HOLZER: Well, I'll be getting the art crowd, because it's art festival time. For some it will be art entertainment but there will still be a lot of people in Venice who aren't thinking about art and I hope I'll be able to say something interesting to people who are just going to lunch or doing what people do.

TAYLOR: Apart from Venice, there was the big Dia installation, and your Guggenheim Museum show. There's been stacks of press. How do you feel about your new ubiquity?
HOLZER: I hope people don't get entirely sick of it. And I hope that I can make enough good stuff that it won't be a snore to see it. It's up to me.

Paul Taylor was an art critic and the editor of *Art & Text*; he contributed to the *New York Times* and *Flash Art*.

The interview originally appeared in *Flash Art International*, no. 151, March/April 1990.

What is our relationship to time; how do we imagine the past or the future? Jannis Kounellis' thinking centers upon issues and concerns of cultural anthropology. In his work the artist takes up the lost thread of human interrelationships with tradition in order to transport universal ideas of culture into the present. Darkness, fire, the resources of nature - Kounellis reaches back to the topoi of narratives that speak of Man's immediate relationship with his environment. The materials used in the installations - gas burners, metal, coal, burlap, stone, wood - symbolize cultural relics which recall the depths of our cultural heritage and prompt reflection on our contemporary cultural identity. Installations in historical sites stimulate thoughts about the past in the mirror of cultural self-reflection. Kounellis regards himself as a painter; he takes up points of reference in the history of art. By radicalizing and objectifying painting, however, he creates archetypal memorials that oppose overdiversification in an era of disintegrating values. (G.D.)*

Jannis Kounellis
A Grand and Liberating Process

INTERVIEW BY MARIO DIACONO

MARIO DIACONO: In order to gain a precise idea of the work you and others are carrying out at this moment, I feel the need to point out the existence of a unifying thread over and above the political changes we have experienced in our lifetimes, which could go far toward explaining why your work has taken the form it reveals today. To my way of seeing, the genesis of this historical moment, conceptually speaking, resides in the so-called assisted readymades of Marcel Duchamp, which brought reality into art at a level theretofore unknown. Rather than being introduced as representation, reality was for the first time placed on display directly, by means of...

JANNIS KOUNELLIS: We should point out, however; that the urinal of Duchamp is placed sideways... in this way it creates a different reality.

DIACONO: It's not the object, which is why I state that it is not the readymade but rather the assisted readymade of Duchamp, that is to say, reality undergoing a value-change by means of gesture, which, as gesture, can assume great complexity.

* 1936 Piraeus, Greece / lives in Rome.

KOUNELLIS: Yes, it can carry many readings... but I'd like to tell you something: Duchamp is without doubt a person of great fascination, but it is not he who interests me.

DIACONO: I know.
KOUNELLIS: Picasso interests me, because he succeeds in modifying and giving shape to reality.

DIACONO: But I would say also that, knowing your work as I do, in order to build a genealogy, that for you modern art begins with a duality, Munch and Cezanne, then continues with another duality which in my view is Picasso and Mondrian; then, just when you debarked as an artist, occurs another duality: Burri and Fontana on one hand, Rauschenberg and Johns on the other. From the beginning, you formally chose duality... the line coming from Cezanne, Mondrian, Johns, the formalist point of view, but, from the point of view of art ideology, you felt the impact of the lineage of Munch, Picasso and Pollock as the more truly present force. Yet formally, that which had liberated the language for you as for others, independent of its cultural figure, was the way in which Duchamp ruptured the rapport between art and reality by means of the object.
KOUNELLIS: That's true; what you're saying has some basis; above all because Pollock no longer made easel painting, so there is a completely different dimension... When Pollock says: I'm inside, not outside, the painting, he's speaking about the end of the world of tonality; his is a participation, a clean break with the representational... easel... painting; he finds himself in front of another reality, this reality. That was a time of great discovery for us all, and if you remember, in the beginning, the paintings I was making with letters... they were made on the wall, with Kentong, and they had an adhesion to the wall.

DIACONO: So the canvas in that period...
KOUNELLIS: ...was a metaphor for the wall.

DIACONO: As if you were painting on the dimensions of space, not of the canvas.
KOUNELLIS: Not the canvas. That was the new element. For this reason I continue to believe this period was a true beginning, of a rapport, a rapport with space... part of a rapport which I kept up afterwards; that is, going from the wall to the window... it is the same code.

DIACONO: If the window throws you outward, the wall throws you inward.
KOUNELLIS: Exactly. But the thing is the same: door; wall... always inside a cavity which is space and which permits you to station a work. The clas-

sical painter never knew this problem... his intentions were other... but, at the time of this beginning, Duchamp was not present.

DIACONO: In my view, however, the Sixties' interpretation of Duchamp's work was there.
KOUNELLIS: ...by way of Rauschenberg...

DIACONO: By way of Johns above all, but even through Pollock in some way, since...
KOUNELLIS: Pollock was in contrast.

DIACONO: That's it Pollock pointed the new direction for art, toward a new reality introduced by Duchamp... he contributed that consciential element missing in Duchamp.
KOUNELLIS: Yes.

DIACONO: So in this sense, Pollock is just as indispensible as Duchamp.
KOUNELLIS: Also, because he introduces an element which Duchamp wanted to do away with, that is, dramaticality. That's why I mention Picasso, because this dramatic sense comes to Pollock straight from Picasso... which then... seems to become, in our latest period of crisis... an element of strength.

DIACONO: But there's this fundamental divergence, that the interpretation of Duchamp during the Fifties functioned first and foremost in American art - Johns, then Warhol; then Koons; now this latest Englishman, Damien Hirst... there continues the interpretation of Duchamp started in America.. In Europe, paradoxically, it's the heritage of Pollock that continues while being absent in America itself. But speaking specifically of your work it follows lines travelling from Munch to Pollock, but with respect to the work of Manzoni or indeed Klein, your work begins also with an adhesion to reality already somewhat impregnated by America, while I cite Klein or indeed Manzoni because the anthropologies of Klein and the achromics of Manzoni are trully contemporary to your first letter painting.
KOUNELLIS: Remember, the last time we met we spoke with friends about Fontana, about when he was selling paintings made on standard store-bought canvases... canvases of standard Impressionist measurements.

DIACONO: Burri also sold paintings on those store-bought canvases.
KOUNELLIS: It's important to see what this is, this clean cut on the one hand, and on the other a painting that's Impressionist in measurements; Van Gogh possesses a true coherence through figuration, but Fontana,

no... his is an Impressionist painting, and over it there is a cut... it's v
strange, and it is also something that grates, incoherent, but grating: I
say it's a contradiction... it's not the monochrome of Klein, it is far m
dramatic, more lively. But the space remains relatively anchored to ea
painting, and this the knife does not justify... the violent gestuality on a t
ically Impressionist stretched canvas. Pollock meanwhile is a whole ot
matter.. epic... the founder of the American language... seen for the f
time in a space which embraces everything at once. For this reason, i
epic. With a finality, however: the creation of a new and unique rea
That's it: Fontana does not confront the problem... whereas we w
thinking along the same lines as Pollock. I never needed to produce arti
shit... I have great esteem for Manzoni, but that was not my problem.
this to cast a stone in favor of Pollock and to say, also, that with Pop
a grand and liberating process was interrupted.

DIACONO: No one recalls that your letters stand in time contempora
ous with Manzoni's artist shit.
KOUNELLIS: Yes, exactly.

DIACONO: However, the difference is that conceptually, artist's shit sees
most no development whatsoever, while on the other hand...
KOUNELLIS: It's like a comic: descriptive, while from the letters came fo
a development. Manzoni's origins are in the Thirties, mine are an intuit
of depth and remain such from that period on. I remember Mafai say
something out of the ordinary. He was speaking of this post-post-po
war period, and it was at the end of the Fifties that I heard it from h
Forty years later and the post-war period is not over. In fact, the Be
Wall falling enthralled everyone, but no one mentions that we had hac
live all those years in a prolonged post-war which produced penalti
produced stunted artists... they wanted it that way... not that the art
were stunted... truly dramatic conditions... and out of this I came to
the importance of drama, of this idea of drama and the idea of shad
when everything around me grinds to homogeneity, drama remains a pe
erful structural factor.

DIACONO: Yes.
KOUNELLIS: While weakness gains apologies all around, I've never give
a thought, because I recognize it as pure foolishness, leading to negativi
succeed or fail, one cannot identify with weakness.

DIACONO: Don't you think we can finally say, after fifty years, that eve
thing we are doing, looking back now, was born in the first ten years
this century, but we are in fact the consequence of Fifties culture, that

Fifties condition us culturally, influence us, guide and orient everything we do today.

KOUNELLIS: Yes, but the whys and wherefores of a culture must be placed in perspective. Who knows... Rossellini's first films were truly, objectively incisive.

DIACONO: When I say the Fifties, the Fifties begin in forty-five, not in 1950.

KOUNELLIS: That's our problem precisely: the post-war; the losing of the war creates a figuration of a most particular nature, not third-world by any means, it refigurated poverty but was not third-world...

DIACONO: Because neo-realist poverty isn't historical poverty, but the result of depression...

KOUNELLIS: ...of civilization's fall... a constant drama running from the lack of goodwill to the decline of values, to the loss of identity... which is vast... from Masaccio to barocco, all no longer finding an interpretive reality, the lost thread of discourse: intuition, banishing confines, metabolizing and re-presenting it in full integrity and putting in play these multiplicities of identity so profoundly anchored to values, the willingness to comprehend the other; in which the verity of the other is discovered... wherein above all, in European painting, one resembles the other. Everyone had a painting different from the other, yet so similar... all analyses begin there, and as for Duchamp, he seems to me today as he seemed to me before, always too intelligent.

DIACONO: When speaking of Duchamp we never mention works so much as deeds.

KOUNELLIS: Yes, he's extremely intelligent, grand bourgeois, but we haven 't even got a bourgeoisie... the fascination is understandable, the possibilities of these things, it is part of our history but we need something, even for an instant, that recounts this enormous drama we carry on our shoulders, a drama of enormous loss, and from which can come a rich and fertile world out of this graveyard without end.

DIACONO: Yes, but the Fifties succeeded in giving expression to this drama There were two camps in art during the Fifties, while today there are no longer two camps, unlike the Fifties.

KOUNELLIS: There was a dual system in the Fifties: two blocs, two positions, a dialectic, and clearly many things have changed, but new possibilities emerge, and we need time to make out the new boundaries, but the new figuration will be different. Thus I believe that the various cultural monopolies of the Fifties and Sixties are extinguished and demodé today.

DIACONO: Yes. The Fifties saw a regressive political camp and more or less without wanting to, it was linked to the emergence of mass culture. There was another way to make art that, by its very nature, refused to subject itself to the yoke of mass culture's rules, and this to me was the path of Klein, Manzoni, and your own.

KOUNELLIS: Yes, many artists formed during that time lacked on-going analysis of the conditions of the time... artistic illuminations existed, bolts of lightning, profound, extremely incisive, but often lacking continuity.

DIACONO: Earlier we were speaking of music, the musical analysis Adorno made in "The Aging of Modern Music". Music, too, failed to contribute in any way to this type of analysis.

KOUNELLIS: A different type of man was required... another position. The circumstances of his retreat will condition the visions of the hermit. Each person must decide whether to go into refuge here, or to choose a life of intrigue and adventure, diversely incisive, elsewhere.

DIACONO: The whole problem, don't you think, stems from the fact that today there is no time. No time for creation of tradition, and lacking a tradition all notion of reference points goes by the wayside...

KOUNELLIS: Yes, that's what we said before regarding the Fifties: such a great level of desperation was established that it became the beginning of a tradition... and this is not lost. The weakening of centers impells you to work to exhibit, to live in a wider circle, and much energy is required in order not to lose the sense of center.

DIACONO: Yet a tradition, how to put it, a tradition in negative, a tradition coming out of the dawning of desperation, rather than the...

KOUNELLIS: But the Capriccios of Goya became a desperation without precedent; no one would say they were negative because there is a force in this artist that transforms everything into positive terms.

DIACONO: But for this reason, given his desperation, Goya establishes no tradition, while Manet, unaflicted by a sense of desperation but possessing a construction, creates a tradition.

KOUNELLIS: That's hard to say, because the black paintings of Goya go right up to Guernica.

DIACONO: They become tradition by means of discontinuity, a leap of seventy years...

KOUNELLIS: Bringing painting in one flash to an unknown peak which is the tradition of all modernity. The liberalism of Goya is the true liberal tradition, thus also that of Manet.

DIACONO: Because I believe that Goya of the black paintings lends an intellectual point of view... he is already beyond, as you say, already beyond Manet, already actually meeting up with...
KOUNELLIS: ...Manet with the Olympia is redoing Goya of the Maya desnuda, and...

DIACONO: ...meeting up with the Demoiselles d'Avignon, not with Manet, so that Manet in that sense... is already before Goya.
KOUNELLIS: Manet is an atmosphere, but he resembles early Goya, since the minute you take away the atmosphere you immediately find Goya... Manet does not constitute a tradition, because he at all times is grounded in the tradition of Goya... the Olympia, the Execution, do not interrupt it.

DIACONO: All right, but the point I want you to get at, not at a definition, but... a point of reference, as to what degree all of your work, in some way formally an opposition to the tradition of painting when you speak of your references, you always refer back, essentially to the dramatic moments of painting and not to the dramatic moments of the non-pictoral, that is, you do not refer to Duchamp or to sculpture or to the object, you make a work absent of painting, yet inside your work all the references to tradition with a capital T to which you refer are references to painting.
KOUNELLIS: In effect, I have always called myself a painter, but while during Futurism there were modernist motivations, in my condition of post-war man I have only a reconstruction plan in front of me, to reform language in order to be able to speak and this has nothing at all to do with modernism. This is why tradition is for me of utmost importance.

DIACONO: Even if today, historically speaking, your work comes to be placed under the aesthetic of arte povera, yet in this sense your work has no relation with arte povera, since arte povera is founded on the object, on the sculptural tradition.
KOUNELLIS: The experience of those years was not tied to the object; this is the diversity of the Duchampian ocean.

DIACONO: At no time does arte povera speak of painting, it speaks of some other thing, never of painting as a reference point, considered as no longer efficient, efficacious, but of which you can nonetheless say: my work is the way it is because the painted canvas as it has been made up to now no longer functions. In my opinion this is not the premise underlying the work of the other artists...
KOUNELLIS: One-hundred pounds of coal in the corner of a room is not an object; it represents a divergence from traditional sculpture, and it is irrevocably connected to the space surrounding it.

DIACONO: Yes. Among your contemporaries you hold that there is no one who, how shall I put it, returning, of whom... implicitly or indirectly, with regard to painting methodology... it might be said that they have continued to push ahead... I do not say always, I do not say tendentially, but for a moment, the idea that the canvas could still function as the spokesman of our drama...

KOUNELLIS: I don't know, I 've always distinguished between painting and fresco. The fresco offered in those initial years a way out for painting, connecting art to architecture and to the public... to make or not to make a painting, at any rate, does not matter, and the level of utopia and vertiginous verticality are the only goal posts and this, in the end, is the prerogative of the artist.

DIACONO: This morning, purely by accident, I entered for probably the fiftieth time the church of San Luigi dei Francesi, to see...

KOUNELLIS: The Caravaggios.

DIACONO: ...three paintings by Caravaggio, and never before did they appear so splendid, so perfect...

KOUNELLIS: ...as now...

DIACONO: ...as seen for the fiftieth time, these paintings have the dimension you mention, almost a metaphor for the fresco, though on canvas...

KOUNELLIS: ...which doesn't matter.

DIACONO: ...it doesn't matter...

KOUNELLIS: Yes, but the fresco implies not only application of color on the wall, it has to do also with the dimension and the support of architecture, an image taking form within confines which architecture offers and which the painter finds assigned to him there, by accident.

DIACONO: ...Yes, but I'm thinking that when you say a pile of coal placed in a room has the physical weight of a painting in fresco, the last painting of those dimensions which would come to my mind is that of Caravaggio.

KOUNELLIS: Of course, because it's more realistic, because there are details, the feet for example... neither realism nor naturalism, it is an ideology counter-reformationist if you like, expressed there in an explicit manner.

DIACONO: Yes. The Caravaggios are really like a room, and the men a bunch of men in the corner of a room. That is, the space is a physical space, although represented illusionistically.

KOUNELLIS: Yes, the shadows heighten the physicality. It is present as value

and as perspective of a new imaginary dimension which comes down to us today and gives strength to those who believe that flat color leads to a summary definition and to pragmatism.

DIACONO: The point I want to make is, by comparing a coal-pile in a room to a fresco you were thinking of the dimensions of your work not along the same lines as, say, the Seicento onward, but rather as connected to the dimensions of painting from 1400 to 1600 in which the fresco was truly the essential point of reference from Piero to the Sistine Chapel...
KOUNELLIS: Connected to a public space, to a theater, to the church with its power, and ideology.

DIACONO: So, Jannis, I'd like to rekindle this rapport of yours, the idea of painting, in the sense that from the internal content of the work you set out to arrive at a way of making painting that comes down to us as you say from the black paintings of Goya to the canvases of Pollock while the position of the painting to yourself or to the society around you, in a certain sense, for you, the point of reference is the mural painting of the Quattrocento and of the Cinquecento.
KOUNELLIS: Yes, for me this condition of painting is everything, while at the same time I love Munch, who never painted a mural in his life.

DIACONO: Yet Munch stands somewhere within that span of tradition extending from the black paintings down to Pollock.

Mario Diacono is a writer and art critic; he lives in Boston.

The interview was published in the catalogue, Jannis Kounellis, Castelluccio di Pienza, 1996.

Joseph Kosuth* regards the creative process as a method of objectifying and de-mystifying art. How does an artwork function? In his quest for the meaning of art, Kosuth takes up paradigms from linguistics and philosophy. He applies linguistic models to art in a dual approach - employing language as the basic formal material of his work in art and at the same time describing, with reference to Wittgenstein's philosophical analyses of language, the mechanisms that both open and determine access to the meaning of art.

Kosuth couples his methodical search with extensive research into systems of thinking in the humanities and social sciences, exploring the vocabulary of great thinkers such as Ludwig Wittgenstein, Sigmund Freud and Walter Benjamin and collecting their remarks, aphorisms and statements. He incorporates quotes from this inexhaustible source of knowledge in his room installations. Texts are applied to walls and fragmented further through the overpainting of specific passages. In this way, the pure text is modified and becomes an image whose meaning is derived from the juxtaposition of spatial, linguistic and pictorial components. (G.D.)

Joseph Kosuth
Between the Dream and Ideology
Four Random Comments

Random Comment # 1: (from) Writing And The Play Of Art

> History cannot be more certain than when he who
> creates the things also narrates them.
> Giovambattista Vico

Two recent installations of mine, "The Play of the Unsayable" at the Vienna Secession and the Palais des Beaux Arts in Brussels for the Wittgenstein centennial, and "The Play of the Unmentionable" for the Brooklyn Museum in New York, among other aspects, had the intention of disrupting the habituated, institutionalized approach to the exhibition format. I am not an art historian, nor am I a curator. But since I began as an artist I have felt that the material of an artist is meaning, (if only its cancellation) not forms or colours, so more than anything else, my material has been the context itself. When the Vienna Secession invited

* 1945 Toledo, Ohio / lives in New York and Ghent.

me to do the Wittgenstein show, they made the point that the Secession is perhaps the only museum in the world run by artists. They told me that they felt that it would be most appropriate if such an exhibition would be organized not by an art historian or a philosopher, but by an artist. It was from this point of view that I began to consider what the difference was if an exhibition is a work of art itself. The primary difference is that the artist, due to the nature of the activity, takes subjective responsibility for the "surplus" meaning that the show itself adds to the work presented in it. Traditionally, the art historian's practice involves objectifying what is basically a subjective activity, by masking it with a pseudo-scientific veneer. While scholarship has a role to play in the assessment of older works, the closer one gets to contemporary art the more the need arises for an informed understanding rather than such "objectivity". The role, in fact, played by the latter pretense is to create a history by authoritative voice. Such a "voice", articulated in the construction of a cultural *Autobahn* of "masterpieces", tends in the end to glorify a particular cultural history, and by extension, a particular social order. What the public experiences from this sort of "surplus" meaning is more often authority itself, with the result that viewers are depoliticized as they are distanced from the meaning making process in the cultural act of looking.

My agenda in organizing the Wittgenstein show was neither to "craft" history nor promulgate an historical vision. On the contrary, the viewer was invited to participate with me in a consideration of the meaning my juxtapositions produced. I neither masked the event of my juxtaposition (or my role in doing it), nor made claims of validity, value or importance pertaining to the integrity of the individual works used in my installation. But in viewing the relation between works, in a context of meaning constructed by me, the viewer is invited to *participate* in the meaning-making process, and in doing so begins to understand and experience the process of art itself. Rather than usurping the integrity of individual works, I was told by many viewers of both the Wittgenstein show and the Brooklyn show that seeing works employed as I did in such installations articulated difference in such a way as to make the works more visible, not less. In such a context, work unfettered from being signposts of authority is seen as the residue of an artist's thinking and as more accessible. The viewer gets a sense of how art is made and how artists think. My work, that "surplus" meaning of the choice of works and their form of presentation - all that which goes into that installation - is not unlike a writer's claim of authorship to a paragraph, comprised as it always is of words invented by others.

In the introduction to the Wittgenstein show I make the following statement: One question remains unsaid: What is this text? This text owes

its existence to the parentheses of my practice as an artist. This text speaks from the first and last. While philosophy would want to speak of the world, it would need to speak of art as part of that, if only to deny it. That which permits art to be seen as part of the world also nominates it as an event in social and cultural space. No matter what actual form the activity of art takes, its history gives it a concrete presence. Framed by such a presence then, this theory is engaged as part of a practice. Such theory I'll call primary. Secondary theory may be no less useful (in many cases more useful) but the point I'm stressing is that it has a different ontology. Primary theory is no more interesting than the practice, in toto, is. However, theory is linked to an art practice is unconcretised (or unfertilized) conversation after (or before) the fact. It is the fact of an artistic process which, having a location as an event, permits the social and cultural weight of a presence independent of a pragmatic language. It is, in fact, the nominated presence of the process which allows secondary theory its external object to be discussed. Secondary theory, like philosophy in general, ultimately locates itself as an activity which attempts to explain the world that the external presence represents. It may be theory discussing theory, but the discussion of secondary theory always presumes the location of its subject, at some level, as having linkage to the world. Behind every text about art rests the possibility of an artwork, if not the presence of one.

Texts about artworks are experienced differently than texts that are artworks. It is abundantly clear by now, that we do not need to have an object to have an artwork, but we must have a difference in the play manifested in order to have it seen. That difference which separates an artwork from a conversation also separates, fundamentally, primary theory from secondary theory. The work of art is essentially a play within the meaning system of art; it is formed as that play and cannot be separated from it - this also means, however, that a change in its formation/representation is meaningful only insofar as it effects its play. My point is that primary theory is part of that play, the two are inseparably linked. This is not a claim that the commentary of secondary theory can make. Talking about art is a parallel activity to making art, but without feet it is providing meaning without an event context that socially commits subjective responsibility for consciousness produced (making a world). Standing guard, just out of sight, is the detached priority of an implied objective science.

One can perhaps, as well, understand the texture of the difference I am referring to between primary and secondary texts and secondary texts in the way primary texts are treated by secondary texts. I am considering here the treatment of artists' writings by art critics and historians. Be-

neath the often condescending special status such texts are given (used, like artworks are, as nature for the historians and critics to make culture from) there lurks a kind of philosophical unease, as though this sleeping Dracula may awaken, daylight or not, a professional stake through his heart or not, and ravage their countryside. (Well, here we are).

Random Comment # 2: Failing And Testing

> The eye of the intellect sees in all objects what is brought with it the means of seeing
>
> Thomas Carlyle

Whatever one would want to say about that project called Conceptual art, begun nearly 30 years ago, it is clear now that what we wanted was based on a contradiction, even if a sublime one. We wanted the *act* of art to have integrity (I discussed it in terms of "tautology" at the time) and we wanted it untethered to a prescriptive formal self conception. Paul Engelman, a close friend of Ludwig Wittgenstein and the collaborator with him on the house for Wittgenstein's sister, has commented about tautologies that they are not "a meaningful proposition (i.e. one with a content): yet it can be an indispensable intellectual device, an instrument that can help us - if used correctly in grasping reality, that is in grasping facts - to arrive at insights difficult or impossible to attain by other means". What such questioning directed us toward, of course, was not the construction of a theory of art with a static depiction (a map of an internal world which *illustrates*) but, rather, one which presumed the artist as an active agent concerned with meaning; that is, the work of art as a *test*. It is this concept of art as a test, rather than an illustration, which remains. What, then is the contradiction? It is as follows. How can art remain a "test" and still maintain an *identity* as art, that is, continue a relationship with the history of the activity without which it is severed from the community of "believers" which gives it human meaning? It is this difficulty of the project which constituted both its "failure" - as Terry Atkinson has written about so well - as well as the continuing relevance of the project to ongoing art production. It would be difficult to deny that out of the "failure" of Conceptual art emerged a redefined practice of art. Whatever hermeneutic we employ in our approach to the "tests" of art, the early ones as well as the recent ones, that alteration in terms of how we make meaning of those "tests" is itself the description of a different practice of art than what preceded it. That is not to say that the project did not proceed without paradox.

Can one initiate a practice (of anything) without implying, particularly if it sticks, as having a teleology? Even at the end of modernism a continuum is suggested, this is one of the ways in which its success constituted its failure. What it had to say, even as a "failure", still continued to be art. The paradox, of course, is that the ongoing cultural life of this art consisted of two parts which both constituted its origins, as well as remained - even to this day - antagonistic towards each other. The "success" of this project (it was, in fact, believed as art) was obliged to transform it in equal proportion to its "success" within precisely those terms from which it had disassociated itself from the practice of art previously constituted. Within this contradiction one is able to see, not unlike a silhouette, the defining characteristic of the project itself: its "positive" program remains manifest there within its "failure", as a usable potential. One test simply awaits the next test, since a test cannot attempt to be a masterpiece which depicts the totality of the world; indeed, it is only over the course of time that the process of a practice can make the claim of describing more than the specific integrity of its agenda. It is such work, like any work, located within a community which gives its meaning as it limits that meaning.

What is the character of such "tests"? As Wittgenstein put it: "In mathematics and logic, process and result are equivalent". The same I would maintain, can be said of art. I have written elsewhere that the world of art is essentially a *play* within the meaning system of art. As that "play" receives its meaning from the system, that system is - potentially - altered by the difference of that particular *play*. Since really *anything* can be nominated as the element in such a play (and appear, then, as the "material" of the work) the actual location of the work must be seen elsewhere, as the point or gap where the production of meaning takes place. In art how and why collapse into each other as the same sphere of production: the realm of meaning.

As for the project of Conceptual art, we know that what is "different" doesn't stay different for long if it succeeds, which is perhaps another description of the terms of its "failure". Thus the relative effectiveness of this practice of art was dependent on those practices of individuals capable of maintaining a sufficiently transformatory process within which "difference" could be maintained. Unfortunately practices begun in the past are subject to an over-determined view of art history whose presumptions are exclusive to the practice of art outlined here. The traditional scope of art historicizing - that is, as a style, and attributed to specific individuals - is most comfortable limiting itself to perceived early moments which are then dated and finalized. While such "credits" make sense emotionally for the individuals concerned, we've seen where it stops the conversation just where it should begin. In actual fact, the con-

tinued "tests" of the original practitioners should be considered on their own merit along with the tests of other generations, insofar as all are relevant to and comprising their own part of the social moment".

Random Comment # 3: 'Not Only To Prolong Our Sleep'

In his book "The Sublime Object of Ideology", Slavoj Zizek discusses the well known dream about the "burning child", from which I will quote at length. It begins with the dream...

A father had been watching beside his child's sickbed for days and nights on end. After the child had died, he went into the next room to lie down, but left the door open so that he could see from his bedroom into the room in which his child's body was laid out, with tall candles standing around it. An old man had been engaged to keep watch over it, and sat beside the body murmuring prayers. After a few hours' sleep, the father had a dream that his child was standing beside his bed, caught him by the arm and whispered to him reproachfully: "Father, don't you see I am burning?" He woke up, noticed a bright glare of light from the next room, hurried into it and found the old watchman had dropped off to sleep and that the wrappings and one of the arms of his beloved child's dead body had been burned by a lighted candle that had fallen on them.

The usual interpretation of this dream is based on the thesis that one of the functions of the dream is to enable the dreamer to prolong his sleep. The sleeper is suddenly exposed to an exterior irritation, a stimulus coming from reality (the ringing of an alarm clock, knocking on the door or, in this case the smell of smoke), and to prolong his sleep he quickly, on the spot, constructs a dream: a little scene, a small story, which includes this irritating element. However, the external irritation soon becomes too strong an the subject is awakened.

The Lacanian reading is directly opposed to this. The subject does not awake himself when the external irritation becomes too strong; the logic of his awakening is quite different. First he constructs a dream, a story which enables him to prolong his sleep, to avoid awakening into reality. But the thing that he encounters in the dream, the reality of his desire, the Lacanian Real - in our case, the reality of the child's reproach to this father, "Can't you see that I am burning?", implying the father's fundamental guilt - is more terrifying than so-called external reality itself, and that is why he awakens: to escape the Real of his desire, which announces itself in the terrifying dream. He escapes into so called reality to be able to continue to sleep, to maintain his blindness, to elude awakening into the real of his desire. We can rephrase here the old "hippie" motto of the 1960s: reality is for those who cannot support the

dream. "Reality" is a fantasy construction which enables us to mask the Real of our desire.

It is exactly the same with ideology. Ideology is not a dreamlike illusion that we build to escape insupportable reality; in its basic dimension it is a fantasy construction which serves as a support for our "reality" itself: an "illusion" which structures our effective, real social relations and thereby masks some insupportable, real impossible kernel... The function of ideology is not to offer us a point of escape from our reality but to offer us the social reality itself as an escape from some traumatic, real kernel.

What some have approached as myth and Zizek (through Lacan) utilizes as a dream, can function, for us as well, as a way to re-think the question of art and ideology. Our mythic inheritance of a tradition of art, those surfaces which endlessly replicate themselves in the market, have a tale to teach. What Benjamin called "the unique phenomenon of a distance however close it may be" constructs a fiction which continues to hold the belief of many. The belief of this system (they are in a cluster, they overlap, complement and complete each other) in order to function, assert that the value of art, and that is to say its meaning, is somehow *in the goods*, in the physical manifestation of the work. What I want to do here is to take Zizek's point about the relationship between "reality" and the dream. Let us stretch this argument dangerously and consider, for a moment, art as a kind of societal "dream" within which the artist, taking from that horizon of mass culture within which all of our consciousness is produced, makes visible that which "reality" must mask. The task for the artist, then, is to connect the work in some important way to that aspect of reality which is concrete, yet, at the same time, not embed the work there so completely that one simply participates in the weaving of that "reality". The ideological function of art is operating when the social reality itself is presented by that work as unproblematic, as a kind of mirror. In such a way art celebrates and validates, as it entertains.

Limited as it was in some regards, the "tautology" was a useful device in blocking the "mirror effect" which can compromise works which utilize elements from daily life (even if it was language) and do so without telegraphing the knowledge that it was art to the viewer based on the choice of morphology or media. The descriptive role of art was put into disequilibrium: one could construct "a picture of relations" (even if dynamic or contingent) and use it as a "test" by putting it into play within the meaning-system of art. Such a work proved not to be an illustration but a *demonstration* and in so doing told us some things about art and culture, and the function and role of both in society.

Is the crisis of meaning in society now reflected in the present conflict over the future role of art another way of seeing its manifestation as being either "dream" or ideology? Try to overcome momentarily one's dissatisfaction with the terms and consider what the ideological package of art consists of. Without an "endpoint" - even a theoretical one - one cannot organize meaning within a hierarchy of significance. And, as we know, it is the promise of progress which has given the "avant garde" its role within modernism. This an another way of saying, of course, that the world of formal invention, painted windows and artistic supermen depends on *belief* (it operates from metaphysics) and *authority* (the "goods" emanate with power-economics, and otherwise). The point of all of this would be hopelessly lost if one cannot release that conventional view of art, which begins with misunderstanding the role of the object. Understandably some of this has been inherited from art's earlier association with handicraft, with its labour intensive appeal to value. Art's earlier role within religious belief and its more recent manifestation of its appeal to the dynamic of market force to establish "quality" along the very same axis, is all part of the ideological package of the ongoing dominant belief system of art. Needless to say, this has been little affected by the fall of the Berlin wall. Indeed, this shift in our presumptions about art evolved in the east only somewhat later than in the west, but that shared the character of being an alternative cultural activity - in the west as part of liberal tolerance, in the east it took place outside of official history. The cultural life which it shared is instructive, however: both because a critique against a not dissimilar orthodoxy of formal authority within artistic practice.

A main theme, within modernism, has been the mythic one of expression. The web of belief around certain objects, under the name of Expressionism, of course, fulfils several needs. But as for "expression" itself, its instituzionalization in the more recent past into Expressionism created a paradox of impersonal *generalized* marks intended to celebrate the personal. The signifying role of auratic relicry which we inherited from Christian ritual found another cultural life in the market, but ritual without religion is simply a stage for authority, albeit in the guise of "quality". *Of course* art is a form of expression, what else could it be? Such a truth is truistic, however, and we can thank Expressionism for how "expressive" all the work now looks which was once called anything but. We know now what Expressionism was expressing: Expressionism. What can really be said about expression itself, as a generalization, once it is in the work? If it is not a generalization, but specific, then it has a kind of functional "content" which is part of the work's *play*, with no role as "expression" per se. The conditions of meaning which the works establishes are projected, always, on their *own* terms.

Indeed, it is in the establishing of those terms where the work's relation with the world is articulated. Without that "world" the terms would be meaningless, a private language. This is the juncture at which either the "dream" speaks the artist, or the "mask of ideology" makes its provision with the world.

It would be an error, to draw wide political conclusions from the analogy applied here. The usefulness of my arguments in this instance remain to be seen. I do maintain, nonetheless, that an effect of truth, an insight, can be had from a discourse, which, in itself, need not to be considered either false or true. The elements I use in the production of theory are similarly contingent upon the elements I use in the rest of my work, indeed, they inform each other.

Yet, whether or not one is ambivalent toward a conceptualization, a universe, in which the notion of ideology has a role to play, one thing remains unchallenged, that the grand political experiments of the 20th century have failed has no bearing on our assessment of the real conditions of *our* society. The limits on political freedom and lived reality of inequality must still be seen as problematically compatible with modern liberal society. This fact alone puts an obligation on all of us to work toward the avoidance of a naturalization of the status quo, with the marriage of a regnant science to an economic mechanism which has no internal constraints, nor, for that matter, a human face. This situation is all the more fraught with danger with the passing of Late Capital's failed historic alternative.

Can art evolve into an activity more serious than being expensive neckties for over the sofa? Certainly the foundation is there and the potential of its role already articulated by this point in the 20th century. But it will take a further, and a more radical, re-conceptualization of the practice of art by artists if it is to happen. In the elliptical course of its making *itself* visible, the process of art shows us the world. Artists must use that knowledge if they are to effect that world.

Random Comment # 4: 'Say It Again'
(from my introduction to The Play Of the Unsayable 1989)

The desire to understand cultural information, and particularly art, in relation to language is the initial foundation to actualize a Wittgensteinian insight: drawing out the relation of art to language began the production of a language whose very function it was to *show*, rather than *say*. Such artworks function in a way which circumvents significantly much of what limits language. Art, it has been argued, *describes* reality. But, unlike language, artworks it can also be argued simultaneously *describe* how

they describe it. Granted, art can be seen here as self-referential, but importantly, not *meaninglessly* self-referential. What art shows is such manifestation is, indeed, *how* it functions. This is best revealed in works which feign to *say*, but do so as an art proposition and reveal the difference (while showing their similarity) with language. This was, of course, the role of language in my work beginning in 1965. It seemed to me that if language *itself* could be used to function as an artwork, then that difference would bare the device of art's language game. An artwork then, as such a *double* mask, provided the possibility of not just a reflection on itself, but an indirect *double* reflection on the nature of language, through art, to culture itself. "*Do not forget*", writes Wittgenstein, *that a poem, even though it is composed in the language of information is not used in the language-game of giving information*".

Speech of Joseph Kosuth at the Symposium "The Museum of Contemporary Art between East and West", Kunst-und Ausstellungshalle der Bundesrepublik Deutschland, Bonn, January 1994.

The installation entitled "New Structures" (1995) consists of a rectilinear grid of wall constructed from concrete cinder blocks. The gigantic, room-sized structures underscore the power of architectural stagecraft. Over three decades, Sol Lewitt has consistently pursued an aesthetic position at the crossroads of art and architecture, of art and public life, while developing and refining a vocabulary of images comprehensible to the viewer on the basis of his capacity to perceive spatial relationships. The concrete visible form is employed as a carrier for the realization and communication of an intuitively developed idea. With the structure of the "Open Cube" (1965) Sol Lewitt initiated a continuing series of variations of cubic grid constructions. A second focus of his work is represented in the "Wall Drawings". Forms are displayed on interior walls through isometric projection. Sequences and variations on geometric figures such as pyramids, complex forms and continuous forms enrich the spatial geometry. The "Wall Drawings" are not intended to generate spatial illusions but instead to make an objective idea perceptible. (G.D.)*

Sol Lewitt
Sol Lewitt Interviewed

INTERVIEW BY ANDREW WILSON

ANDREW WILSON: The earliest drawings in this exhibition date from 1958 and include studies of frescoes at Arezzo by Piero della Francesca. What were you trying to achieve with these works?
SOL LEWITT: When I made these drawings I had reached a low point of my art-life. I had no idea what to do. After art school and the army I had done some work in New York as a graphic designer on the lowest level. I became quickly dissatisfied with this work and wanted to return to making art, but really didn't know where to start. So I dragged out some art books and started to make drawings from them. Piero appealed to me for his sense of order, superimposed on which was a sense of passion and ritual. I found that in Velazquez too. I also did drawings from Ingres and Goya.

WILSON: In your wall drawings and elsewhere you represent solids or structures not through perspective but by isometric projection. Why is this? Is it a distrust of spatial illusion?
LEWITT: I wanted to render form but without space as much as possible.

* 1928 Hartford, Connecticut / lives in Chester, Connecticut.

Painting is an activity done on a flat surface. One lesson learnt from the fresco painters of the Quattrocento in Italy was that they had a sense of surface, of flatness where actual linear perspective was not used but a system of isometric perspective that flattened the forms. I thought that was more powerful in terms of expression and adhered to the sensibility of the idea of the flatness of the wall and the integrity of the picture plane. I have always tried to keep the depth as shallow as possible and the integrity of the wall.

WILSON: Nevertheless, I was surprised to see the way in which some of your recent wall drawings - like "#652 On three walls, continuous forms with color ink washes superimposed", 1990, or drawings in the exhibition like "Continuous Forms and Color", 1988 - had developed in articulating a play of ambiguous spatial illusion.

LEWITT: They evolved from the renderings of a cube and became more and more complex. I tried to make the forms complex but to keep them as shallow as possible. Not to make a great illusion of space.

WILSON: Your development from the drawings of 1958 (more or less traditionally figurative and representational) and your structures of 1962 and 1963 is evidence of a radical change in a very short space of time. What sparked this off?

LEWITT: At that time I had a job at the Museum of Modern Art in New York and met other artists such as Dan Flavin, Robert Mangold, Robert Ryman and Scott Burton, and the critic Lucy Lippard who also worked there. Bob Ryman and Lucy Lippard lived in my neighbourhood as did Eva Hesse and Tom Doyle. We had many talks and saw shows at MoMA as well as galleries. The discussions at that time were involved with new ways of making art, trying to reinvent the process, to regain basics, to be as objective as possible. The work of Stella and Johns, who were in a show at MoMA, ("10 Americans") about then, were of particular interest.

My thinking was involved with the problem of painting at the time: the idea of the flat surface and the integrity of the surface. By the end of the Fifties abstract expressionism had passed, it was played out. Pop art had a completely different idea. It was more involved with objects. I wasn't really that interested in objects. I was interested in ideas. Also at that time the ideas of Joseph Albers, of colour moving back and forth. While I was working at I.M. Pei I met Eva Hesse and Robert Slutzky who had studied with Albers. I decided that I would make colour or form recede and proceed in a three-dimensional way.

The idea of flatness of plane naturally evolved into three-dimensionality of form which became wall structures, at first made with colour advancing

and receding and then with only black and white, and finally as freestanding pieces.

WILSON: What did you learn from Flavin?
LEWITT: Flavin's piece, "The Nominative Three", using a progression of one, one-two, one-two-three, was an important example for me. It was one of the first system pieces I'd seen. Judd's progression pieces of that time were also very important. I began to think of systems that were finite and simple. This was the basic difference between the idea of simplifying form to become less expressive, and the idea that the form was the carrier of ideas.

WILSON: Immediately before the first structures you made works which used as their source the serial photographs of Muybridge. And yet the drawings you made showed single figures, isolated, caught. Not a sequence.
LEWITT: As with the Piero and Velazquez drawings, I knew that there was something there that was important to me but I didn't know how to use it. The idea of seriality came later: the idea that all of the parts were only the result of the basic idea, but that each individual part was equally important, and that all parts were equal - nothing hierarchical. A man running in Muybridge was the inspiration for making all the transformations of a cube within a cube, a square within a square, cube within a square, etc.

WILSON: Was it also important that Muybridge used this method as a means of finding out some form of truth, scientific truth, about movement?
LEWITT: That part wasn't as significant to me as the idea that it led to the motion picture which was the great narrative idea of our time. I thought that narration was a means of getting away from formalism: to get away from the idea of form as an end and rather to use form as a means.

WILSON: You see your serial work as forming a sort of narrative?
LEWITT: That was what it was after, yes. As the Muybridge was a narrative of a man running so the combinations of a serial work functions as a narrative also. And also each part encapsulates the entire process and whole idea.

WILSON: Another result of seriality is the creation of a degree of paradox - where a simple system yields complex results or where logic can beget absurdity - is this something you consciously aim for?
LEWITT: The price that you have to pay for following this logical system is that the more complex and absurd the result became perceptually, you would get a forest of trees where it might be almost impossible to discern the original idea.

I was very involved in writers like Samuel Beckett who were also interested in the idea of absurdity as a way out of intellectuality. Even a simple idea taken to a logical end can become chaos.

So when you go back to the wall drawing of continuous forms, you have the same sort of connection between the simplicity of a cube and the chaotic materialisation of a great deal of form. But one follows from the other, and starting with one you have to end with the other, otherwise you don't do the whole process. There is always the tension that leads to a certain ambiguity on one hand and absurdity on the other, and some of the wall drawings - the location wall drawings - were made specifically with this in mind. The more information that you give, the crazier it gets until to construct a very simple form or figure such as a circle you could have three pages of text. In a way it was an extension of the idea that prolixity created simplicity and unity.

Looking back at it now, I think it was in a way also satirising some of the more advanced conceptualists that were abounding at the time. I wasn't really involved in conceptualisation as a movement as such but I was more interested in using abstract or geometric form to generate other kinds of ideas, but not to get into the backwaters of philosophy.

WILSON: Would you also say that your work is at all concerned with metaphysics?

LEWITT: Obviously a drawing of a person is not a real person, but a drawing of a line is a real line.

WILSON: So in 1970 you also wrote that you preferred an art that was "smart enough to be dumb".

LEWITT: It is just that in a way cleverness wasn't an attribute that I admired a great deal. I felt that one should be intelligent enough to know when not to be too intellectual, or to keep things simple when things could get out of hand and be too complex. Perhaps I was talking about some of the more difficult conceptualists. But I admired, for instance, an artist like Hanne Darboven who made a great career out of using numbers and dates. You can also think of On Kawara in the same way.

WILSON: What led you to write the "Paragraphs" and "Sentences on Conceptual Art" for *Artforum*, Summer of 1967?

LEWITT: Robert Smithson managed to get *Artforum* magazine to offer some pages for artists to express their ideas. I wanted to counter the current notion of minimal art. This was being written about by critics, however I thought it missed the point because it regarded this art in a formal way rather than what I believed was more conceptual (e.g., Flavin, Stella, Judd, Andre, Bochner, Smithson).

WILSON: Recent studies of conceptual art have prioritised the position of Duchamp's ready made within the formation of conceptual art - how important to you was Duchamp's example?

LEWITT: Duchamp was making a different kind of art evolving from dada and surrealism. These forms are absolutely conceptual, but I was not interested in them. The use of the term was prior to my own.

WILSON: Given that one of the major tensions in your work exists between the idea and its embodiment in material form, can an idea that is not realised ever be more important than an idea that is? Do you ever see the making of the final object as unnecessary?

LEWITT: There are always many ideas that are never realised but are important in that they lead to other ideas that may be realised. I've always maintained in my work that there is a double focus and that the idea and the result of the idea are symbiotic and impossible to extract from one another. I never thought that if the thing existed only as an idea that it was a complete idea. I had the idea that the cycle had to be complete to be a work of art.

WILSON: But you have written before that a blind man can make art, but the visual result is important. It is what you first see.

LEWITT: No, but it came from somewhere. A blind man can make art but a blind man can't see art.

WILSON: Is there a difference of significative between, say, a wall drawing and a drawing on paper that is "for" a wall drawing?

LEWITT: They are drawings as an end in themselves, too. It's more than just documentation. Once it has fulfilled its function as a road map for making the wall drawing, it exists in itself as a drawing, as a work on paper. I think of them as being of equal importance. I think that the plan is there to be understood.

WILSON: Yet earlier you would exhibit the two together which you don't do now.

LEWITT: I use the title instead. Usually the title is the plan and explains the drawing. The title is the clue to the idea of the piece. Whereas previously I used to make drawings or diagrams to show what the idea of the piece was. Now, what I usually do is try to give a clue to the idea of the piece by means of the title.

WILSON: So when you write that "the serial artist functions merely as a clerk cataloguing the results of the premise" you make your work seem like a chore. Is it really that?

LEWITT: When an artist decides to make photographs of a man running each frame is a part (a necessary part) but only a part. But making each part could be a chore or not.

WILSON: You have said that conceptual art is good only when the idea is good. So what in your terms leads to a good idea, or a bad idea, or a banal idea?

LEWITT: In the course of your mental meanderings through the day you reject a lot of ideas that come through your mind. You do a lot of your work in the course of ordinary activities during the day and your mind either rejects or selects different ideas. You throw them out as you go along. When you finally come to something that you think is fairly interesting, then you want to do that. Maybe it is a bad or banal idea but at the time it seems good.

WILSON: Can the following of the instructions by your assistants ever lead to a wrong result? Do you ever see one of these wall drawings and think "That's been done wrongly"?

LEWITT: No, I haven't. Whatever happens wrongly is because my instructions were wrong and not because of the execution being wrong.

WILSON: Some of your earlier wall drawings - those shown at Konrad Fischer or the Dwan Galleries in 1969 - are isolated on the wall rather than occupying the whole surface. Doesn't that create a sense of hierarchy or frame between the wall and drawing?

LEWITT: "Wall Drawing #3" which I did at Konrad Fischer was a band of pencil lines that was just one metre high and went across the whole wall. I was using the whole wall rather than putting different things on the wall. Which is the idea of the space of the wall, the whole space.

WILSON: Putting different things on the wall in blocks like wall drawing "#2 Drawing Series II (A) (24 Drawings)" is a bit like...

LEWITT: Hanging paintings.

WILSON: ... or even a page layout.

LEWITT: Yes.

WILSON: And the idea for wall drawings was sparked off wasn't it from making drawings for a book, "The Xerox Book".

LEWITT: Yes that was done at the same time. These early wall drawings came from that because that is what I was doing. I had had the idea of doing drawings on walls before that but this was the actual first time. I was working on "The Xerox Book", or had finished it, and that was just

the drawing in my mind. I didn't have the idea of the whole wall, I just had the idea of putting it on the wall.

WILSON: A book is a prime example of a serial narrative structure because you are turning the pages, but you can go to any page at any time.
LEWITT: Right.

WILSON: And doesn't the book form provide a much purer distilled way of showing a serial progression of a drawing, rather than having it on the wall?
LEWITT: Maybe less so, because having it on the wall meant that you saw the whole thing at once, but with the book you only saw each one individually. That was the reason for doing "The Variations of Incomplete Open Cubes", 1914, as a book. The book is one part. There is the three-dimensional realisation, plus the drawing, plus the photograph. Then the drawing and the photograph become a book. But when all the drawings and photographs are on the wall you see the whole thing in one view.

WILSON: The creation of bookworks had been a constant preoccupation. You were, with Lucy Lippard and others, a founder of Printed Matter, to make artists' books more easily and freely available.
LEWITT: A lot of the conceptual work actually existed better in a book form than on a wall. It was really difficult to read everything that was written or to see everything that was presented on the wall. It is much easier if you are sitting at home with a book looking at part of it now and part of it tomorrow and so on and so forth.
Also the price of books was much less than a work of art. Everyone could own one and each one was actually a work of art in itself. We had the idea of Printed Matter as a vehicle to get these books into the hands of people. I had been doing books, as other artists had, but they just piled up. Usually dealers did them as part of a show and they would hand them out, but there was no central point of distribution until Printed Matter and some others, began to distribute these books.

WILSON: Do you think that art should have a social or moral purpose?
LEWITT: No. I think artists should have a social or moral purpose. But there is some art that I think is very good art that is socially, politically and morally motivated like the work of Hans Haacke, or the work of John Heartfield for instance. I think that these are very successful artists who use those ideas very well but, also, many such works are very banal even though the politics are correct.
The Sixties was one of the most art-generative times, but even though there was a political and social upheaval, the arts represented more of an

aesthetic than a political upheaval. There actually wasn't much political art being done at the time. Not nearly as much as now.

WILSON: So an involvement with the Art Workers' Coalition was more about being politicised yourself, rather than making the work political.
LEWITT: Yes.

WILSON: Is the element of installation important to you?
LEWITT: In some works.

WILSON: When you showed the 1966 works "Modular Floor Structure" and "Double Modular Cube" at the Dwan Gallery, you wrote that "although the space of the gallery was a guide to the size of the work, the pieces did not work absolutely with the space". What did you mean by this?
LEWITT: I was thinking about the difference between originating a work for a specific space on the one hand, or originating a work in the studio as a thing in itself and then putting it in its space. Or on the other hand, if you do a thing for a specific space it will always work in that space; if you do a thing for itself, it may or may not work in any given space.

WILSON: Why did you suggest that conceptual artists should be mystics?
LEWITT: I was trying to break out of the whole idea of rationality. At that time there was a great deal of geometric painting that I thought was very boring, and it was very rational.
Conceptual artists were intuitive rather than rational. In other words, to discover their idea - the main idea, the instigator of whatever it is - a leap of faith or a leap of aesthetics had to be made otherwise it was just another rational step. To avoid a rational step intuition is important.

WILSON: So is the idea synonymous with intuition?
LEWITT: Yes. Eventually one must free oneself from the restraint of dogma; intuition does this.

The interview with Sol Lewitt took place at The Museum of Modern Art, Oxford, on January 22, 1993.

Andrew Wilson is an art critic, historian and curator. He is the assistant editor of Art Monthly and lives in London.

The interview originally appeared in Art Monthly, no. 164, March 1993.

Maurizio Nannucci's works complement each other like pieces in an open-ended game whose shifting configurations are thought through and carried out in all possible variations. A progressive metamorphosis of existing images through techniques of substitution and remodeling gives the work its expansive character; any notion of hermetic completion is brushed aside. Nannucci's pluralistic approach encompasses a wide spectrum of artistic media: photography, slide projections, photo-text collages, sound recordings and broadcasts as well as neon installations. Redundancies are intentionally given a place in the oeuvre as a whole, signaling the path that Maurizio Nannucci follows in all of its consequences: the attempt to fathom the richness and subtlety of speech and script, to visualize the intersections and divergences of words and meanings. Language and writing become an extremely fluid, multi-faceted means of appropriating, interpreting and ultimately placing existing images within a circuit that flows between color, sign and signification. The meaning of the texts may be clear and definite or multiple and ambivalent; the paradox of the "possible/impossible" is the path along which the viewer is led in an exploration of the artist's luminous and poetic circuit of images. (G.D.)*

Helmut Friedel
Unexpected Thoughts

A CONVERSATION WITH MAURIZIO NANNUCCI

"Unexpected Thoughts" was the title which the artist originally suggested for the exhibition at the Lenbachhaus. The category of surprise, of the unexpected, which opposes all forms of methodological rigour, marks turning-points in the development of Maurizio Nannucci's work.
"I can't plan surprise in advance. When I stumble across it, it surprises me too. It's something I think of as possible, something I even expect, but which I leave up to change. Of course, I take various steps to make sure that it happens. When using repetition, I have always tried to activate the play of variants, in order to leave enough scope for the possibility of surprise or change. When I'm embarking on a new work, or formulating an idea, or looking at something, or simply engaged in conversation, my thoughts often start to wander in the opposite direction, suddenly standing the previous idea on its head. This habit of mind has influenced works such as "You can imagine the opposite" and "The missing poem is the

* 1939 Florence / lives in Florence and Paris.

poem", where I assert the necessity of a text by negating its presence. Poetry, for example, is evoked by declaring it to be absent. But I should also point out that the selection of the texts which I use in my work is always determined by a particular situation".

However, Nannucci also employs the principles of remembrance and repetition, which would appear to contradict this emphasis on the element of surprise. The device of repetition is a common feature of contemporary art. From the point when Duchamp abandoned art in favour of chess, his artistic "work" could be said to consist in the repetition of a single clever idea.

"Repetition is not so much a matter of always using the same materials and continually referring to "writing" and colour, but rather of memory, of consolidating an image. Before the invention of writing, repetition was used as a form of mental training, making it possible to preserve and transmit memories. This precluded the transmission of commonplaces and prevented people from attaching excessive importance to them. Commonplaces only emerge when memory becomes reflexive and gets itself trapped in a kind of vicious circle. But right now, as formulate these ideas, I realize that I myself use commonplaces, which I pick more or less deliberately out of the discourse surrounding art: by exposing them, I give them a dynamic quality and peel away their conventional meaning. A dislocation takes place which sheds a new light on them and gives them a luminescence of the own. What I mean by this is that the form of light which I use, neon strip lighting, is not autonomous: it's not independent of writing, but closely connected with it in a relationship like that of cause and effect.

As far as Duchamp is concerned, one can indeed say that there is a connection between repetition and the chessboard, if one sees chess as a game about power. The ability to use the art world like a chessboard was Duchamp's great strength, but at the same time it was the main limitation of his art Cage started out by trying to understand and exploit the secret of Duchamp's power, but later, he rebelled against it; he opposed the mechanical - and therefore repetitive - power of the chessboard through the intervention of chance, using the particular form of randomness found in the I Ching. "A further commonplace of art is the title, which is a kind of "Denkbild" or ideational picture, an "icon" of the mind. But Nannucci's aim is quite different: his titles are non definitions, reducing the inscription or, even better, cancelling it altogether.

"To me, the picture, the definition and the object are not equivalent or interchangeable. Instead, writing itself - with its own autonomous set of linguistic figures - functions as a picture. The resulting isolation produces a conflicting movement which contradicts one's own meaning. Sometimes I bring this contradiction out into the open, and sometimes I don't. Empha-

sizing the iconic value of writing enables me to use it as an alternative to other pictures or icons. It "stands in" for things, in the same way that Malevich substituted his black square for the traditional icon. But nowadays, this gesture can no longer be regarded as a radical, definitive statement, since our relationship to tradition has changed: it has lost any real sense of immediacy. All that remains is the "stand in", or what we might as well call the "inscription". By that I mean a form of writing shorn of the things that were supposed to support it and which haven't been replaced. This new status of writing introduces a degree of ambiguity into the sentences that I form: hence they are often invented at random, in the course of a game. In a certain sense, they are governed by chance and game-playing. "The example of Malevich shows that substitution opens up a new avenue, a means of access to another situation. In the case of Nannucci's art, it is the word which opens the door to the picture. The word is an integral part of his work.

"I have always used words and colour as artistic materials I think it was colour which first aroused my enthusiasm; it was only later that I became interested in words, or rather, writing. By going back to writing I have managed to repudiate, as it were, the traditional picture, i.e. the banal, realist picture. Perhaps this is the deeper meaning of the act of substitution. The aim of my work is always to express my own ideas and thoughts. If I have to take images from reality, I modify them with the help of certain artistic tricks. So in addition to substitution, I employ inversion and adaptation. All these procedures are eminently suited for use in connection with words and writing. The fluorescent colour of the neon light supplies a further metaphor. It becomes an integral element in the writing, which is not only a collection of words but also the material through which I express myself. Neverthless, in a different respect, colour remains a primary fact. It is, after all, the first thing the viewer notices: if you look at one of the installations, the first thing you see is the colours and the way they are arranged, and it's only when you've taken those features in that you read the inscriptions. So colour fulfils a dual function".

As far as colour is concerned, the modalities of selection have changed in the course of Nannucci's artistic development. In a number of his early works, colour simply expresses itself as colour, as the fulfilment of colour tout court: one thinks, for example, of inscriptions such as. "This side is red, yellow, blue" or "Something of red, something of blue".

"I have always been interested in the possible definitions of colour. Maybe this is precisely because of my conviction that of all the human senses, the sense of colour is the hardest to pin down. It's difficult to produce a univocal reading of a chromatic sign, because colour is an event which takes place on two separate levels: the symbolic and the sensual. A single colour can mean a wide variety of different things, depending on place or situa-

tion. A single name often encompasses a large number of chromatic variants: the term "blue", for example, can be applied to a broad spectrum of different tones. In paint manufacturers' catalogues one finds an immense range of chromatic variation. I think that one's choice of colour is a very subjective thing: perhaps this is even true colour itself. The selection is entirely autonomous, even where the artist is willing to provide continual explanations. Take this catalogue, which will be red, yellow and blue. Blue and yellow for example are the colours of sand and water, the biblical, cabbalistic colours of the rock from which the water gushed forth when Moses smote it with his staff. But blue and yellow are also the colours of night and of the electric light which brightens the darkness; they are the colors of Van Gogh. So there's a whole series of connotations and allusions that I find intriguing and which undoubtedly influenced my decision to use these two particular colours - but no explanation of such decisions could ever be entirely comprehensive".

Working with words opens up still further possibilities. For example, there was the project entitled "Parole", which involved stopping passers-by on the streets in Florence and asking them to speak a single word. By stringing the words together, Nannucci composed a highly resonant street poem. In this case, the substitution takes place via a phonetic image.

"The variations of intonation produce a certain kind of colour. As far as the underlying intention is concerned, "Parole", like "Sessanta verdi naturali", is a work about colour. When it was completed, it was a work dealing with the entire range of the human voice, just as "Sessanta verdi naturali" explored the range of tonal variations in the colour green. The effect was like listening to a single person speaking in sixty different shades of intonation in the case of "Parole" there was an additional aspect which you don't see in the neon installations but which has a certain significance in a number of other works: the idea of collecting or compiling, i.e. the aim of completely exhausting the possibilities of a concept or category such as "green" or "resonance" by amassing a large number of examples or models. It's an experiment which is obviously doomed to fail, but which allows me to keep a work 'open' over a considerable period of time. This sense of openness is something I find absolutely essential. When I think of my work, I see a wide-open space. My work is a total plan or design within which I try to move around with absolute freedom. This might appear to conflict with the ideas of repetition and collection. But precisely by integrating these two operative levels in my work, I manage to attain the degree of freedom and openness that corresponds to my needs".

The programmatic idea of openness is central to every aspect of Nannucci's work and affects it in a wide variety of different ways.

"I would say that there are two senses in which my work is open and flexible. On the one hand, because of the discrepancy between the medium

and the message, which preserves the indeterminacy of the work, and on the other, because it's possible to vary each work without making changes that would wreck the whole thing. A piece of writing is not inextricably bound to a particular colour: one could use a different colour altogether. This satisfies my need for novelty. For me, going back to a work and presenting a different version of it - by changing the colour or the dimensions - is tantamount to making an entirely new work. Using white instead of red, or considering the requirements of a different spatial situation: such things represent a major advance, and alter my perceptions by establishing a new sense of distance. But there are also works which art instantly complete: as soon as I finish them, there's nothing more to be added. Whatever I do, I've always been strongly against the idea of repeating the same experience".

Space has assumed an increasing importance in Nannucci's art, especially in the works using neon "writing". In an environmental context, a particular relationship is established between the reality of a given architectural space and the act of conceptual substitution.

"The room, the exhibition space, is a factor with which every contemporary artist is confronted. In most cases, we find ourselves operating in places such as galleries or museums, in heterogeneous spaces with a predefined layout. Since my art is governed by the character of the places that people offer me, the differences between individual works are to some extent functionally determined. In my mind's eye I see the varius *ambienti*, the walls of the room in which I'm installing the work, like blank white pages in a book. My intention is to link the various installations so that they form a kind of continous discourse flowing from one page to another, even though each individual work is ultimately a self-sufficient entity. I think that my rigorous approach does indeed create an impression of unity which persists when the viewer looks at my oeuvre as a whole. But as a rule, I tend to operate in the marginal or borderline areas: down by the skirting-boards, at the junction of the walls and the ceiling, in the corners of the room I always try to leave myself an avenue of escape. The viewer, too, has an impression of spatial extension, resulting from the tension which I create by intervening in the marginal zones of the predefined space".

However, there are also a number of works which vigorously assert their centrality, their independence from the walls. They consist of a single word, such as "Time", "Life", "Art", "Sign", "Text", or "Line". Nannucci uses a different colour for each letter of the word, and the letters are subordinated to the structure of the square, so that they form a single sign.

"I've always been interested in conflict, in the clash of ideas. So there's no contradiction between these works and the other things that I do: in fact, they complement what I was saying just now. The stable structure of the

square is a recurrent motif in my work: you can see it in the very first "dattilogrammi", in the format of the photographs in "Sessanta verdi naturali", and in my most recent works, too. The centrality of the square is indeed something to which I'm heavily committed. You can also ascribe it to the order, the homogeneity and linearity of my intentions. This, too, is a part of myself, and it has a certain importance for the construction of the work. All this has less to do with aesthetics than with a deep-seated inner attitude. Take writing, for example. Right from the outset I used my own handwriting for the neon works, but I consistently tried to make the script more homogeneous. In order to make it linear, I began to replace the small letters such as "t" and "g", which would otherwise have been too prominent, with capitals. I always play graphical games with the neon inscriptions, trying to ensure that the transitions between the individual letters are completely smooth, without the usual mask. Referring back to my previous comments, it's clearly apparent that the writing results from the construction itself, from the setbacks which occur and which we have to overcome, or the obstacles which we ourselves erect; the obstacles which arise from the possibilities of expression. It's only then that the work can grow and develop in a space of freedom. This also applies to works with all encompassing titles such as "When colored lines are words and when colored words are lines", where the best possible construction - that of the square - has the absurd effect of making even the centrality of the wall appear "ex-centric".

Neon is a modern, technological material. However, the coloured glass and crystal in Nannucci's neon works is supplied by the traditional glassworks of Murano. This decision is largely governed by aesthetic considerations.

"It's a possibility that the material offers, in exactly the same way that a painter selects his colours, enamels, paper or whatever. I, too, am in the position of being able to choose between a number of unusual nuances of colour. This scope for choice is very important to me, because it enables me to draw out the subtle differences to which I've always been committed. There's also an element of continuity between these works and the first "dattilogrammi", the works made with a typewriter, for which I never used the kind of coloured paper that you simply go into a stationer's shop and buy: instead, I made my own paper by grounding the individual sheets with acrylic paint or tempera, or I had the paper specially coloured by a printer. In a certain sense, the coloured glass and crystal in my current neon works corresponds to the paper of the 1960s. I'm fully aware that this discourse contains an aesthetic component: I work with materials in which this component has a central importance. On the other hand, I've always been strongly opposed to the notion of art as a purely aesthetic category, defined solely in terms of beauty. That's why I tend to keep things firmly under control, to reduce them; an inclination which is apparent in

my economic use of materials. The result is an increase in energy which compensates for the loss of spatial fullness. I'm convinced that a small blue neon work, placed high up on the wall, has the same effect as a wall painted blue from top to bottom. The extreme concentration of colour in the writing reacts with the wall to produce a vicious circle, and this, in turn, opens up further possibilities. It is in this that the energy of the work consists. My relationship to the surface is relatively complex. My works are always works on walls, relating to a particular space: even when I put in pillars, I see them as a kind of wall which has been detached from the outer wall of the room and rolled up, as it were, into a bundle. The viewer may not realize it, but I do a good deal of preparatory work. I start with a sheet of paper on which I note down ideas, and then move on to the actual wall itself, the wall as a surface on which I trace out the drawing or plan, the supporting structure for the neon words".

In statements such as "What are we talking about when we are talking about art" or "No particular feeling accompanies this text", or "There's no reason to believe that art exists", one notices a lack of affirmative values. But precisely this absence seems to express an affirmation of art, albeit in negative terms.

"Texts of this kind do indeed point to an absence, rather than the actuality of a presence. However, they can also be seen as affirmations of art, which seeks in this way to elude excessively narrow definitions. It's probably the case that affirmative statements always impose limits on art - unless one sees art as a limit on all her own affirmation".

Maurizio Nannucci's name is often mentioned in connection with concrete poetry, the Fluxus movement, and so on. However, his art defies such stylistic labelling: in this respect, it is similar to the work of the relatively as small number of artists, from the 1960s to the present day, who have resisted group pressures and followed an entirely individual path which has enable them to make an original contribution to contemporary art. As well as Manzoni, Klein, Broodthaers and Filliou, the names which spring to mind include Byars, Finlay, Boetti, Raetz and General Idea, together with Kruger, Prince and Kippenberger.

"I've never been in a position of opposing or competing with other artists. Instead, I've always tried to establish relationships with them by promoting joint activities, doing collective editions, and so forth. Things of this kind may perhaps furnish a pointer to the links between my work and those of the artists you mentioned, artists with whom I have built up relatively close relationships over the years. The common focus of interest can be traced back to the broadening of horizons, the extension of the sign, the genuine willingness - as opposed to mere declarations of intent - to engage in a dialogue with people as well as things. Regarding the various movements - concrete poetry, Fluxus, or Concept Art - that can be

associated with my work, I would say that no artist can ever be wholly indifferent to the events that surround him. Artists who are contemporary with each other may well give similar answers to the same question. Originality lies elsewhere: it's not something that can be scaled down and schematized. But artists who submit to a particular stereotype, who correspond exactly to a given model, may well end up in a more privileged position than others who are less easy to categorize. That's not the case with the artists you cited".

Maurizio Nannucci has assembled an archive of material and documents relating to the work of other artists. How does he define this part of his work?

"It's connected with the same attitude which leads me to investigate all the possible shades of blue or green. The archive is an unspecified collection which concentrates on marginal areas, on echoes and resonances. It's an integral part of my work: otherwise I wouldn't have carried on with it for such a long time. My interest in collecting documents and materials from other artists and combining them with my own editions was first aroused by the realization that in the field of art, there were a lot of extremely fragile objects being produced; objects which would otherwise have been lost. These things weren't unique works of art: they had no singular qualities, and they weren't even in commercial circulation. Nowadays, the situaton is different. Over the years, I realized that I wasn't the only person who had noticed these objects a lot of other people had woken up to the fact that this material was highly valuable. After all, the most fragile things are often the most precious".

The conversation between Maurizio Nannucci and Helmut Friedel took place on 22 June 1991.

Helmut Friedel is the director of the Städtische Galerie im Lenbachhaus, Munich.

The conversation was originally published in the catalogue Maurizio Nannucci, "You can imagine the opposite", Städtische Galerie im Lenbachhaus, Munich, 1991.

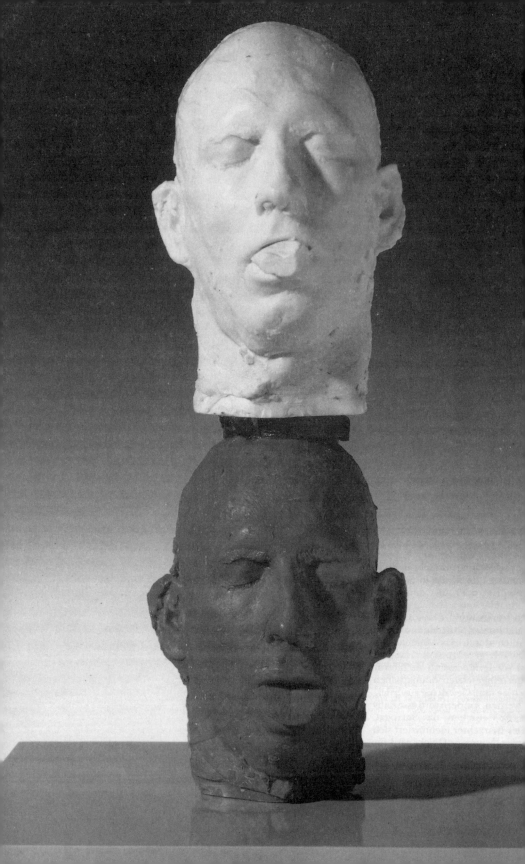

Can an artist gain a measure of certainty about the significance of his work by means of striking statements and word play? During the sixties, Bruce Nauman wrote "The True Artist is a Wonderful Fountain" and "The True Artist Helps the World by Revealing Mystic Truths" - two of the many possible self-definitions that express skepticism about the role of the artist in society. The issue of role consciousness calls attention to the reality confronting the artist.*

Those who open their eyes to the world find themselves faced with aggression, helplessness and pretensions to power. Social reality encompasses a broad spectrum of unspeakable suffering, both obvious and hidden. Because suffering is inexorable, the artist has but a single choice: to achieve heightened self-awareness through the physical experience of reality. Shocking video scenes record the process of self-experience. "Help me, hurt me, Sociology. Feed me, eat me, Anthropology. Feed me, help me, hurt me" (Anthro/Socio 1992). The voice points out the injury inflicted upon human beings in the continuing process of rationalizing and "scientizing" reality. Towering mountains of knowledge abandon mankind to deal with its wishes and fears alone in a world that has become a shell of obedience, ein "Gehäuse der Hörigkeit" (Max Weber). Life amounts to a journey through narrow passages that dictate the direction of every step. The myths have lost their magic, but the artist is capable of creating an image of the unspoken collective anxiety. (G.D.)

Bruce Nauman
Breaking the Silence: An Interview with Bruce Nauman

INTERVIEW BY JOAN SIMON

Reflecting on two decades of his own work, Nauman discloses some verbal and visual ties between his recent political allegories and his earlier use of puns, body parts and space.

BRUCE NAUMAN: There is a tendency to clutter things up, to try to make sure people know something is art, when all that's necessary is to present it, to leave it alone. I think the hardest thing to do is to present an idea in the most straight-forward way.

What I tend to do is see something, then remake it and re-make it and try every possible way of re-making it. If I'm persistent enough, I get back

* 1941 Fort Wayne, Indiana / lives in Galisteo, New Mexico.

to where I started. I think it was Jasper Johns who said, "Sometimes necessary to state the obvious".

Still, how to proceed is always the mystery. I remember at one point thinking that some day I would figure out how you do this, how you do art - like, "What's the procedure here, folks?" - and then it wouldn't be such a struggle anymore. Later, I realized it was never going to be like that, it was always going to be a struggle. I realized I would never have a specific process; I would have to re-invent it, over and over again. That was really depressing.

After all, it was hard work; it was a painful struggle and tough. I didn't want to have to go through all that every time. But of course you do have to continually re-discover and re-decide, and it's awful. It's just an awful thing to have to do.

On the other hand, that's what's interesting about making art, and why it's worth doing: it's never going to be the same, there is no method. If I stop and try to look at how I got the last piece done, it doesn't help me with the next one.

JOAN SIMON: What do you think about when you're working on a piece?

NAUMAN: I think about Lenny Tristano a lot. Do you know who he was? Lenny Tristano was a blind pianist, one of the original - or maybe second generation - bebop guys. He's on a lot of the best early bebop records. When Lenny played well, he hit you hard and he kept going until he finished. Then he just quit. You didn't get any introduction, you didn't get any tail - you just got full intensity for 2 minutes or 20 minutes or whatever. It would be like taking the middle out of Coltrane - just the hardest, toughest part of it. That was all you got.

From the beginning I was trying to see if I could make art that did that. Art that was just there all at once. Like getting hit in the face with a baseball bat. Or better, like getting hit in the back of the neck. You never see it coming; it just knocks you down. I like that idea very much: the kind of intensity that doesn't give you any trace of whether you're going to like it or not.

SIMON: In trying to capture that sort of intensity over the past 20 or so years you've worked in just about every medium: film, video, sound, neon, installation, performance, photography, holography, sculpture, drawing - but not painting. You gave that up very early on. Why?

NAUMAN: When I was in school I was a painter. And I went back and forth a couple of times. But basically I couldn't function as a painter. Painting is one of those things I never quite made sense of. I just could't see how to proceed as a painter. It seemed that if I didn't think of myself as a painter, then it would be possible to continue.

It still puzzles me how I made decisions in those days about what was possible and what wasn't. I ended up drawing on music and dance and literature, using thoughts and ideas from other fields to help me continue to work. In that sense, the early work, which seems to have all kinds of materials and ideas in it, seemed very simple to make because it wasn't coming from looking at sculpture or painting.

SIMON: That doesn't sound simple.

NAUMAN: No, I don't mean that it was simple to do the work. But it was simple in that in the '60s you didn't have to pick just one medium. There didn't seem to be any problem with using different kinds of materials - shifting from photographs to dance to performance to videotapes. It seemed very straightforward to use all those different ways of expressing ideas or presenting material. You could make neon signs, you could make written pieces, you could make jokes about parts of the body or casting things, or whatever.

SIMON: Do you see your work as part of a continuum with other art or other artists?

NAUMAN: Sure there are connections, though not in any direct way. It's not that there is someone in particular you emulate. But you do see other artists asking the same kinds of questions and responding with some kind of integrity. There's a kind of restraint and morality in Johns. It isn't specific, I don't know how to describe it, but it's there, I feel it's there. It's less there, but still important, in Duchamp. Or in Man Ray, who also interests me. Maybe the morality I sense in Man Ray has to do with the fact that while he made his living as a fashion photographer, his art works tended to be jokes - stupid jokes. The whole idea of Dada was that you didn't have to make your living with your art; so that generation could be more provocative with less risk. Then there is the particularly American idea about morality that has to do with the artist as workman. Many artists used to feel all right about making a living with their art because they identified with the working class. Some still do. I mean, I do, and I think Richard Serra does.

SIMON: No matter how jokey or stylistically diverse or visually dazzling your works are, they always have an ethical side, a moral force.

NAUMAN: I do see art that way. Art ought to have a moral value, a moral stance, a position. I'm not sure where that belief comes from. In part it just comes from growing up where I grew up and from my parents and family. And from the time I spent in San Francisco going to the Art Institute, and before that in Wisconsin. From my days at the University of Wisconsin, the teachers I remember were older guys - they wouldn't

let women into teaching easily - and they were all WPA guys. They were socialists and they had points to make that were not only moral and polical, but also ethical. Wisconsin was one of the last socialist states, and in the '50s, when I lived there and went to high-school there, Milwaukee still had a socialist mayor. So there were a lot of people who thought art had a function beyond being beautiful - that it had a social reason to exist.

SIMON: What David Whitney wrote about your "Composite Photo of Two Messes on the Studio Floor" (1967) - that "it is a direct statement on how the artist lives, works and thinks" - could apply in general to the variety of works you made in your San Franciseo studio from 1966-68.
NAUMAN: I did some pieces that started out just being visual puns. Since these needed body parts in them, I cast parts of a body and assembled them or presented them with a title. There was also the idea that if I was in the studio, whatever I was doing was art. Pacing around, for example. How do you organize that to present it as art? Well, first I filmed it. Then I videotaped it. Then I complicated it by turning the camera upside down or sideways, or organizing my pacing to various sounds.
In a lot of the early work I was concerned with ideas about inside and outside and front and back - how to turn them around and confuse them. Take the "Window or Wall Sign" - you know, the neon piece that says, "The true artist helps the world by revealing mystic truths". That idea occurred to me because of the studio I had in San Francisco at the time. It had been a grocery store, and in the window there was still a beer sign which you read from the outside. From the inside, of course, it was backwards. So when I did the earliest neon pieces, they were intended to be seen through the window one way and from the inside another way, confusing the message by reversing the image.

SIMON: Isn't your interest in inverting ideas, showing what's "not there", and in solving - or least revealing - "impossible" problems related in part to your training as a mathematician?
NAUMAN: I was interested in the logic and structure of math and especially how you could turn that logic inside out. I was fascinated by mathematical problems, particularly the one called "squaring the circle". You know, for hundreds of years mathematicians tried to find a geometrical way of finding a square equal in area to a circle - a formula where you could construct one from tht other. At some point in the 19th century, a mathematician - I can't remember his name - proved it can't be done. His approach was to step outside the problem. Rather than struggling inside the problem, by stepping outside of it, he showed that it was not possible to do it at all.

Standing outside and looking at how something gets done, or doesn't get done, is really fascinating and curious. If I can manage to get outside of a problem a little bit and watch myself having a hard time, then I can see what I'm going to do - it makes it possible. It works.

SIMON: A number of early pieces specifically capture what's "not there". I'm thinking about the casts of "invisible spaces": the space between two crates on the floor, for example, or the "negative" space under a chair.
NAUMAN: Casting the space under a chair was the sculptural version of de Kooning's statement: "When you paint a chair, you should paint space between the rungs, not the chair itself. I was thinking like that: about leftovers and negative spaces.

SIMON: But your idea of negative space is very different from the sculptor's traditional problem of locating an object in space or introducing space into a solid form.
NAUMAN: Negative space for me is thinking about the underside and the backside of things. In casting, I always like the parting lines and the seams - things that help to locate the structure of an object, but in the finished sculpture usually get removed. These things help to determine the scale of the work and the weight of the material. Both what's inside and what's outside determine our physical, physiological and psychological responses - how we look at an object.

SIMON: The whole idea of the visual puns, works like "Henry Moore Bound to Fail" and "From Hand to Mouth", complicates this notion of how we look at an object. They are similar to ready-mades. On the one hand, they translate words or phrases into concrete form - in a sense literalizing them. On the other hand, they are essentially linguistic plays, which means abstracting them. I'm curious about the thought process that went into conceiving those works. For instance, how did "From Hand to Mouth" come about?
NAUMAN: In that case, the cast was of someone else, not of myself as has generally been assumed - but that doesn't really matter. It was just supposed to be a visual pun, or a picture of a visual pun.
I first made "From Hand to Mouth" as a drawing - actually there were two or three different drawings - just the idea of drawing "from hand to mouth". But I couldn't figure out exactly how to make the drawing. My first idea was to have a hand in the mouth with some kind of connection - a bar, or some kind of mechanical connection. I finally realized that the most straightforward way to present the idea would be to cast that entire section of the body. Since I couldn't cast myself, I used my wife as the model.

I worked with the most accurate casting material I could find, something called moulage. I found the stuff at some police shop. You know, they used it to cast tire prints and things like that. It's actually a very delicate casting process; you could pick up fingerprints in the dust with it. The moulage is a kind of gel you heat up. Because it's warm when you apply it to a body, it opens up - all the pores - it picks up all that, even the hairs. But it sets like five-day-old Jell-O. You have to put plaster or something over the back of it to make it hold its shape. Then I made the wax cast, which became very super-realistic - hyper-realistic. You could see things you don't normally see - or think about - on people's skin.

SIMON: All your work seems to depend not only on this kind of tactile precision, but also on a kind of incompleteness - a fragmentariness, a sense of becoming. As a result, your pieces accrue all sorts of meaning over time. With "From Hand to Mouth" - completed over 20 years ago - what other meanings have occurred to you?

NAUMAN: Well, it's funny you should ask that, because not long ago I read this book in which a character goes to funeral homes or morgues, and puts this moulage stuff on people and makes plaster casts - death masks - for their families. I had no idea that this was a profession. But it turns out that this moulage is a very old, traditional kind of material, and was often used this way. But it just connects up in a strange sort of way with my more recent work, since over the past several years I have been involved with both the idea of death and dying and the idea of masking the figure.

SIMON: An early example of masking the figure - your figure, to be precise - was your 1969 film "Art Makeup".

NAUMAN: That film - which was also later a videotape - has a rather simple story behind it. About 20 years ago - this was in '66 and '67 - I was living in San Francisco, and I had access to a lot of film equipment. There were a lot of underground filmmakers there at that time and I knew a bunch of those guys. And since everybody was broke, I could rent pretty good 16mm equipment for $5 or $6 a day - essentially the cost of gas to bring it over. So I set up this "Art Makeup" film.

Of course, you put on makeup before you film in the movies. In my case, putting on the makeup became the activity. I started with four colors. I just put one over the other, so that by the time the last one went on it was almost black. I started with white. Then red on the white, which came out pink; then something very black on top of that.

One thing which hadn't occurred to me when I was making the film was that when you take a solid color or makeup - no matter what color - it

flattens the image of the face on film. The flatness itself was another kind of mask.

SIMON: The whole idea of the mask, of abstracting a personality, of simultaneously presenting and denying a self, is a recurring concern in your work.

NAUMAN: I think there is a need to present yourself. To present yourself through your work is obviously part of being an artist. If you dont want people to see that self, you put on makeup. But artists are always interested in some level of communication. Some artists need lots, some don't. You spend all of this time in the studio and then when you do present the work, there is a kind of self-exposure that is threatening. It's a dangerous situation and I think that what I was doing, and what I am going to do and what most of us probably do, is to use the tension between what you tell and what you don't tell as part of the work. What is given and what is withheld become the work. You could say that if you make a statement it eliminates the options; on the other hand if you're a logician, the opposite immediately becomes a possibility. I try to make work that leaves options, or is open-ended in some way.

SIMON: The tenor of that withholding - actually controlling the content or subject - changed significantly when you stopped performing and began to allow the viewer to participate in some of your works. I'm thinking of the architectural installations, in particular the very narrow corridor pieces. In one of them, the viewer who could deal with walking down such a long claustrophobic passage would approach a video monitor on which were seen disconcerting and usually "invisible" glimpses of his or her own back.

NAUMAN: The first corridor pieces were about having someone else do the performance. But the problem for me was to find a way to restrict the situation so that the performance turned out to be the one I had in mind. In a way, it was about control. I didn't want somebody else's idea of what could be done.

There was a period in American art, in the '60s, when artists presented parts of works, so that people could arrange them. Bob Morris did some pieces like that, and Oyvind Fahlstrom did those political-coloring-book-like things with magnets that could be rearranged. But it was very hard for me to give up that much control. The problem with that approach is that it turns art into game playing. In fact, at that time, a number of artists were talking about art as though it were some kind of game you could play. I think I mistrusted that idea.

Of course, there is a kind of logic and structure in art-making that you can see as game playing. But game-playing doesn't involve any responsibility - any moral responsibility - and I think that being an artist does involve

moral responsibility. With a game you just follow the rules. But art is like cheating - it involves inverting the rules of taking the game apart and changing it. In games like football or baseball cheating is allowed to a certain extent. In hockey breaking the rules turns into fighting - you can't do that in a bar and get away with it. But the rules change. It can only go so far and then real life steps in. This year warrants were issued to arrest hockey players; two minutes in the penalty box wasn't enough. It's been taken out of the game situation.

SIMON: Nevertheless, many of your works take as their starting point very specific children's games.

NAUMAN: When I take the game, I take it out of context and apply it to moral or political situations. Or I load it emotionally in a way that it is not supposed to be loaded. For instance, the "Hanged Man" neon piece (1985) derives from the children's spelling game. If you spell the word, you win; if you can't spell the word in a certain number of tries, then the stick figure of the hanged man is drawn line by line with each wrong guess. You finally lose the game if you complete the figure - if you hang the man.

With my version of the hanged man, first of all, I took away the part about being allowed to participate. In my piece you're not allowed to participate - the parts of the figure are put into place without you. The neon "lines" flash on and off in a programmed sequence. And then the game doesn't end. Once the figure is complete, the whole picture starts to be recreated again. Then I added the bit about having an erection or ejaculation when you're hanged. I really don't know if it's a myth or not.

I've also used the children's game "musical chairs" a number of times. The simplest version was "Musical Chairs (Studio Piece)" in 1983, which has a chair hanging at the outside edge of a circumference of suspended steel Xs. So, when the Xs swing or the chair swings, they bang into each other and actually make noise - make music. But of course it was more than that because musical chairs is also a cruel game. Somebody is always left out. The first one to be excluded away feels terrible. That kid doesn't get to play anymore, has nothing to do, has to stand in the corner or whatever.

SIMON: There seems to be something particularly ominous about your use of chairs - both in this and other works. Why a chair? What does it mean to you?

NAUMAN: The chair becomes a symbol for a figure - a stand-in for the figure. A chair is used, it is functional; but it is also symbolic. Think of the electric chair, or that chair they put you in when the police shine the lights on you. Because your imagination is left to deal with that isolation, the image becomes more powerful, in the same way that the murder offstage

can be more powerful than if it took place right in front of you. The symbol is more powerful.

I first began to work with the idea of a chair with that cast of the space underneath a chair - that was in the '60s. And I remember, when I think back to that time, a chair Beuys did with a wedge of suet on the seat. I think he may have hung it on the wall. I'm not sure. In any case, it was a chair that was pretending it was a chair - it didn't work. You couldn't see in it because of that wedge of grease or fat whatever it was - it filled up the space you would sit in. Also, I'm particularly interested in the idea of hanging a chair on the wall. It was a Shaker idea, you know. They had peg boards that ran around the wall, so they could pick up all the furniture and keep the floors clean. The chairs didn't have to be on the floor to function.

In 1981, when I was making "South American Triangle", I had been thinking about having something hanging for quite a long time. The "Last Studio Piece", which was made in the late '70s when I was still living in Pasadena, was made from parts of two other pieces - plaster semicircles that look like a cloverleaf and a large square - and I finally just stuck them together. I just put one on top of the other and a metal plate in between and hung it all from the ceiling. That was the first time I used a hanging element. I was working at the same time on the "underground tunnel pieces". These models for tunnels I imagined floating underground in the dirt. The same ideas and procedures, the same kind of image, whether something was suspending in water, in earth, in air.

SIMON: "South American Triangle" in a certain sense continues these ideas of game-playing, suspension, inside and outside, and the chair as a stand-in for the figure. In this case though, we're talking about a big steel sculpture hanging from the ceiling, with the chair isolated and suspended upsidedown in the middle of the steel barrier. This seems considerably more aggressive than the earlier work, though the content is still covert, an extremely private meditation. But the title hints at its subject matter and begins to explicate its intense emotional and political presence. I'm wondering what your thoughts were when you were making this piece?

NAUMAN: When I moved to New Mexico and was in Pecos in '79, I was thinking about a piece that had to do with political torture. I was reading V.S. Naipaul's stories about South America and Central America, including "The Return of Eva Peron" and especially "The Killings of Trinidad" - that's the one that made the biggest impression on me. Reading the Naipaul clarified things for me and helped me to continue. It helped me to name names, to name things. But it didn't help me to make the piece. It didn't help me to figure out how the bolts went on. It just gave me encouragement.

At first, I thought of using a chair that would somehow become the fig-

ure: torturing a chair and hanging it up or strapping it down, something like that. And the torture has to take place in a room (or at least I was thinking in terms of it taking place in a room), but I couldn't figure out how to build a room and how to put the chair in it. Well, I'd made a number of works that had to do with triangles, like rooms in different shapes. I find triangles really uncomfortable, disconcerting kinds of spaces. There is no comfortable place to stay inside them or outside them. It's not like a circle or square that gives you security.

So, in the end, for "South American Triangle", I decided that I would just suspend the chair and then hang a triangle around it. My original idea was that the chair would swing and bang into the sides of the triangle and make lots of noise. But then when I built it so that the chair hung low enough to swing into the triangle, it was too low. It didn't look right, so I ended up raising it. The triangle became a barrier to approaching the chair from the outside.

Again, it becomes something you can't get to. There is a lot of anger generated when there are things you can't get to. That's part of the content of the work - and also a genesis of the piece. Anger and frustration are two very strong feelings of motivation for me. They get me into the studio, get me to do the work.

SIMON: That sense of frustration and anger also becomes the viewer's position in approaching and making sense of your work, especially a piece as disturbing as "South American Triangle". One critic, Robert Storr, said recently, "Unlike settling into the reassuring "armchair" of Matisse's paintings, to take one's seat in Nauman's art is to risk falling on one's head...".

NAUMAN: I know there are artists who function in relation to beauty - who try to make beautiful things. They are moved by beautiful things and they see that as their role: to provide or make beautiful things and they see that as their role: to provide or make beautiful things for other people. I don't work that way. Part of it has to do with an idea of beauty. Sunsets, flowers, landscapes: these kinds of things don't move me to do anything. I just want to leave them alone. My works come out of being frustrated about the human condition. And about how people refuse to understand other people. And about how people can be cruel to each other. It's not that I think I can change that, but it's just such a frustrating part of human history.

SIMON: Recently, you've returned to video for the first time since the late '60s. In "Violent Incident" (1986), you not only moved from "silents" to "talkies", but you also used actors for the first time. Nevertheless, the video seems to pick right up on issues you've explored from the beginning. The chair is a central element in the action an the whole tape cen-

ters on a cruel joke. Again there is this persistent tension between humor and cruelty.

NAUMAN: "Violent Incident" begins with what is supposed to be a joke - but it's a mean joke. A chair is pulled out from under someone who is starting to sit down. It intentionally embarrasses someone and triggers the action. But let me describe how it got into its present form. I started with a scenario, a sequence of events which was this: Two people come to a table that's set for dinner with plates, cocktails, flowers. The man holds the woman's chair for her as she sits down. But as she sits down, he pulls the chair out from under her and she falls on the floor. He turns around to pick up the chair, and as he bends over, she's standing up, and she gooses him. He turns around and yells at her - calls her names. She grabs the cocktail glass and throws the drink in his face. He slaps her, she knees him in the groin and, as he's doubling over, he grabs a knife from the table. They struggle and both of them end up on the floor.

Now this action takes all of about 18 seconds. But then it's repeated three more times: the man and woman exchange roles, then the scene is played by two men and then by two women. The images are aggressive, the characters are physically aggressive, the language is abusive. The scripting, having the characters act out these roles and the repetition all build on that aggressive tension.

SIMON: Sound is a medium you've explored since your earliest studio performances, films and audiotapes. The hostile overlayering of angry noises contributes enormously to the tension of "Violent Incident".

NAUMAN: It's similar with the neon pieces that have transformers, buzzing and clicking and what not; in some places I've installed them, people are disturbed by these sounds. They want them to be completely quiet. There is an immediacy and an intrusiveness about sound that you can't avoid.

So with "Violent Incident", which is shown on 12 monitors at the same time, the sound works differently for each installation. At one museum, when it was in the middle of the show, you heard the sound before you actually got to the piece. And the sound followed you around after you left it. It's kind of funny the way "Violent Incident" was installed at the Whitechapel. Because it was in a separate room, the sound was baffled; you only got the higher tones. So the main thing you heard throughout the museum was "Asshole"!

SIMON: That's sort of the subliminal version of a very aggressive sound piece you used to install invisibly in empty rooms, isn't it?

NAUMAN: You mean the piece that said: "Get out of the room, get out of my mind"? That piece is still amazingly powerful to me. It's really stuck in my mind. And it's really a frightening piece. I haven't heard it for a few

years, but the last time I did I was impressed with how strong it was. And I think that it is one of those pieces that I can go back to. I don't know where it came from or how I managed to do it because it's so simple and straightforward.

SIMON: How did that come about?

NAUMAN: Well, I had made a tape of sounds in the studio. And the tape says over and over again, "Get out of the room, get out of my mind". I said it a lot of different ways: I changed my voice and distorted it, I yelled it and growled it and grunted it. Then, the piece was installed with the speakers built into the walls, so that when you went into this small room - 10 feet square or something - you could hear the sound, but there was no one there. You couldn't see where the sound was coming from. Other times, we just stuck the speakers in the corners of the room and played the tape - like when the walls were too hard to build into. But it seemed to work about as well as either way. Either way it was a very powerful piece. It's like a print I did that says, "Pay attention motherfuckers" (1973). You know, it's so angry it scares people.

SIMON: Your most recent videotapes feature clowns. I can see a connection to the "Art Makeup" film we talked about, but why did you use such theatrical clowns?

NAUMAN: I've got interested in the idea of the clown first of all because there is a mask, and it becomes an abstracted idea of a person. It's not anyone in particular, see, it's just an idea of a person. And for this reason, because clowns are abstract in some sense, they become very disconcerting. You, I, one, we can't make contact with them. It's hard to make any contact with an idea or an abstraction. Also, when you think about vaudeville clowns or circus clowns, there is a lot of cruelty and meanness. You couldn't get away with that without makeup. People wouldn't put up with it, it's too mean. But in the circus it's okay, it's still funny. Then, there's the history of the unhappy clown: they're anonymous, they lead secret lives. There is a fairly high suicide rate among clowns. Did you know that?

SIMON: No, I didn't. But it seems that rather than alluding to this melancholic or tragic side of the clown persona the video emphasizes the different types of masks, the historically specific genres of clowns or clown costumes.

NAUMAN: With the clown videotape, there are four different clown costumes: one of them is the Emmett kelly dumb clown; one is the old French Baroque clown (I guess it's French); one is a sort of traditional polka-dot, red-haired, oversize-shoed clown; and one is a jester. The jester and the Baroque type are the oldest, but they are pretty recognizable types. They

were picked because they have a historical reference, but they are still anonymous. They become masks, they don't become individuals. They don't become anyone you know, they become clowns.

SIMON: In your tape "Clown Torture" (1987), the clowns don't act like clowns. For one thing, they're not mute. You have the clowns tell stories. Or, I should say, each of the clowns repeat the same story.
NAUMAN: Each clown has to tell a story while supporting himself on one leg with the other leg crossed, in such a way that it looks like he is imitating sitting down. So there is the physical tension of watching someone balance while trying to do something else - in this case, tell a story. The takes vary because at some point the clown gets tired and falls over. Then I would stop the tape. Each of the four clowns starts from the beginning, tells the story about 15 times or so, falls over and then the next clown starts.
This circular kind of story, for me, goes back to Warhol films that really have no beginning or end. You could walk in at any time, leave, come back again and the figure was still asleep, or whatever. The circularity is also a lot like La Monte Young's idea about music. The music is always going on. You just happen to come in at the part he's playing that day. It's a way of structuring something so that you don't have to make a story.

SIMON: What's the story the clowns tell?
NAUMAN: "It was a dark and stormy night. Three men were sitting around a campfire. One of the men said, 'Tell us a story, Jack'. And Jack said, 'It was a dark and stormy night. Three men were sitting around a campfire. One of the men said, "Tell us a story, Jack". And Jack said, "It was a dark and stormy night..."'.

This text is an excerpt from interviews with Nauman for the film, Four Artists: Robert Ryman, Eva Hesse, Bruce Nauman, Susan Rothenberg (Michael Blackwood Productions, 1988). The interviews were recorded in London, January 1987.

Joan Simon is a Paris-based writer and curator. She is a regular contributor to "Art in America", and general editor of the "Bruce Nauman" catalogue raisonne (Walker Art Center).

The interview originally appeared in *Art in America*, no. 9, September 1988.

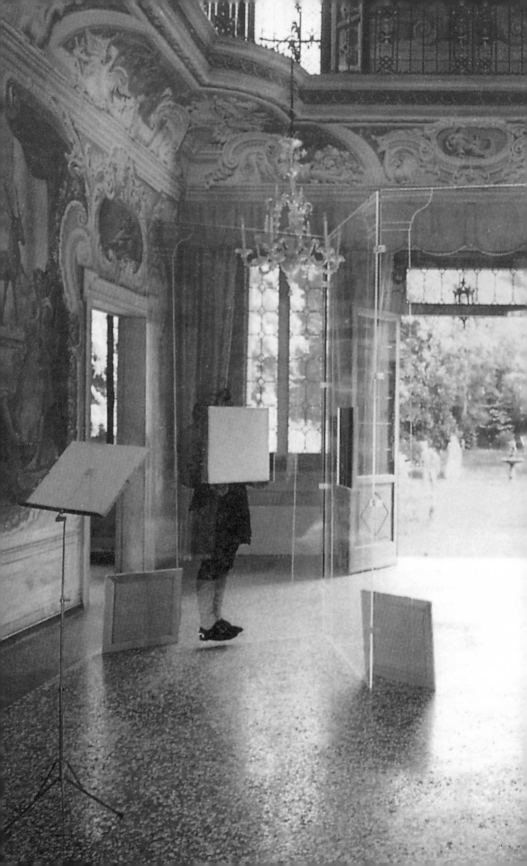

Historically speaking the discovery of symmetry lies at the route of all aesthetics. The concept of creating harmonious order among discreet parts by means of symmetrical design is evidence of mankind's power to shape and impose structure in the face of the randomness and chaos of the natural world. Aesthetic motives culminate - long after the possibilities of symmetry and its opposites have been exhausted - in the tendency to widen the distance between the artist and the object of art. Georg Simmel saw the development of aesthetics as a process of flow between these two points. A close look at the work of Giulio Paolini suggests that the artist's concept encompasses the beginning and the end of aesthetic motivation in art.*

Visible expressions of this extension of distance may include allusions or aphorisms or, in Paolini's work, an operative logic that penetrates and explores the entire context of art itself. Paolini's works form a setting for critical vision and represent a museum of an aesthetic memory against oblivion. The artist makes use of classical stylistic elements to make the origin and meaning of art comprehensible. Classical pictorial elements are repeated, duplicated and mirrored. Although symmetry facilitates the process of ordering visual impressions, pictorial representation deludes the perceptive faculties. The viewer must pass beyond the aesthetics of pictorial imagery and pursue the concept to its conclusion. (G.D.)

Giulio Paolini
Artiste manqué

FROM PAINTING LESSONS

As time goes by, I have turned into an object of curiosity. I mean to say that this is far from the very first time that I have been asked to express an opinion on the world in which we operate, or on subjects like the theme of these conversations to which I have been invited to make a contribution: "Why do we continue to make and teach art?".

What is art? I'm sure that none of us can answer that question with any certainty. We're unable to fix our gaze for any great length of time on this sphere or point of light that leaves us in doubt as to whether it's a star, a planet, or a satellite, which is to say that we never cease to wonder if its light is radiant, natural, or reflected. I talk about art without really being able to do so... And this can't be resolved simply by resetting our sights.

* 1940 Genoa / lives in Turin.

Allow me to appeal to an image: while manning his observation post, an astronomer comes to the realization that the distance between himself and the stars has come to be the same as the distance between himself and the earth. While intent on studying the firmament, he floats in a space that's free from gravity and he can no longer establish contact with the world; he can send no messages back to the world.

But perhaps the telescope is pointing in the other direction...

And what about truth?

The astronomer's only remaining truth is his instrument: the very same instrument that permits him to observe the truth.

The artist, today, knows himself to be *less* capable of self-expression than anybody else.

The artist alone has always and everyday experienced the ungraspability or the non-existence of self-expression. If self-expression finds manifestation, it does not do so *in* him; at best he performs the bitter task of lending it a voice.

And the artist understands, more than anyone else, that the image he chances to discover belongs not to him but to everyone. Appearances notwithstanding, his destiny lies in an absence from the world, in an exile from time and place.

So if I am here to satisfy your curiosity, I have to admit from the very start that our appointment is an appointment *manqué*; and it could hardly be otherwise, since the voice to which you're listening is the voice of an *artiste manqué*. The curiosity, moreover, which you excite in me doesn't find its focus is any single individual among you, and surely not in that single individual who happens to be me.

Now I'd like to present the thoughts I have always had about *the place of representation*, understood as a space within the work (about the nature of this space, and the co-ordinates in which it might be inscribed). I have used the word "thoughts", yet I don't intend to be unclear: I have never actually "thought" a work, even if that might seem to be the case to those who see a work and immediately glimpse - or imagine themselves to glimpse - the thoughts that gave birth to it. The artist and the work are complementary to one another, and not at all sequential to one another. Just as it is essential for the work, in order to exist, to deliver itself to the gaze that gives it substance (be it the gaze of the author or the spectator), the artist, as proof of his own salvation, has to discover something (the work) that enables him *to look*. So I can say that I am the product of the thoughts of my works, rather than vice versa. The artist does not think; he is a castaway, a survivor who has managed to escape from the danger that lies in the destination which the work itself represents. The artist is an unstable figure... inhabited by contradictory attitudes. He seeks the new,

eternally searching for originality - for roads not yet traveled - but always in accordance with a code; he is a herald of norms and rules, even if of norms and rules which as yet remain unknown to him. He has to let others participate in his vision, but no one is allowed to appropriate it. (Not even the artist himself is allowed to appropriate it; as the work discovers its formulation, he already turns his attention to the next.) The artist is ironic, but makes no practiced habit of irony. He has nothing to prove, and simply perseveres in the pursuit of his path.

He remarks, among other things:

"I'm convinced that any relationship with the public comes about by itself, that it's of no primary concern to that artist, and that one isn't once again to invoke the obscenity of a marriage of art and society. My very own activity tends, moreover, to define itself as irremediably 'academic'".

"Can a work survive, and outflank the scandal of communication?".

"The reason for my never having painted reality lies in my persistent conviction that reality is a notion that cannot be defined. Reality is too evident to allow itself to be made more real".

He will even teach:

"The surface of a canvas or a sheet of paper is traversed by innumerable projections and experiments that belong to past experience, no less than to future eventualities.

"Before moving on to particulars, we should take a brief look at the functions and possibilities that we want to attribute to supporting surfaces. In other words, and paradoxically, all the possible images which a surface has represented, or might represent, can be reduced, or dilated, to a representation of itself. As though addressing a challenge to the infinite, it's a question of seeing the sign no longer as illusory artifice, and instead as a virtual instrument. The exercises performed in the Academy can draw upon the very environment in which they are carried out, making use of all the suggestions and questions that gradually present themselves. The 'life drawing,' for example, does not exclude the copying of a previously painted image, since such an image is no less 'life' than any other object might be. So nothing could be more *finished* than a work which is yet to be begun. Yet everything, in order to exist, requires that we *begin again*. The place of representation is the space required for its manifestation".

The work does not produce space; it institutes space; it searches it out within itself in order to give itself manifestation; it evokes it in order to *represent itself*. It can therefore be nothing other than the realm of perception, of interpretation...

The artist (the castaway) is thus dispossessed of himself and truly runs the risk of no longer being recognized (noticed). Of obstinately persisting in

the pursuit of something by which he indeed, quite unawares, is already possessed.

Prospector for gold, conjurer, chess player, hermit, pearl diver, artist, master of ceremonies - are these all so many synonyms? The last, for example - in accordance with established codes - is the person who commits himself to the search for truth while knowing that it cannot be obtained. "Ceremony" is no automatic repetition of a conventional procedure, and instead is an essential event in its very own right: an event that unleashes panic just as it produces ecstasy; an event that kindles or extinguishes faith. Perhaps the artist is someone or something - on the order of a stand-in - who no longer *practices* the ceremony of the perception of the world, and who instead has come to *live* it, conjoining revolution and discretion, demanding the absolute without knowing how to make use of it... Like a rite into which you have to descend, or myth...

Thousands of statues constitute that body of iconography - that body of imagery - which illustrates those mysterious figures, improbable yet possible, to which we refer as the gods and their deeds...

The spaces that hold them apart from one another - the dense void which makes them visible, the distances which place them in perspective - are no less numerous.

I have insisted too often - and too often, I have to admit, repeated myself - on my perennial reticence to offer an active and conscious contribution to the search for "truth", or at least for a possible meaning that might be discovered in the endless expanse of images.

Having laid the first stone (while still having published no blue-print) I have continued to raise the scaffolding for a building that awaits construction: a building which no one has commissioned, and which no one is destined to inhabit.

Yet insisting, repeating, and continuing seem to be the only way in which to bear the total weight of an emptiness which no one imagines himself to be able to fill. So here I am in my studio. I never begin with a blank sheet of paper (rather than points of departure, the blank sheet of paper and the untouched canvas are points of arrival). A page from a newspaper, a small rectangle drawn in pencil, with other rectangles around it, sometimes traversed by a diagonal, a fold in the paper, and here's a room... Everything is set in motion, or withheld from motion, by that certain touch of laziness demanded by impatience.

The general crisis of the bases of things today gives authorization, in opposition to any number of outworn and outdated truths, to an equal number of uncertain or gratuitous heresies. What I see as my own particular praxis leads me to believe in the truth of fiction, in representation as an absolute which affirms that "whatever becomes has already been".

My anti-futurist convictions (but the prefix "anti" is an echo of futurism) and my phobia with respect to airplanes (but immobility is the sublimation of speed) to some extent condition my consumption of space and time.

I have always admired those artists to whom I refer as "painters of the motionless". They forget reality to the point of forgetting themselves; they transform snap-shots into pictures posed in a studio.

And there we have it. I grasped the meaning of drawing from photography, of drawing defined as that which is always true, and which therefore has always remained intact. Even if there is no such thing as drawing without line, line nonetheless "moves" - as in the terminology of the game of chess - in ways that supply that verb with no direct object (in ways that imply no becoming in time). Line appears where it was expected to appear. So drawing is something similar to that prodigy of orthographic convention which places a capital letter at the start of each line of a poem (I refer to the convention of "titling" parts - as though making them self-sufficient - that belong to a greater whole); or to the motionless running of rivulets of water at the moment in which it thaws; or to petals and leaves abandoned to a sudden gust of the wind; or to the shapes of dunes in the desert; or to the typical outlines of orography, or of borders that separate nations.

These are images of things which are precious and precarious, as though brought to light by the diligent hands of an archeologist, entrusted with the custody of the traces left by time.

What more can be said about a drawing? It's a circumstance, both rare and obvious, in which everything is miraculously found in its proper place. It's a bird's-eye view, or a vision that appears before closed eyes. The acrobat's smile at the most delicate point of his performance. The ancient profile of ruins which seem at the very same time to come into existence and as well to endure. The golden reflection on the curtain fringe, while waiting for a show to begin...

Photography and drawing seem in short to share the aptitude - or perhaps the calling - to make things transpire: they assume a transparency that has no end, that tends towards the infinite, that presents no "image" while instead provoking "imagination", and while always peering beyond contingent limits.

So I stop and gaze for a very long time, with no act of observation, at the most banal and meaningless painting in the window of an antique shop, or at the diminutive sign that announces with Bodonian elegance on the door of a nearby shop, "open all day". Suspended and inviolable images subtracted from the world and held in isolation; and placed where they are to arouse our wonder for the very fact, itself a wonder, of offering themselves to our gaze. And the sense of wonder increases if nothing, from one

occasion to the next, has changed, if nothing has been added to or removed from the scene.

We are all intent on something, or entrusted to something. Like the solitary navigator who leans beyond the hull of his vessel in order for his weight to hold it in balance or alter its course, we remain quite motionless, but are only apparently inactive. Permit me another image: the image of Nicéphore Niépce as waited at the window, one morning in 1822, next to his *chambre noire*... The contents concealed in that "chamber" were an impalpable illusion, but also a model. From that day on, signs and colors, volumes and distances, and everything else to which we refer as form, began to draw themselves, to deposit themselves. No longer forged by others or bent to others' ends, they effected their own transferal into simulations of the shadow of reality. That "chamber" can already be seen, essentially, as the studio of the modern artist, which is a place, from that moment on, where the visible flows into an unprotected and utterly retinal void, a photographic void.

But it's time to get on with things, and to come out into the open. Friedrichplatz is no theater, as a piazza, say in Italy, often may seem to be. Yet the tables of Café Paulus give you the impression of enjoying a special vantage point, the threshold of a door that stands ajar and offers a view of the back-stage preparations at a theater. We're in Kassel, in the days just before the opening of Documenta.

The artists are moving with quickened steps (more determined than inspired it seems) to reach their appointed places. I recognize one of them (an well-affirmed artist, certainly not *manqué*) who strides beyond space and addresses the frontiers of time: he rushes to the task of openly retrodating one of his works, thus declaring himself the precursor of an image which not only I believed to be my own. Trapped in his anxious need to correct history - "his" history - he's likely, at a rate like this, to end up by dating his most recent work to a moment before his own birth...

A bit farther on, another episode, other maneuvers so clamorous as to end up in the newspapers.

Similar things take place every other year in Venice. I'm just a few dozen yards from the entrance to the pavilions of the Bienniale. Here again, the exterminating angel discreetly keeps an eye on me, ready to go back into hiding no sooner than his figure appears to grow clear.

I stay where I am for quite some time, for no good reason, waiting for a signal from I really don't know whom, observing the unknown orbits traced by the steps of the many participants, all of them attempting to forget that they are there.

After a while, I too move on, wholly unaware of the direction in which I

have come to move. An interminable, extenuating wait; nearly a question of taking flight, with no hasty accelerations or careful pauses. Even today I cannot remember having been there, just as I cannot remember having not been there. Tomorrow there's a chance that I'll ask myself if that body was really my own, or perhaps the body of a hostage - myself - who was incapable of assuming a role. Robbed, disappointed, or *manqué*, the artist neither wants nor is able to defend himself.

"I'd rather not..". I too would like to follow the example of Bartleby the scrivener and refrain from making any statement.
Melville's words seem to echo the extreme discretion, the touching modesty of Henry James, or the ritual abstinence of Raymond Roussel, that acrobat who could set words free from the force of gravity. Or the dizzying, poetic fervor of Giambattista Marino; or, better, the resolutory conversion which Borges ascribes to him in "A Yellow Rose", remarking on the moment when "he saw that it lay in its own eternity, and not in his words, and knew that we can mention or allude to it, but never give it expression".
Some time ago, a happy coincidence gave me the chance to attend a public meeting with Borges in Rome. I'd like to quote two brief replies he offered, and which I see to be of inestimable value. A member of the audience remarked, "But you are famous as a Baroque poet, as the modern world's last protagonist of a Baroque poetic". He replied: "The Baroque, surely, is a valid form of art. Baroque poetics consists of memorable metaphors. I was or attempted to be a Baroque poet when I was young. Now I try to be simple, and I find that this is far more difficult". I grow ever more convinced that this "simple" opens back to "distant", or even to "absent".
Someone else asked him, "How do you write a poem?" He replied, "I assume a passive attitude, and I wait". I quote from memory, and Borges spoke, moreover, through an interpreter, so I'm unable to vouch for reporting his words with absolute accuracy, but essentially he stated, "I wait, and my only concern is to make it entirely beautiful; I want it all to be utterly beautiful". He then concluded: "I have the feeling of receiving a gift, but I couldn't quite say if it comes from my own memory, or from something belonging to others. And I try not to interfere too much".

Allow me once again to look for orientation in a couple of fragments that my horizon of uncertain references casts onto the shore without desiring to do so. For example, the enchantment of certain vaguely pedagogical illustrations in old treatises on perspective. Those pictures in which a group of people are intent on the study of the placement of objects in space - objects which are only volumes (cubes, prisms, cylinders) or even perhaps

less than that: pure appearances that in order to discover themselves de-limit a portion of the ground.

Or certain foreign language courses where the characters depicted are only extras and have nothing to say, finding their only function in the speaking of words that hold no other message than the exercise of pro-nouncing the terms to which they correspond.

Finally, we can listen together to a couple of phrases. "Robinson, which of the lakes do I prefer?" In this question that Beau Brummel directs to his valet, Bartleby's preference for doing and saying nothing at all becomes a forgotten preference: forgotten, unexpressed, and above all unrecorded. The dandy is thus the artifex, but not the author, of an unbridgeable, he-roic distance from the world, of a mode of writing so lofty as to have no need to settle onto a page, so lofty as to disavow the space of the page in order to hover free in the emptiness of time.

"Soyez les bienvenus à Neuchâtel". This is the phrase that the innocent hand of *l'Ecrivain*, Jaquet-Droz's robot in the Neuchâtel Museum, writes out for us; for each and every one of us, and each and every time. A si-milar robot at the Museum in Neuilly - *Le Poète* - heaves his chest, issues a sigh, and then says nothing at all.

This text originally appeared in Giulio Paolini, "Lezione di pittura", Exit Edizioni, Lugo 1994.

Motionless stillness allows the flow of time to penetrate our consciousness with even greater power and immediacy. The photographs of Hiroshi Sugimoto are devoid of people and movement. This stillness makes an accomplice of the viewer in an unspoken understanding of an allegory of time. "Night Seascapes", views of the sea and sky at night, appear in a series of virtually identical scenes whose differences are nearly imperceptible at first glance. Silence sharpens the perceptions, and subtle nuances of change become visible. In 1991 Sugimoto hung seascapes in waterproof Plexiglas frames on a wall and exposed them to a continuous flow of water. The water causes the pictures to fade, slowly dissolving their contents. "Artworks wipe away all traces of their production; the presentation of art wipes away all traces of the artwork" (Adorno). Sugimoto's photographs reduce the cornucopia of visual impressions, diverting thoughts to a single one, ad unum. Wordless immersion in abundant diversity in order to find the particular is one approach to aesthetic insight. Sugimoto photographed the guilt sculptures of the Bodhisattva Kannon, "Flod Sanju Sangendo, The hall of the 33 Bays" (1995) in Kyoto. According to legend, a true believer can find the face of his beloved among the identical figures. (G.D.)*

Hiroshi Sugimoto
Time Exposed

INTERVIEWED BY THOMAS KELLEIN

THOMAS KELLEIN: What gave you the idea of visiting the American Museum of Natural History in 1976 with a camera? It must have been an important decision to start your "Diorama" series there.
HIROSHI SUGIMOTO: It was some time ago, I think almost nineteen years. It all happened by accident. I decided to move to New York. The first things I encountered in New York were these diorama sets in the Museum of Natural History on Central Park West. When I saw them I felt as if I had taken drugs. I was wondering whether it was just me seeing, for instance, a dead bear behind glass like a hallucinogenic vision. That gave me a very deep experience and a very good idea about life. Dead animals can give you an impression that they are alive. It is my mind telling me that things are alive. But that might be just my feeling. Perhaps the whole world around me might be completely dead. That first impression of the Museum of Natural History remained very strong. Thinking it over, I wanted

* 1948 Tokio / lives in New York.

to prove that it could be presented through a photographic technique. The way I saw it has now finally found an effective presentation in my photography; so I have become confident in these "Diorama" sets. To bring the dead to life was almost like taking up a Jesus Christ idea.

KELLEIN: Did you check other photographic techniques early on, using colour film or flash lights to create these pictures?
SUGIMOTO: No, colour photography is too artificial for me. It doesn't seem to represent reality or nature. The colours look like chemical colours. Black-and-white is an abstraction from the real world. It gives people a more realistic impression. They can project their own image of colour into the black-and-white.

KELLEIN: In the Museum of Natural History all original diorama sets have very strong colours. When I saw the installations after knowing your photographs, I immediately thought the black-and-white might be the reason that your photographs look like snapshots taken in real nature; whereas the colours in the museum look so artificial that the make-believe function of the museum showcases does not work any more.
SUGIMOTO: Yes, the colours come from the backdrop paintings. They were quite nicely done during the Federal Art Project in the 1930s, but these are the colours of the painters. They do not represent nature. When people in the museum see the actual diorama sets, they see some paintings and a kind of stage design. The dead animals and the other materials appear theatrically in front of these backdrop paintings. By looking at black-and-white photography, people activate their own imaginations. They make themselves believe that this is the real world. Over the years, I have hung many shows and I have encountered only a few people who had doubts that the "Dioramas" were photographs from reality. Many people don't even notice it. With the "Seascapes" the opposite happens. They ask: Were you really there, did you really take the picture on that coast?

KELLEIN: Would you think that the illusionistic effect of black-and-white in your photography functions in the same way for all the different fields you are working in, that is for the "Dioramas", the ""Seascapes"" and the "Theaters"?
SUGIMOTO: There is no way of truly representing natural colour, either in photography or in painting. In painting they have done it for several hundred years. Photography by contrast is only 160 years old. However, photography in black-and-white is still the best choice, colourwise and formwise. I very much admire the Flemish painters of the 16th century and their realistic visions. Their craftsmanship reaches, I think, as far as painters can reach. There is a different tradition of realism in Japanese sculpture,

also in Chinese painting during the Sung dynasty, but in Japan especially during the Kamakara period (1185-1333). They created very, very good portraits. The Flemish and Italian Renaissance paintings were a great moment for realism Jan van Eyck, Petrus Christus, Rogier van der Weyden. I strongly feel that there is a relation between this kind of painting and the early stages of photography.

KELLEIN: So you admire craftsmanship and a scholarly approach to art? Do you think that art can reach an ideal result?
SUGIMOTO: I have learnt a lot from studying craftsmanship in painting, and I admire the minutiae of that art. That is very important because it still gives strong impressions to the people. They naturally want to see the details. Every living person has eyes constantly moving, all the time. People cannot really concentrate. They don't look at a thing for a long time. Our eyes are always moving and searching for something else to see. We have no quiet and peaceful moments to face something. This is a major function of painting and photography. You can look at the portrait of a young, woman by Petrus Christus quietly, little by little, and study the details for one hour or even two hours. So you get into the details of her face. In front of a real young lady that is impossible (laughs).

KELLEIN: She would probably start to look back, right?
SUGIMOTO: Yes, and then you seem to behave like a dirty old man (laughs). But the function of photography is the same. The work makes you really stop and study something. It freezes the world and keeps it there, immobile, open to your research and study. In order to study the world, you have to stop it. It is the same procedure as if you were a scientist studying an insect. You have to kill it and then sit down and start examining it. This same method is used by the photographer. You use a sample to understand the whole thing, the whole world.

KELLEIN: Can we talk about your other groups of work? We mentioned the "Dioramas", but can we also talk about the "Seascapes" and the "Theaters"?
SUGIMOTO: Actually all my three photographic series started around 1976/1977. In all cases I started with an idea. It took me quite a while, however, to find out if it would work. My method is different from the one that most photographers use. I do not go around and shoot. I am not a hunter. I usually have a specific vision, just by myself. One night I thought of taking a photographic exposure of a film at a movie theater while the movie was being projected. I imagined how it could be possible to shoot an entire movie with my camera. Then I had the very clear vision that the movie screen would show up on the picture as a white rectangle. I thought

that it could look like a very brilliant white rectangle coming out from the screen, shining through the whole theatre. It might seem very interesting and mysterious, even in some way religious. So the next step was to make that happen. If I already have a vision, my work is almost done. The rest is a technical problem. It is a very difficult process, though, because you have to keep trying and trying. My work becomes a trial-and-error process. The results have to coincide with my vision. With the "Theaters", the first test was actually quite successful. It was basically easy but I still had to refine the quality a lot. It took about one year to get the quality I wanted. Since then I have kept going on and on.

KELLEIN: What happened with the "Seascapes"?
SUGIMOTO: It was the same thing. I was half asleep when I had a very clear vision of a sharp horizon, a very calm seaside, with no clouds and a very clear sky. The horizon was exactly in the center of the image. That vision was probably something dating back to my childhood. I still remember my first encounter with the ocean. I was born in Tokyo, which is near the sea. Usually Japanese people like to see Mount Fuji. For me, it was very important to see the ocean, the big ocean. I liked this image and I started to think about a series. It had to do with the idea of ancient man, facing the sea and giving a name to it. Naming things has something to do with human awareness, with the separation of the entire world from you. Language has to do with the need to communicate with a world that is separated from yourself, the separation between inner world and outer world would be less clear without language. So with the "Seascapes" I was thinking about the most ancient human impressions. The time when the first man named the world around him, the sea.

KELLEIN: What about the "Dioramas"? They also have to do with very early stages of mammals and human evolution.
SUGIMOTO: All of the series are interrelated. They all came to me around 1976 for some reason. Probably that was the most imaginative time of my life, shortly before I was thirty years old. Since then I have been like an old man, practically. Nothing that strong has happened to my mind since then. I stay up late, intentionally, but nothing happens (laughs). Maybe I am already half dead.

KELLEIN: Can we speak about your plan to photograph the "1001 Standing Images of the Thousand-Armed Kannon Bodhisattva" in Kyoto, the Sanju Sangendo?
SUGIMOTO: Yes, this is the best extension of the "Seascapes" idea. These Buddhist wooden sculptures of the 12th to 13th century present an identical image a thousand times. But they are all different. The "Seascapes" fol-

low the same kind of concept. They all look alike, but they are located at different places in different countries, and the oceans have different names. In the case of the Sanju Sangendo I don't know the original concept behind these sculptures. To me, it is very similar. Visually it is very different, though. It is the idea of one thousand and one times a one thousand-armed Kannon. The artists made the figures intentionally different. The Bodhisattva figures are arranged horizontally in thirty-three bays. When I took the picture of each, neighbouring pieces would overlap each other. I would like to present this work in a sealed space with four walls. People would feel that they were surrounded by this order of Kannon Bodhisattvas. This is a recent idea, but it is not different from my previous work.

KELLEIN: Let me ask you about the contents of the three different large series, "Dioramas", "Seascapes", and "Theaters". They seem to cover the different fields of man, nature and culture. Is that an oversimplification?
SUGIMOTO: Man, nature, culture? I was thinking more of art, science and religion, but these have the same roots originally. A Renaissance idea of unity that has since been divided. Today, many people see no connection between the different fields. To me, it is all very obviously one thing. So the "Seascapes" are not representing man and nature only, they are also very religious. Many people have pointed that out to me. The same with the "Theaters". Some people see them as a religious image. One young girl who was studying one of the cults of Buddhism using chant, suddenly started chanting while looking at my "Theater" series. This was amazing to me. I didn't mean that (laughs). The "Seascapes", of course, represent nature in a very straightforward way, and science, too. You can see science especially in the "Dioramas" that deal with early stages of mankind in the prehistoric age. The diorama sets in museums are all presented in the name of science, whether you believe it or not. To me, it does not look like science, but like science fiction.

KELLEIN: Do you use the same camera for the three different bodies of work?
SUGIMOTO: Yes, I have only one kind of camera, which is American-made. It is a wooden camera, like a 19th-century style box.

KELLEIN: How large are the negatives?
SUGIMOTO: Eight by ten inches. This is the maximum size that I can carry by myself. I travel a lot, and that is my physical limit.

KELLEIN: What about lighting?
SUGIMOTO: I always work with the available light. For the "Dioramas", for instance, I cannot get into their spaces. They are sealed. Usually they have

too much light for me. If I can turn some lights off, a good result is easier to reach. Sometimes I can cut the lights off, sometimes I can use a blackboard, too. I always use long exposures, ten minutes, twenty minutes, sometimes forty minutes. I use some interesting photographic techniques like dodging, which means covering certain areas of the image during the time of the film exposure in order to have some other parts come out more clearly. If the sky, for instance, is too bright I cover a part of it during the exposure. The same is possible if the foreground needs more light. I try to create a very natural lighting in my photographs. So I actually recreate the diorama scenes. My transformation of the diorama into photography has the purpose of making it more believable, more real.

KELLEIN: So make-believe seems to be a crucial quality of your work. On the other hand, if you look at an animal in these photographs, you realize that the scene cannot be true, although it looks like a snapshot. It looks completely surreal.
SUGIMOTO: Right.

KELLEIN: You told me the other day that it is especially difficult to work on the Seascapes.
SUGIMOTO: Since I have been working on the "Night Seascapes" too, I have been in a twenty-four-hour operation. I work day and night. I stay up continuously, every day. Technically speaking, the "Seascapes" are truly the most difficult works, although they seem to be simple to do. You just go out and you take a picture of nature. There is literally no technical gimmick involved. But regular nature photography uses a lot of trees or mountains, or other figurative things. But if you intend to take a picture of the air, how do you do it? Air is transparent, there is nothing to see. You have to have a hundred per cent pure processing method, otherwise many different things show up in your negative, for instance the unevenness of the film emulsion or even dust. You have to be extremely accurate to record very minor things. It is like listening to the insects in a field. With a garbage truck next to the field you won't hear anything.

KELLEIN: How long is the exposure for the "Seascapes", usually?
SUGIMOTO: It is very straightforward. In the daytime it is 1/30 or 1/60, during the night sometimes between five and ten minutes. I have started to try two- and three-hour exposures for the "Night Seascapes" now, because I watch the stars and the moonlight. I don't want to photograph the moon itself, but its passage over the water and the light it throws.

KELLEIN: Is this to make these photographs more natural, or even more painterly?

SUGIMOTO: Yes, the "Night Seascapes" function almost like a painting. I design the visions first. Then I calculate the passage of the moon and its lighting, also the degrees of the moon by the season and by the time of night. So today I work more like an astronomer, by calculating the visual effects. I want a macrocosmic effect on the image. The direction of the moon is very important. It has to be south or south-east of the position of the camera. It is also of importance where on the globe you take the pictures. The further you go north, the more the moon will move horizontally Towards the equator the moon shoots up straight. This is something you can design before you create an image.

KELLEIN: Have you ever thought of enlarging your prints so that they would meet the sizes of today's large photography, often shown by other artists?

SUGIMOTO: I want to make people see my works twice, from a distance and from close up. If you have a large photograph you start to see the grain. You see the water, for instance, as a large amount of dots, and that is where the image ends. Everything is a dot. By using my size, which is four times bigger than the negative, people can get very close to the image and truly study the waves, for instance. You still don't see the grain. I want people to be drawn into my pictures.

KELLEIN: Why did you choose the title "Time Exposed" for this publication?

SUGIMOTO: Time is a theme of my work. All three series are related to time. The "Theaters" are images of constant movement. The "Dioramas" are continuously still. The "Seascapes" are split into two images, an image of the sea and one of the sky. Both have been in motion since their creation.

Thomas Kellein, an art historian, is director of the Kunsthalle Bielefeld.

The interview originally appeared in the catalogue, Hiroshi Sugimoto, "Time Exposed", Kunsthalle Basel, 1995.

There is no black curtain concealing the entrance to the video presentation room, and not a single sound is heard outside - nothing to heighten the sense of anticipation. In dispensing with these elements of staging, Diana Thater steers the viewer's gaze directly towards her world of images. Oversized projections of the pictures cast on the walls of the room by a beamer give the viewer the sense of being totally surrounded by visual impressions. The room becomes a constantly moving carousel of colorful sensations, narrative images and technical apparatus. The videotapes are characterized by the interplay of formal structures and narrative pictorial elements. Diana Thater finds ideas in literature, in science fiction as well as in fairy tales. Her stories deal with the subjects of being and consciousness, Man and nature, nature and the natural. The artist reworks the narrative plot by preparing indexes; restructuring items of content beyond recognition. The simultaneity of structural modification and rigorous alteration of the narrative action permits the artwork to develop a complex life of its own. The world of images in motion becomes a projection of the artist's own subjective self. (G.D.)*

Diana Thater
Who Are We?

INTERVIEW BY OTTO NEUMAIER

OTTO NEUMAIER: The title of your most recent work is "Electric Mind". I guess that many people would expect a kind of virtual-reality installation when they hear something like that. But what they see is a kind of return to nature. There is certainly a relationship, however, between the title and this return to nature. Could you explain this a little bit?
DIANA THATER: The title is actually taken from a phrase contained in a short story by Pat Murphy printed in Isaac Asimov's *Science Fiction Magazine* in 1985 which I used as the basis for a screenplay which, in turn, the installation is based on. In this short story, a girl is killed in a car accident, and her father, a scientist who is experimenting with transferring the mind of one person to another one, imprints her mind onto the brain of a chimpanzee so that something of his daughter is left. The father refers there to the patterns, the habits of the mind as like an electrical fingerprint. And he says that he takes the fingerprint of the electric mind and imprints it on the chimpanzee's mind. The mind of the chimpanzee is not replaced, it has just an electrical overlay on it.

* 1962 San Francisco, California / lives in Los Angeles.

Neumaier: A kind of software programming?

Thater: Exactly, on top of it. It is simultaneously two minds. The title of the short story is "Rachel in love". But I preferred the title "Electric Mind", which I took it out of the story because it also refers to the way I see the mind as multiple things, as one thing overlayed on another overlayed on another overlayed on another..., and because the relationship between these things is electrical. In other words, it's a life, it's in constant motion, it moves. I don't see history as a linear evolution. I see it in the same way as the installation, that is, like multiple layers which are evolving at different speeds, like the planets going around the sun. Everything is moving at different speeds and encountering each other at different times, and who you are at a specific moment is a result of which patterns encounter which patterns and which overlays are on top of each other. So you are never the same at any one time. We are continually in flow. And that's why the title "Electric Mind" is really meaningful to me. And, of course, we do go back to the primate. We go back to this chimpanzee. And there is a relationship between all of my works: Who we are right now is what we were and what we will become. There is a simultaneity of everything in our lives. And encoded in us is the fact that we were once apes.

Neumaier: It is really amazing that we experience ourselves as one person although when I was born I was someone totally different from what I am now and what I will be at some time.

Thater: But what you are now encompasses what you were and who you will be. And this also refers to the mind of the viewer who is ultimately the subject of the work. They must take all of these things which they are given and construct them on their own.

Neumaier: Is there a connection between "Electric Mind" and your earlier work, for instance "China", where you also refer to a novel? And there is a similar motif in this novel by Angela Carter, since there is also a girl, and this girl decides to become a wolf and to live with the pack. In "Electric Mind", the girl doesn't actually decide to become a chimpanzee.

Thater: No, it's inflicted on her. In Carter's story the girl makes a conscious choice to become something else, to give her life another aspect, whereas in this story, the girl is not given a choice. But in the end she chooses to live her life as a simultaneous pairing of things. So she accepts it. In the story she continually asks her father: "Am I real?" And it keeps coming back to her: "Yes, you are real". Which overlay is dominant, whether it's chimpanzee or girl, whatever it is, is real. And she has to accept that. It's a sort of coming of age story. And it's the same with Angela Carter.

NEUMAIER: "Electric Mind" is based upon a screenplay. Do you have plans to make a film out of this screenplay or was it just a kind of model for the installation?

THATER: It was intended as a model. The film was never intended to be made. In my work the central object, the center or main element, is always missing. In this case the film would be the central object. Everything would point to it. The reason the center is missing in all my works, however, is that the viewer is supposed to step into the place of the center and to construct for her- or himself what that centrality or what that primary thing looks like. And the point about giving so many clues, so many arrows and so many directions toward it is that the center becomes every viewer who enters into it. All of my work is referential. It all refers back to the model or the thing. The thing that's missing is the model. The thing that's missing is the synthesis of all of the elements. But all of these things point to it.

NEUMAIER: "Electric Mind" contains on two monitors a series of words or concepts. Is this a sequel to the "indexes" you introduced in earlier works?

THATER: Right. I always make indexes with my works. In this case, there is the phrase "A mouse is a cat is a chimp is a girl". But it's actually listed as "mouse, a is", "cat, a is", etc., like an index entry if you look them up. And, of course, the final entry is "girl, a", and there is no "is" so that it indicates that it's the last one in the list.

NEUMAIER: Is this the last element also in a semantic respect?

THATER: If we make the whole thing into a sentence, it's the last thing. It's the end of her journey, which is to find out which of these things she is.

NEUMAIER: And the end is just to accept herself as she is?

THATER: Yes. And this amounts to accepting the fact that she is many things all at the same time. And the point for the viewer, of course, is that the work of art is many things at the same time and that the viewer him- or herself as well. And never a synthesis, never a thing, but always a space; never an object, but always a subject. If we had to make the choice: "Am I a thing or am I a space?", we'd rather be a space than a thing. "Am I a subject or an object?", we'd rather be a subject than an object. It's how we construct our relationship to our lives, how we construct our relationship to a work of art, as opposed to standing in front of the work of art and having it tell you everything that it is and to direct it at your point of view instead of have it flow around you.

NEUMAIER: The screenplay "Electric Mind" contains a story, a narrative. This is not to the same extent true of the installation. But you talk your-

self about a narrative contained, maybe, indirectly in the installation. Should we take this literally?

THATER: The narrative implicit in the installation is always the story of its being made and its being shown. The installation not only includes the images, it includes also the equipment which is laid out for you to see and to interact with spatially and sculpturally. So the narrative implicit in the installation is not only a story of the past, when I videotaped it, it's also a story of the present, when it exists.

NEUMAIER: But this would be a kind of narrative which can essentially be reduced to self-reference. And a language-game of self-reference is not a narrative in the strict sense. Language can be used in many various ways, of course. One way is to tell a story. It is almost impossible, however, to tell a story in an installation which surrounds you. So, this is a different language-game, and we have to ask: What is this language-game? It includes self-reference. So the next question is: What does self-reference mean? It can be used differently, for instance, to suspend or remove the meaning of an utterance. Apparently, by "telling" the story of how it was made, your installation says: "That's what I am". This has a technical aspect as well as an ironical one. But this is perhaps also the place where, in a meta-sense, a kind of narrative comes in which answers the question of the installation about "Who am I?", that is, the installation says: "Well, look around, that's me".

THATER: Everything in the installation is supposed to say: "This is who I am". The equipment is self-referential. In the shooting of the work, you have three cameras, and in the projection of the work, you have three projectors, and they take the place of the three cameras. So, things replace other things and refer back to the previous thing and forward to the next thing. I am the artist, and then I identify artist and camera, camera and projector, projector and image, image and viewer. So, there is this chain of references: One refers to the other, and each one refers back to the one before it. And the question is: What is the work of art? Who projects the work of art? Is it the artist or the viewer? Who projects meaning into the work of art? Obviously, all of my work is ultimately meant to exist in a sort of fully intensified present, the moment when the viewer enters into it, synthesizes and starts to put things together and link up chains and link herself to the projector, the projector to the camera, the camera to the artist, the artist back to the viewer. Once you start to participate in this linking of chains of references and self-references, you come back to this idea of what is the work: It is a projection of myself and of what I construct out of it.

NEUMAIER: In general, this game of self-reference is open-ended, infinite.

Maybe, this is also one point of your installation "The Bad Infinite", where you have the images of one camera and the images of a second camera which show also the first camera. Of course, you could go on and on and on.

THATER: And the third camera sees the second camera and the first camera and the people carrying the cameras through the forest. Again, it refers to its maker and its being made and its being shown. And all of these references are supposed to contribute to the momentary experience of synthesizing it, how all of these references come together.

NEUMAIER: But this is in some sense true of every kind of art. It refers to the artist also, sometimes indirectly.

THATER: Of course.

NEUMAIER: Many authors characterize your installations as the viewers necessarily being involved in the whole event or process. It seems to me, however, that this is a characteristic of any kind of installation. For, if it's an installation there is no possibility to have the usual face-to-face relationship of a viewer, but you are surrounded by a space, you are involved in the space. But what is then the difference which distinguishes your way of working from other kinds of installations?

THATER: The point of the viewers' relationship to the work of art is that this imagery is filmed and videotaped with an empty space in it already that is left for the viewer. For instance, I made a piece called "Abyss of Light" which is a Western, a Western where you are continually, if it were a John Ford Western, waiting for the hero to emerge on the scene. And the point is that the person who we are really waiting for to emerge is the viewer. And the viewer is the hero of my Western, the viewer is the subject. So the work of art is not positing itself as an object, it's positing itself as a reflection of the subject, or has a place for the subject to stand. So it's not something to be looked at, it's something to be looked with, which is, of course, *not* true of most installations.

NEUMAIER: You mentioned John Ford as a reference point for "Abyss of Light". This brings me to ask for the role cinema plays in your work.

THATER: All of my ideas come out of cinema. The reason cinema is so interesting to me is that when landscape was no longer a viable representational subject in the work of art, i.e. in paintings, it made this transference into cinema. The image of the nineteenth century landscape painting, the landscape, became cinema. And the meaning of the landscape painting, of course, goes into non-representational art. This sort of transcendent feeling that we gain from, say, German Romantic painting, we can simultaneously gain from a John Ford Western or an Ad Reinhardt Black

Painting. So there is this sort of simultaneity where the primary image from the nineteenth century painting, the landscape, splits off and goes to become the background for cinema and the meaning of abstract art in the twentieth century. This is what I take from cinema, and a lot of my work is based on cinema. For instance, "Electric Mind" is based on the opening sequence of a James Bond movie. I take these weird references from cinema, simultaneously from John Ford and from Godard, but also from American structuralist cinema, from people like Hollis Frampton and Paul Sharits, who are using the machinery to refer to itself and constantly to be a reflection of itself. I'll take it wherever I can get it. But all of my work finds its basis in American cinema, which utilizes the landscape as a character.

NEUMAIER: There is perhaps one difference between an installation and traditional landscape painting, where you have, on the one hand, a prospect to some natural process, which is often dangerous, even life-endangering, but, on the other hand, the point of view of the viewer is from a refuge so that he or she is not really endangered. This doesn't work in an installation, because you are surrounded by the whole thing.

THATER: It's the encountering of the sublime. If you just look, say at a Friedrich painting you see the little, tiny character and the awe-inspiring landscape, but you are here and you are safe. But when you go to the Grand Canyon, you are not here and you are not safe; you are surrounded by it. But at the same time when you are looking at the Friedrich painting and you are safe, *you are not safe*. Because, if you feel the painting, if you really look at the painting, the sublime is not the landscape, it's the *work of art itself*. And then you are no longer safe, because that's the awe that you encounter. And so in my installations I want to make that happen as well, that there is this dislocation of the center, and there is this moment when you are surrounded by what is perhaps the most beautiful thing you have ever seen or the most frightening you have ever seen or simultaneously both. This encounter with the sublime can happen in front of a Barnett Newman as easily as it can happen in the desert.

NEUMAIER: You made one installation with the title "Up to the Lintel" which is just a literal translation of "the sublime". As far as I know, this was a self-referential piece too, that is, the location where the installation took place was filmed and then projected onto itself. Was this a realtime projection of the images?

THATER: Yes, it was shot between six and midnight, and it was projected between six and midnight. So, you have really Newman's "The Sublime is Now" perspective: right now, right here with me, in this place, in this time. The piece took place in a suburban house, in a very beautiful lit-

tle neighbourhood in California. You know, the sublime is most unexpected when it enters into that sort of an environment. And so you would drive down this street and you would encounter this little suburban house that was glowing and pulsating with video images of itself, and the sunset was directly behind the house. I based this piece on Magritte's "Empire of Light" where in the sky it's daytime and in the house it's night. The sky would be lit-up orange, pink and blue, and the house would be glowing with the colours of the video band. The viewer would come into the house and walk around, and in the last room she would find a perfect little architectural model of the house that was also lit-up from inside. So first, you encounter it large, overwhelming and glowing, and then you enter into the building and there are video projections everywhere, and you are going to this last room, and there is a little tiny model. So once you are outside and then you are inside. And this is also a characteristic of the sublime. You are very large at first, and then you become very tiny and small. There is this feeling of fear when encountering such a vast thing.

NEUMAIER: Usually when the sky darkens and the houses start glowing, this is because people watch TV. Maybe, the main difference between watching TV and entering a video installation is that in watching TV you have really a narrative there. Therefore, you make different experiences, and in some sense you are removed from your everyday experience, particularly in America. This brings me to ask whether people have difficulties to change their points of view or whether they expect a kind of narrative when entering your video installations.

THATER: Yes, I think so. And they have a very short tension span for a video installation. But I don't care what their expectations are. In order to experience a work of art you have to be willing to give yourself up to it. We are larger than TV and we control it. But the point about my work is to say that what you look at looks back at you. So that's why it's larger than you and why the house is glowing, and it's obviously not TV. It's not someone watching TV in the living room. This is projected at you. And it's larger than you. And it acknowledges your presence by leaving this open space for you. So it has a consciousness of you as well. As we say: When you look long into the abyss, the abyss also looks into you. And that's why I named that other piece "Abyss of Light". When you look into the emptiness or when you look into the video installation, it looks back at you.

NEUMAIER: This is perhaps also a reason why you chose the medium of the video installation which gives us experiences of space and time, and in your work there are lots of back-references in temporal and spatial re-

spects. If I see it correctly, in "Electric Mind" there are also inner and outer spaces projected into each other, in a physical sense as well as in a psychological sense. You can look outside the door at one projection, but on the other hand, when coming from the outside, you can see already a bit of what's going on inside. So, there is a kind of translucent membrane between the two things.

THATER: And this is why I really did make an effort, and still do, to differentiate myself from the video installation artists who came before me, by not showing my work in a blackened room. And I don't want my work to be in a theater. I don't want my work to function like a dream, where you enter the darkened room and the image appears before you on a huge screen. I want to acknowledge that the outside world exists. So, windows are left open, doors are left open, and I use these neutral density film gels just to darken the glass so that the light doesn't make the image impossible to see. So, as you are coming up to it, you see that there is something happening inside, and when you are inside, you see that there is something happening outside. There is this interchange between the inside and the outside. So, the video installation and the work of art doesn't exist in a vacuum.

NEUMAIER: Could it be, however, that you would also like to prevent that the technology is so impressive?

THATER: Yes, you are not supposed to be in awe of the technology. And I purposefully make my work all myself. I don't have five technicians running around to do it for me. The whole point of that is to make what a person like me could make; and one aspect of this is that it's not awe-inspiring technology.

NEUMAIER: This is shown by the defamiliarization of the images caused by the techniques you use. There is at least one technique, however, which impresses by its absence: You don't use sound, you have a silent room. This is awe-inspiring, but it is part of your technology.

THATER: Well, the point with that is that you are supposed to hear the equipment. Furthermore, sound is often used to lead the viewer. And a lot of video artists have used sound to frighten the viewer. I am sure you have seen a lot of works like this. I am not against that, but I am very interested in it. I don't want to use sound to frighten or to guide the viewer, however. I want to use the image. I am really interested in the dominance of the image.

NEUMAIER: But you made a piece for MTV which includes sound.

THATER: There I collaborated with a sound artist, T. Kelly Mason, to make a soundtrack for the piece. "Shilo" is the only piece I have really made

sound for, but if you watch "Electric Mind" closely, you see there is a sound recordist in this piece. He is there with a microphone. He is recording sound, and it exists.

NEUMAIER: But where does it go to?

THATER: I would like to make a piece for commercial television, and I would also like to make an advertisement for a piece like "Electric Mind". Then I will include sound. But I don't want to use sound in the installation to guide the viewer into some kind of thought. I prefer the live sound of the moment that you are in.

NEUMAIER: Has your artistic approach something in common with the approaches of some sound artists or composers, for instance John Cage? You used prepared monitors, for instance, and this reminds me of the prepared piano.

THATER: It's based on the prepared piano. I am interested in these approaches, because I think what they formulated was not necessarily a way of working just in music. For instance, Nam June Paik made prepared video monitors with big magnets stuck on them. And a lot of early video artists we no longer hear about made fantastic prepared video monitors. So, I go back to the beginnings of my medium and refer to these people. When I say "prepared monitor" I am referring to John Cage and I am referring to Nam June Paik. I am consciously referring to the history of my medium and where it comes from. And I am interested in continually referencing that and simultaneously moving away from it, so, introducing other elements into it. Of course, what I introduce into it is a false narrative. A lot of those people didn't work that way. You know, when Nam June made "prepared monitors" he just turned the television on and let it play broadcast TV, but I introduce my own imagery into that. This is the addition that I have made.

NEUMAIER: Let me come back to "Shilo" and "China". In the center of these pieces is nature (as well as perhaps in all of your pieces). It is our animal nature which is in their center. Some people regard "China" as a comparison, or as a play, between domesticated nature and wild nature, but we could see this also from another perspective, that is, that those domesticated animals represent our wild nature, or the animal nature of humans.

THATER: Six of one half a dozen of the other. I work with animals, but I don't work with random animals. I choose the animals that I work with because of their relationship to society. And I chose wolves because wolves were the first animals domesticated by men. And I chose them because they chose us.

NEUMAIER: And you chose chimpanzees because they are the closest to us on the evolutionary chain?

THATER: Exactly. And I also worked with talking birds. So I work with animals with whom we have constructed a kind of close relationship in that we ask them to imitate us in some way. We ask them to be like us. But the point of all my work is: Isn't it we who are like them? I wrote an essay about "China" which opens up with the remark that when man first saw a wolf he realized that the wolf could be like him. And the essay ends with: Wasn't it the wolf who saw that we could be like them? So, we have constructed a relationship with this animal based on who we think we are and who they think they are.

NEUMAIER: So, the essential question is "Who are we?". This brings me to my final question: In your installations we are surrounded by what's going on. We make always the experience that something is happening in our backs and that we can't escape what's going on. In connection with what you said about the sublime, our position in nature etc., there is one main thing which we can't escape and which plays the essential role in the discussions about the sublime, that is, death. Death is also a part of human life. If we ask who we are, we have also to include that we are mortal beings. And to be mortal means that we are finite. The best way to demonstrate our finiteness is time, and time is an essential element of your work. So my last question is: What is the role of death in your work? Is this part of our nature also there?

THATER: In the temporal and spatial environment that I create there is simultaneously the sense of loss. When we encounter the sublime, the reason we are so afraid is because we encounter our end, we encounter our annihilation. And in work of art such as this I would hope, and I have found, that viewers often leave with this profound sense of sadness, because there is this loss at the heart of it, there is this emptiness at the heart of it. It is the loss of ourselves which is, of course, the ultimate loss. This is related to the idea of the sublime; that when we encounter something and it causes this response in us, that this response really comes out of our loss of ourselves into the landscape, or the loss of ourselves into the work of art which is a sort of small death. We enter into the work of art and we lose our hold on reality.

NEUMAIER: As you certainly know, according to Schiller the sublime refers to something we can't escape physically. The only way to deal with it would be to get a kind of moral superiority about it. Do you think that this is really possible or that it could be achieved by dealing with art? By making this experience of getting a kind of quietness or calmness, by let-

ting things be, by allowing them to be what they are - like the girl in "Electric Mind" who allows herself to be?

THATER: Accepting who she is is accepting the fact that she is temporal, that she soon, too, will be lost. There is a profound sadness in that, but it is also the same place from which we experience joy. And when we experience a work of art, I do believe that the two primary experiences that we feel are loss and joy. That's the most beautiful thing about a work of art. And only when we have them together can we have either one of them.

The conversation between Diana Thater and Otto Neumaier took place in Salzburg, on 11 June, 1996 on the occasion of the opening of the exhibition Diana Thater "Electric Mind" at the Salzburger Kunstverein.

Otto Neumaier, a philosopher and writer, teaches at the University of Salzburg; he is editor of Conceptus and co-editor of Noëma.

Since so much art has already been produced, Rirkrit Tiravanija asks, how can one justify the intention to make more of it? By inventing totally new kinds of art objects? There is nothing less appealing to Tiravanija than the prospect of exhibiting finished art objects. Instead, he diverts attention to the context of art, using communicative modes of direct interaction. Tiravanija sets up meeting places to satisfy a simple desire: people meet, talk with each other, eat together. In 1995 Tiravanija converted a New York gallery into a kitchen where he made Thai soup. A year later he had a replica of his New York apartment built at the Kölnischer Kunstverein. After furnishing the rooms he made them available for visitors to live in. The artistic gesture insistently calls attention to the cultural environment. In offering an abode, Tiravanija realizes his concept of art as a form of open communication with an ethical focus on the other and thus stimulates a discussion of the context, site and place of art today. (G.D.)*

Rirkrit Tiravanija
In and around Minneapolis, March 1995

INTERVIEW BY ROCHELLE STEINER

Following are excerpts of a conversation with Rirkrit Tiravanija that took place in and around Minneapolis between March 16/21.1995.

ROCHELLE STEINER: How did you get started as an artist?
RIRKRIT TIRAVANIJA: I left Thailand just as I finished high school. I went through an American education in Thailand at an American Catholic school, so I was already speaking English and had some basic ideas or illusions about western things. I never really had in mind that I was going to become an artist. I made good drawings. These things are in retrospect you're here, you look back and you realize certain things. When I was a child, the teacher I liked the most in school was the art teacher. I could relate to him. He taught me how to tie my shoe lace. The first time I realized that I was interested in anything was when I made a little drawing of a bee in the 5th grade - no 4th grade - and the teacher really appreciated it and showed it to the class. That was a little thing, but the idea of art was not really a consciousness. It was just there - something you do something you enjoy doing, and something you could do by yourself.
When I was 19 years old I left Thailand and went to Canada. At that point

* 1961 Buenos Aires / lives in New York.

I left high school thinking I would go into photojournalism because I enjoyed the idea of being mobile, of traveling a lot. I wanted to see everything, and this was a situation that could put me there. I wasn't really ever interested in making a lot of money. I just wanted to get by, but I wanted to see everything. So, photojournalism was the way to go. And at age 19 I had no idea what art was, what it looked like, or what it really meant. I knew Picasso, maybe but just by name. I had never really looked at it. I went to Paris, and went through the Louvre, and saw some things, but they were just things on the wall. So then I went to University and took history to start my relationship with photojournalism. I also took a class in modern photography and a class in contemporary art history. I saw certain things from the slides and listened to the instructor and something clicked. I realized there was something more than just traveling, and looking around, and looking at things. There was a bit more. So I went to the counselor and asked about art schools, and applied to the art college. I had an interview. That summer I just took some photographs, made some watercolors drew some pencil drawings. I went with the portfolio, and I got accepted into the school. It was kind of just falling into it.

STEINER: What did your parents think?

TIRAVANIJA: My father wasn't resistant to what I was doing. He never made any issue of whether I was something or the other, but art wasn't something he really encouraged either. I always said I would go into architecture. Since I liked art it was something I could do and earn a living with. My father still doesn't know exactly what I'm doing today because all of my family is back in Thailand. I tell them I'm travelling, and doing this and that, but I never really explain that I'm making art, or what the art is, and how it works.

I've noticed that since I've left Thailand, art and culture - or the idea of having some sort of cultural identity - has changed. There is a lot more support now in Thailand for artists. You could actually make a living as an artist. People actually say to me now that it was a good idea to become an artist because you can make a living. So it's kind of an interesting thing. I don't think people will ever understand exactly what I'm doing, but I think it's important to keep doing it. And I think it's important for them that you keep doing it because even to point to a little thing where they might be inspired is important. Even if they never understand it...

In Thailand, art was always in certain ways in life. It was in things you use, like in the cups and the spoons, and it was always there. So you never had a distance from it. You don't look at it as art, but as something you use. And the distance from it is a kind of different approach to dealing with what art is or what art could be. And maybe that's kind of a western think-

ing. You have to balance yourself between the two because you are in between somehow.

STEINER: Is that how you would define yourself as an artist - situated somewhere between western and non-western ideas about art?

TIRAVANIJA: I kind of try not to call myself an artist... There is always a point in your life where you make things, or think about making things, and you feel like you need to show them, and show them in specific situations because they mean certain things. Having been through certain things I can say that I think you have to be true to yourself. In the end it's really yourself you're dealing with. A show in a museum is significant because you can talk to a lot of people and have a dialogue, but at the same time it's probably the last thing you want to think about in terms of what you want to do as an artist.

Art has many different levels, and you have to make your own level. You have to decide where you want to be, and then just go for that. It doesn't have to do with anything else in the world. Just yourself. You get there, and maybe nobody sees it, but you get there. It is, at least as I think of it, a spiritual thing. And you can't lose that spirit just because there are other things distracting you from what you should be thinking about.

My relationship to being an artist is to not be defined because there are many ideas of what an artist is. If you define yourself then you're already there: you already know what you are and you don't have to go on anymore. So my relationship to not defining myself is in the interest to keep moving. I may make the same thing over and over again until I die, but spiritually it goes forward. That's how I see it. But I think the thing is not to let other people define you, so that one doesn't have to even discuss this relationship of whether one is an artist or not. People have asked me when I became an artist, and my answer to that is when I learned how to tie my shoe lace. I think that in that act certain things became important, and that's how I've come to this point.

STEINER: For people who cook curry on a daily basis, what do you think the would say about that aspect of your work?

TIRAVANIJA: Well, there are some fantastic historical moments in art where, say somebody shows up with the urinal and puts in the space and that changes a lot of things. Cooking is something you see everyday, and you do everyday, but it's changed. When I go back to Thailand, it may cause some reactions, but I don't really know.

STEINER: One thing I've learned about your works is that everyone remembers it in a very personal way. Everyone has a different memory of their experience with it. It's not the same as a recollection of a painting

hanging in a gallery or museum, though of course everyone has their own experience of a painting too. Through your work the individuality of the viewer is intensified. You have your own experience based on whether you came in and ate, or saw the dirty dishes after the fact, or were passing through the installation and didn't know it was art.

TIRAVANIJA: Art works in different ways and in different situations, so one could possibly say that one's always making art. And then, on the other hand, one could also say that one is never making art. It depends where you're standing. It depends who you're talking to. But I think art is always being made. It's just a matter of perspective.

ROCHELLE STEINER: Do you think you're going to leave New York?

TIRAVANIJA: Well. I'm always kind of leaving. That's why I live in New York, because it's one place where you can go easily to anywhere you want. In a funny way. I have no time and no space in the sense that my time is other people's time, and my space is other people's space. I think in the west, or particularly in America, people have a sense that you have to have your time and you have to have your space. You have to have your parameters and your privacy. I don't have that relationship to time and space. It's a part of the way I feel about things, and I think it's the way I live. You know. I have time for everything and everyone, and I have space for everything and everyone. It's not like I need it for myself. I don't see it in those terms...

STEINER: So if you could take off and go anywhere you wanted now, where would you go?

TIRAVANIJA: Where would I go right now?

STEINER: Yes.

TIRAVANIJA: Well. I must say, there are lots of places... In a funny way I would go to Berlin, because I have a funny attachment to Berlin for some reason. But in practical terms I would love to go to... See there is not one place I can say. I would rather land in Berlin and get a car, and just drive around. There's not really one place I'd just go to and sit in.

STEINER: I kind of assumed you'd go someplace, and then go someplace else from there. But I meant would you go south, or would you go west...

TIRAVANIJA: I guess would go east-east, but I always gravitate towards sort of south anyway. I mean. I love being in Spain. I love Portugal... I'd go to Vietnam, I'd like to go to Thailand, but that's a lot of work, so I'd go to Vietnam...

Rochelle Steiner is the assistant curator of contemporary art at The Saint Louis Art Museum.

A wall or a floor, a sheet of newspaper or a piece of oilcloth, a canvas or a glass plate - any of these may serve Niele Toroni as a surface on which to replicate his working method: "Imprints of a No. 50 Brush, repeated at regular intervals (30 cm)". Having defined his methodology in a joint manifesto written in 1967 together with Buren, Mosset and Parmentier, he has since remained true to his principle. Nothing has deterred him from reproducing the imprint in rhythmic arrangements of rows, from rendering spatial surfaces and lines visible, over and over again. These "travaux/peintures" may appear puristically conceptual or appropriately balanced in a classical sense by virtue of his use of regularity, arrangement and measure in combination to achieve a style that expresses beauty. In reality, however, these clichés are the work of a "peintre" simply applying his method, an artist who sees "painting as a way of earning one's living". This view of things implies a distancing from the entire theoretical superstructure of art and thus from every related "ism" as well. When Niele Toroni enters a room in which he intends to paint, carrying a small case that contains the working materials, the brushes, the paints and a pair of compasses, he appears as a genuine painter, ingenious and in tune with his concept. (G.D.)*

Niele Toroni
Published - Unpublished 1970/1996
Pot-Pourri

Take the sea for example. For many people the sea is blue, always has been and always will be, even if they have never seen it. So they look at the sea but no longer want or are able to see it. I am sorry for such people and they frighten me, since in any situation at the edge of any sea, they will never see anything more than this cliché of the sea. They won't want a greenish sea, and wouldn't be able to see one. No such thing is possible. That could not be *the sea*.

When people say, "Toroni's work doesn't interest me because it's always the very same thing" (marks of a No. 50 brush, repeated at regular intervals, always of thirty centimeters) it strikes me that they are uninteresting, since already they are wholly conditioned by the "blue sea". People who find it impossible to look at a particular work, at a given and particular time, with all its sense of continuity (an unchanging method) and all its particular differences: differences connected with the physical realities of

* 1937 Locarno-Muralto (Switzerland) / lives in Paris.

a method of work on the various occasions on which it's employed (the color of the marks, the materials used, dimension) no less than with the place and the atmosphere. Differences determined by questions of repetition and continuity.

"It's always the same very thing" seems to me the most stupid of excuses. It's as though a person were to say: walking is always a question of doing the very same thing, putting one foot in front of the other, so I'm going to give up walking until I discover some new way of doing it. You'll generally discover that these sorts of people (you see it in the art world) will do their very best to let "novelty" take them just about anywhere. An entire category of people, found in every field, eternally insist on change only in order to continue with always the very same thing, and thus maintain their privileges. Since 1967, I have always insisted on working/painting in one, single way: the method of working quite literally defines the entity presented to our eyes. The way in which I work/paint is the common denominator of all the works/paintings I submit to view. It says everything, and yet says nothing (means nothing) if you don't take a look at the particular work in question. We should also talk about the differences that mark every individual patch of color within any given work: differences due to the fact that every patch of color has a separate and individual existence, and as such is unique and not ideal. But we'll discuss this another time. Let's get back to your question. We can turn to another example, the example of medicines and household detergents: they regularly change their packaging, becoming more colorful, less colorful, fashionable... but always with the same old rubbish inside.

My problem has nothing to do with the creation of new "artistic packaging" that conceals an old ideology. Pseudo-change in form has itself become a formality.

Enough. Surely you'd find it a waste of your time to talk with a person who insists, "I'm not interested in making love, it's always the very same thing". That's their problem.

Painting as subject
The exhibition as object
Perhaps the whole business is a pretext for existing here and now
The presence of the work/painting - everything
The absence in spectacularity - nothing
Giving you something to see is the only thing I can do:
you can buy somebody a drink (*payer à boire*)
you can't buy anybody something to see (*payer à voire*)
Perhaps an exhibition of a position, and not an exhibition of objects
I don't get along with artists for whom art is therapy (*terapia*)

I don't get along with artists whose approach to art declares it be some kind of holy ground (*terra pia*)

Did you see the man who saw the bear? No, but I saw the man who saw the public-service artist:

painter, sculptor, philosopher, sociologist, and architect, and also politically correct

What a great artist!

Un mostro può fare una mostra?

The main thing for me was to try once again to bring painting into our field of view: patches of color, applied with a No. 50 brush and repeated at regular intervals, always of thirty centimeters...

This time around, the event was presented in a chapel; but first of all, for me, on walls.

So why not? Especially since the walls of chapels have often been known to host a good deal of very fine painting.

(You can draw up your list on your own, which perhaps won't be the same as mine).

Not too big a space, an area of calm, of meditation, often quite simply a resting place. The little chapels along the roads of the area in which I live are always flanked by a bench - often no more than a plain block of rough-hewn granite - in the shelter of their eaves. There, beneath the gaze of more or less successfully painted madonnas, saints, and infant Jesuses, the passer-by sat down to catch his breath, took a flask of red wine from his knapsack, and for a while forgot the distance which he still had to travel.

I myself feel a bit like a passer-by, sheltered in a chapel for the time it takes to realize a work/painting: - an old project - while thinking about Dante.

Did he really believe in Hell, Purgatory, and Paradise?

In any case, he loved the stars.

The last line of his *Inferno*:

e quindi uscimmo a riveder le stelle

of his *Purgatorio*:

puro e disposto a salire a le stelle

of his *Paradiso*:

l'amor che muove il sole e l'altre stelle

The ceiling of Padua's Arena Chapel is full of stars, even arranged into pentagons.

The school of the monochrome (since now it's indeed a question of a true and proper school) bores me, like every other form of mannerism.

Poor Rodchenko, who thought that artists were over and done with!

One could say, paraphrasing Châtelet on philosophy: "By proclaiming the death of art you create widows and orphans who make such a noise that you find yourself in a worse position than before".

And everyone cheerfully re-does his monochrome, the only thing still possible and true, since it illustrates the only theory that still remains possible etc. etc...

Now, the monochrome was and is interesting only when it is nothing more than a monochrome, independently of the person who made it.

Today, in spite of everything, one runs no risk of being mistaken for a housepainter! Yes, one might of course turn to a housepainter for the vulgar execution of a work, but if the canvas is green one will have to give notice of the name of the artist who conceived it, and delegated authorization for its execution. Let's imagine a blue canvas, how terrifying, it might be a forgery... Unless it's a postcard (postcards too follow the fashions). An all blue postcard, "the sky here is always blue". All white, "snow everywhere". All yellow, "we're bathed in sunshine". I've yet to see one all brown, "we're in the shit", but surely you'll find one somewhere.

But it's also true that the galleries too show very few brown or maroon monochromes. Less salable?

The good, middle-class collectors (upper and lower) - would they accept the use of certain colors?

Colors that conjure up smells?

Long live the new monochromes and their artists! But allow me to find them no more interesting than neo-geo.

Painting a great colored square all on its own, or a triangle plus a rectangle inscribed in a trapezoid - like paintings, in short, of giraffes or apples -is of no interest to me. Simply because the result it offers - the things to which this sort of praxis offers visibility - strikes me as now uninteresting.

The making of self-styled "painting" as a demonstration of its uselessness and impossibility is a strategy I found seductive when I was young.

Up until the day when I saw that I wasn't making paintings: I was illustrating my own small ego (or we could say, to put it more simply, that these images were the form I had chosen for the little film I was making about myself). There were objects, and canvases, in the manner of... (monochromes included) and sometimes aesthetically successful, but there wasn't any painting!

Now, quite to the contrary, my work as a painter is totally a question of trying to accomplish the act of painting. I believe it's still possible to do so (even if I sometimes think that it's useless to do so in the art world) and immodestly imagine that I'm close to the goal. My goal, of course, not Joël's. But then I start to think, now that would be a fine exhibition, two huge monochromes that perfectly fit into the cages at the ends of a soccer field, to be quickly installed at half-time, for a quarter of an hour of art and culture for the brutes (like myself) with a fanatical love of football, free of charge and with explanations broadcast over the P. A. system...

All sorts of wonderful things remain to be done.

Which is to say that the marks left behind by a No. 50 brush continue to be monochrome (of a single color), but that the work/painting is never a monochrome. The mark left behind by a No. 50 brush is only visible, or readable, in relation to the surface, the support, on which it's inscribed; and by virtue of revealing itself, it reveals that surface, rather than in any way hiding it.

You can talk, if you like, about my work/painting as bichrome.

Why is *arte povera* bought by the rich?

Why does everyone, from the extreme right to the extreme left, defend the same pseudo-artistic values?

Why does the so-called "new painting" vehicle nothing but an old ideology?

Why are the churches emptying, while the museums are filling up?

Why is the Mona Lisa sad?

Why does nearly everybody feel so bad when someone takes a hammer to a sculpture by Michelangelo, and yet remain indifferent when a Palestinian refugee camp is annihilated?

Why is it that artists, imprisoned in illusions of their own freedom, do not see (or do not want to see) that really they are jesters and servants. And in the service of whom?

Why should painting be only a mental thing?

Why would everyone laugh if someone today were to invent the steam engine, whereas the art world carries on with nothing other than "steam engines" that are always found to be interesting?

Why do flowers which are ever so beautifully painted and look so real never wither?

Why aren't today's photographers the *artiste-peintres* of yesterday?

Why are there more works of art in Swiss banks than in museums? For the good of humanity?

Why is the role of art to be always and only amusing and reassuring?

Why should the artist's "sincerity" give justification to whatever he produces and to any and every gesture he performs? Is the "sincerity" of any old reactionary a justification for what he says and does?

Why do people who live off others, and who are generally referred to as parasites, receive the honor, when they do the same thing in the art world, of being respectfully referred to as critics?

Why can't painting be just another trade with which you make your living?

Why should one always allow oneself to be taken in by the dominant ideology that reduces the problem of form (of the figure) to a formal problem, so as all the better to keep us entangled in formalities?

Ever since the "Renaissance", the artist has always worked for the potentates of his age.

In many cases, all we know of an artist's activity consists of works which were carried out on commission (and which therefore reflect the patron's tastes and points of view).

Patrons have never belonged to the class of the oppressed.

In retrospect, art history is ready to prove to you that all these beautiful things were created for the good of humanity.

Artists today (with a few exceptions) still work for the powerful. And this is not at all a question of showing or not showing at this or that gallery and not at this or that other one. It likewise has nothing to do with whether or not they sign this or than petition... It's a question of the work they produce, of their refusal to rethink Art.

How would things stand if everything which has always been thought of as art were to turn out instead to be merely consumer goods? If that's the case, its production, distribution and transformation will be seen to have obeyed the laws that regulate all consumer goods.

So why talk about Art History?

And even if up until yesterday things couldn't indeed have been otherwise, they can no longer be that way today. Nothing is gained by trying to make something survive, so as then to end up by outliving oneself.

You have asked for an explanation of the words that appeared on the invitation to an exhibition I held last year (1972) in Paris. They read: "No text will be handed out for the purpose of serving as a label that justifies and attributes a value to the work/painting which this show presents".

That seems quite clear to me. I clearly intended to take a polemical stance with respect to what I saw at the time, at least in Paris, as a deluge of "artists' texts".

But still today I can say that I don't think much of "artists' texts", especially if already declared as such. Why? Because you read them and discover that they're hardly credible!

Just about every day, you in fact receive some brand new text from an artist with the modest ambition of classing himself as a theoretician. But a closer look reveals that the authors of these texts should at least have the courage to call a spade a spade: these texts are advertisements.

Everybody knows, even if they're not prepared to admit it, that the purpose of these theoretical-advertisement texts is to serve as labels that justify and attribute a value to the works which their authors are also producing at the very same time.

And you'll note (with rare exceptions) that even in the best of cases these writings which are ever so up to date are sadly in the service of works of art which aren't.

I myself believe, and find it to be self-evident in the field of work called

painting, that theory is inseparable from praxis: I am interested first of all in *what the praxis itself produces.*

A text that serves only to justify the "work of art", and thus the existence the artist who authored it, can only be idealistic, no matter its ambitions or the terms of its formulation. Its goal is to bolster the survival, and thus the perpetuation, of the myth of art.

The artist, here, does the very same thing that the critic used to do and, generally speaking, still does: he writes a preface. If you want a bit of amusement, try reading a few from five or six years ago. If you venture any farther back than that, you'll feel that laughter is out of place: you'll see it to have turned into Art History, which is serious stuff. Do you happen to be acquainted with the dictionary definition of the word "preface"? A "preface" is an "introductory discourse preceding a literary work, usually explaining its subject, purpose, scope and method". That strikes me as an elegant way of saying that it finds its function in conditioning the reader.

You'll say that what with the way we're all conditioned today... well, a little more or a little less won't really make much difference. But here we're dealing with conditionings imposed by art, and by the artist in person. By the very protagonists of what many so sadly experience as one of the last surviving spaces for the freedom of the individual!

Basically, I'd have to say that I feel a bit uncomfortable with "texts". A text is almost always "classical", and written for the purpose of imposing its convictions.

For me, however, as I remarked a couple of years ago in a magazine, I have no interest in the imposition of convictions. The undermining of prejudice would be quite enough.

He looked at the lake.

The ever-present question returned: "What am I seeing?".

But wasn't it the lake that was seeing him?

On the two green walls of the room, the marks of a No. 50 brush, repeated at regular intervals, intervals of thirty centimeters, are undeniably there. Are they a lake?

Everybody says that the "viewer" makes the work.

Perhaps.

Luckily enough, it isn't the drinker who makes the wine.

A great conference. All of them had studied Art History for years. The theme was "La Leonarda di Giocondo da Vinci", and it had proved to be a source of long and intense debate, sometimes even of polemic. A fascinating publication will soon appear, and will then be discussed on television.

People are capable of comprehending space through reason. Time, however, as Henri Bergson recognized, can be grasped only with the aid of intuition. How then can the experience of time be linked to the experience of space?

Bill Viola's video sequences open hidden doorways to perception, bringing to light what lies beyond the reality of everyday perception. Well into the late seventies, Bill Viola used the medium of video as a means of self-experience. After abandoning this self-oriented model he directed his gaze towards the mystics of religious traditions. The power of the mysticism lies in the vision that enlightenment allows mind and spirit to become evident in immediate and direct ways. This experience liberates powers capable of forming the basis for a new perception of time and space and the "conditio humana".*

The video installation entitled "Buried Secrets" (1995) comprises a series of five separate installations designed as a passage through the realm of sensual perception: "Hall of Whispers", "Interval", "Presence", "The Veiling" and "The Greeting". All of the senses are addressed as the viewer moves through the visual spaces, gradually developing links between the spatial experience and the contingencies of human existence. Scenes move at different speeds, dimensional relationships change - light and dark, hearing and seeing, past and present. (G.D.)

Bill Viola
In Response to Questions from Jörg Zutter

INTERVIEW BY JÖRG ZUTTER

JÖRG ZUTTER: When was your first direct encounter with European culture?
BILL VIOLA: At the moment I was conceived. My mother was born in northern England. My father's mother was German, and his father Italian, and he first went to school as a child in New York speaking no English whatsoever. This is the peculiar and particular nature of America - the shadow of Europe always behind you, conscious or unconscious. It is precisely this diffracted view, the fact that it is an angular shadow, diffuse, shifting, amalgamated, and not a faithful image, that has fascinated so many in the European intellectuals, from de Tocqueville to Eco and Baudrillard.

ZUTTER: You have had over 20 years of involvement with Europe on various projects. How does this first-hand knowledge of both the original object and its "shadow" affect you and your work?

* 1951 New York / lives in Long Beach, California.

VIOLA: It is of course interesting and at times amusing if you know the origin of things. However, it doesn't particularly disturb or excite me that here in southern California I can drive past a Spanish-style house with authentic ceramic roof tiles, or houses of traditional New England wood frame, English Tudor, and Japanese styles all standing next to each other on the same street, or that I can go into the sterile and bizarre setting of a shopping mall to purchase a genuine Tuscan leather bag while a group of Mexicans with motors strapped to their backs are blowing away fallen leaves from indoor Australian native trees while Mozart plays from concealed loudspeakers at a nearby Japanese Sushi bar. This is normal. This is how I grew up. It gives me energy. It is the Europeans, I think, who are more likely to be concerned about the "crisis of representation" those conditions appear to evoke. When I first went to Japan I was concerned that a traditional Buddhist pagoda was standing right next to a McDonald's. After living there later, I realized that the Japanese aren't too worried about it - when they are hungry they go to the McDonald's, when they want to pray they go to the temple.

The unique place of material culture in today's world is that, as a set of images, it is not proprietary anymore. It is not proprietary anymore. It is not national. It is the property of all - any time, any place, any material or style, any period in history. The key underlying common element now is not appearance, it is use. This is what is defining value. And the key currency of the interchange of this value is the image. This is why art is at such a critical point in its evolution and why many modes of artistic practice are being called into question. And this is also why there is so much uncertainty. As Rumi said in the thirteenth century: "Any image is a lie", yet as William Blake said 500 years after that, "Anything to be believed is an image of Truth".

ZUTTER: But is there a course of action for the artist, or even the individual on the basic survival level, that this situation provokes?

VIOLA: It is not the point to try and "resolve" these apparent collisions as much as it is to realize that they are the direct and predictable expression of a new and unfamiliar set of conditions now in place. These conditions are not geographic, climatic, conventional or traditional. The real ordering forces at work today under the surface, that create these seemingly jarring juxtapositions, are alpha-numeric; they are informational and economic, and ultimately political. Their ground is transcultural and multinational. It is only because we are still viewing the landscape at the surface level, and don't see what pops up and meets the eye in seemingly random or unrelated patterns from below is really integrally bound together, connected and coherent, just beneath the surface. To see the unseen is an essential skill to be developed at the close of the twentieth century.

ZUTTER: Your first extended stay in Europe was when you were 23 years old, working for one and a half years at the Art/Tapes/22 video studio in Florence, Italy, in the early 1970s. Did this classical environment and birthplace of the Renaissance have any influence on your work?

VIOLA: It is always interesting to encounter with the mature intellect ideas that are practically instinctual and well instituted in our bodies as "common sense". The effects of the avant-garde thought of the Renaissance can be felt in every industrialized country on earth, Japan and the Far East included. So to some extent, these influences were already there. Personally, it was most important for me being there, to feel art history come alive off the pages of books, to soak into my skin. I probably had my first unconscious experiences then of art as related to the body, for many of the works of the period, from large public scuplture to the architecturally integrated painting in the churches, are a form of installation - a physical, spatial, totally consuming experience. Furthermore, in function, classic Renaissance art was not a lot more like contemporary television than contemporary painting, with many of the images designed to communicate well-known stories directly to the illiterate masses in highly visible public spaces.

ZUTTER: What kind of personal work did you do during your stay in Florence?

VIOLA: Actually, in Florence I spent most of my time in pre-Renaissance spaces - the great cathedrals and churches. At the time I was very involved with sound and acoustics, and this remains an important basis of my work. Places such as the Duomo were revelations for me. I spent many long hours staying there inside, not with a sketchbook but with an audiotape recorder. I eventually made a series of acoustic records of much of the religious architecture of the city. It impressed me that regardless of one's religious belief, the enormous resonant stone halls of the medieval cathedrals gave an undeniable effect on inner state of the viewer. And sound seemed to carry so much of the feeling of the ineffable.

Acoustics and sound, a rich part of human intellectual and speculative history, are thoroughly physical phenomena. Sound has many unique qualities compared to an image - it goes around corners, through walls, is sensed simultaneously 360 degrees around the observer, and even penetrates the body. Regardless of your attitudes towards the music, you cannot deny the thumping and physical vibration in your chest cavity at a rock concert. It is a response beyond taste. When I discovered standing wave patterns, and the fact that there is a total spatial structure of reflection and refraction, a kind of acoustic architecture in any given space where sound is present, and that there is a sound content, an essential single note or resonance frequently latent in all spaces, I felt I had recognized a vital link between

the unseen and the seen, between an abstract, inner phenomenon and the outer material world.

Here was the bridge I needed, both personally and professionally, and it opened up a lot of things that were closed off, myself included. Here was an elemental force that was between being a thing and an energy, a material and a process, something that ranged from the subtle nuance of experiencing a great piece of music to the brute force of destroying a physical object by pressure waves, as any sound is well capable of doing. This gave me a guide with which to approach space, a guide for creating works that included the viewer, included the body in their manifestation, that existed in all points in space at once yet were only locally, individually perceivable. I began to use my camera as a kind of visual microphone. I began to think of recording "fields" not "points of view", I realized that it was all an interior. I started to see everything as a field, as an installation, from a room full of paintings on the walls of a museum to sitting at home alone in the middle of the night reading a book.

ZUTTER: Many people are mistrustful of the physical effects of electronic images and sounds. What is the place of the body and physical sensation in your work and in the nature of the medium you have chosen?

VIOLA: At a time when the body has been neglected and/or rejected as a serious instrument of knowledge for so long, the physicality of these new media has been grossly overlooked. (In cinema, for example, this has been due to the dominance of the literary/theatrical). There is still such a strong mistrust in intellectual circles about things which speak to the mind via the body. It's as if they can see that this direction will ultimately lead to opening the locked gate to the forbidden zone of the deeper emotional energies. In my opinion, the emotions are precisely the missing key that has thrown things out of balance, and their restoration to the rightful place as one of the higher orders of the mind of a human being cannot happen fast enough. The pitfalls of mere feelgood sensuality and sentimentality are clear enough. As American philosopher Jacob Needleman has said, by ignoring the emotional side of our nature, we have turned our backs on the most powerful energies of our being, the source of the most human of qualities, compassion, and without which no authentic moral power is possible.

Just recently in an interview in Kassel, the questioner was describing just my work as using "effects, the same as Hollywood", and suggested that somehow these were lesser elements, sensual and momentary, even seductive and therefore dangerous. We must revise our old ways of thinking that perpetuate the separation of mind and body. These attitudes negate much of the world culture's response to the questions of mind and being and self; for example, they deny the validity of such things as the

2,500-year-old history of Buddhism and the significance of the various disciplines of meditation throughout the world. Without this approach of understanding and controlling the mind through the body, we find that ironically one of the major problems in the West today arises from a lack of focused development mind, neglected by an over emphasis on the body as a cosmetic self-defining image detached from any deeper function.
It is true that from an intellectual viewpoint the scary part of the body's mechanism is that is purely responsive and mostly involuntary - instantaneous and therefore isolated from the normal mechanisms of rational analysis and logical thought. There is great potential for misuse and manipulation in work of this nature. And it is true that without an established wider cultural context of image language there can be a proliferation of misuse, either through ineptitude, misunderstanding, or deliberate abuses of the form that go unnoticed or uncriticized. These aspects are hopefully the result of a temporary transitional situation, as we move away from print and literary modes and into the world of the image, away from deductive reasoning and toward associative patterning. One of the greatest challenges in today's culture, urgently necessary from a political point of view, is how to bring analytical skills to beat on the perceptual physiological language of the image, an event and not an object - constantly changing, living, and growing.
As Neil Postman has observed, most media messages today exist in a zone beyond true or false and are impervious or irrelevant to traditional discursive logical methods of establishing their authenticity. Even a college education isn't enough. In America, Reagan-Bush media advisors like John Deaver and Roger Ailes have successfully utilized the circumstance of a largely media-illiterate population ill-equipped to read accurately the full information content of its dominant medium, television, with dangerous political consequences for the democratic system. Significantly, the skills required to successfully decode commercial and political messages have become associative and arise from the domain of art, not reason. This places a new importance on the skills and knowledge of the artist and the role of art education in daily life.

ZUTTER: There are formal elements in your work that relate to the European tradition, such as the references to painting (Goya, Bosch, Vermeer, etc.) and particularly traditional structures such as the altarpiece triptych ("The City of Man. Nantes Triptych"). What is your interest in repeating such classical forms?
VIOLA: I consider myself to be part of a long tradition of art-making, a tradition that includes my own cultural background of Europe, as well as the late twentieth-century's expanded range of Oriental and ancient Eurasian culture, and even embraces our current nineteenth-century French model

of the post-academy avant-garde and its rejection of tradition. I do feel that there are serious problems with the conclusions of a 150-year-long evolution of the rejection of tradition, as necessary as it was in the first place. Especially, our connection to Eastern culture should not be under-valued.

Don't forget that one of the great milestones of our century has been the transporting of ancient Eastern knowledge to the West by extraordinary individuals such as the Japanese lay Zen scholar D.T. Suzuki and the Sri Lankan art historian A.K. Coomaraswamy, an event on a par with the re-introduction of ancient Greek thoughts from the Moors in Spain. The con-nection between Europe and the Orient runs deep and was over-shad-owed by the developments of the Renaissance and later mass industriali-zation. In the age of air travel it is easy to forget that you can walk from Kamchatka to Iberia. There were Buddhist missionaries in Jerusalem at the time of Christ, and the apostle Thomas spent time in India.

Concerning my use of the classical triptych, the triple image is an ancient form. I am interested in its use as referent of the European Christian tra-dition, as an image that arises out of culture and therefore resides within, not without, many of the people who have come to see it in Europe. I am less interested in its use as a quotation, or an "appropriated image", be-cause I think that if one proceeds too readily down that path you can eas-ily become enamoured with the process of quoting in and of itself and lose respect for the latent power of the objects and materials themselves, and the inner transformative reasons for appropriating them in the first place.

Beyond more technical reasons such as the delicate balance of the num-ber three and its use for comparative contrast and interaction, both visu-ally and especially temporally, ultimately my interest in the triptych form is that it is a reflection of a cosmological and social world view, "Heaven-Earth-Hell", and its tripartite structure is an image of the structure of the European mind and consciousness. These aspects can become activated energies when applied to images of a contemporary nature.

ZUTTER: Your videotapes and installations are infused with emblematic transformations and archetypal images. Some works suggest subconscious dreams and remind us of the theories of Swiss psychologist C.G. Jung to whom you have referred. What is this connection?

VIOLA: First of all, I think it important to recognize that it is no longer ac-ceptable to scrutinize things solely from the perspective of our local, re-gional, or even "Western" or "Eastern" cultural viewpoints. We share a privileged position at the end of the twentieth century in possessing un-precedented, vast, readily available intellectual resources gathered from around the world and from diverse histories by the intensive labor of

scholars and translators in many disciplines. Any contemporary comprehensive assessment and analysis of a set of ideas has to be based on its place in world culture.

The contribution of Freud and Jung and the European psychological movement was very great. It opened up to Western culture, for the first time in many centuries, the inner energies of the human mind. C.G. Jung particularly was more open to aspects of world culture and its precedents, and his theory of archetypal images, as a kind of visual archeology of the mind, is a very powerful model, with important implications for the practice of art. Especially relevant is the notion, a basic component of ancient culture, that images have transformative powers within the individual self, that art can articulate a kind of healing or growth or completion process, in short that it is a branch of knowledge, epistemology in the deepest sense, and not just an aesthetic practice. The potent combination of this narrow aesthetic approach with the extreme progression of a commodity-based commercial system is largely responsible for the dismal state of the art world and the preponderance of trite, frivolous, empty art objects over the past decade and longer.

However, the work of Jung, Freud, and the others has also to be seen in the light of world history. In this sense, the nonmaterial-based cultures of Asia far outshine the Europeans in the depth and breadth of their speculations on the nature of mind and self. The-turn-of-the-century psychologists represented the first primitive, yet far-reaching, steps by the West towards illuminating the nature of the inner world. Recent work by psychologists now well-versed in Eastern thought, such as James Hillman, as well as the radical conclusions on the nature of matter (a term so long synonymous with the universe itself in the Western mind) by twentieth-century physicists such as Werner Heisenberg, represent converging thought streams that redefine the world to include inner realities, that shift Western science on a track closer to the tradition of the East, and that indicate that this development of ideas is much larger than what Freud and Jung initially described. Several millenia of Buddhist sutras, texts, and philosophical science on the nature of mind greatly exceeds the Psychoanalytical Society archive in Vienna. Ancient Hindu texts and speculation on theories of representation far outnumber the writings of contemporary French intellectuals on the same subject. There is non excuse to ignore the larger picture any more, in science, philosophy, or art history.

ZUTTER: Why have your interests in individuals been focused so strongly on the mystics of history, usually of religious traditions, rather than the principal artists of the past?

VIOLA: Actually I can see a strong connection between the oustanding mystics and artists. I think my interest in the mystics arose out of certain

problems, initially unconscious, that I was having with the notion of art history itself. I later came to realize that the existence of what I studied in school. What we call "art history", is more circumstantial than actual. It exists because it has occurred but not because there is any more than only the most vague and general connection between the works as a whole. The use and creation of images is so fundamental to human beings since the beginning of time that it has to be considered an essential part of humanity's existence, like sex. So, if there is this natural propensity to create images, then there will always be this thing called "art history" and there will be as many artworks of as many varied forms and purposes and natures as there are babies. Furthermore, the majority of creative expressions in images by human beings will necessarily be excluded. Three primary books I had in university, and still the dominant one in use, Janson's "History of Art", never included Japanese, Chinese, or Indian art, although it wasn't called the "History of European Art". In fact, much of the work I was seeing on my travels to Asia and the South Pacific, classical and contemporary, wasn't being discussed. Other things were being labeled "folk art" and excluded.

If the intentions, essences, purposes, and very nature of these creative expressions are so diverse and contradictory, then one of the only ways to link them all to include them in the same category is either circumstantial, i.e., that they all have condensed out of the linear accumulation of history, or formal, i.e., that this one exhibits these physical characteristics and not these, a form of zoology and an approach applied from nineteenth-century scientific materialism. What was missing for me was the essence of the artist's vision, the connection to the deeper levels of human life that I felt the great artists I was coming to admire all spoke to, since their techniques and styles were secondary elements that existed solely in service to this, "the great work", the real power of their accomplishments.

When I began to focus on this aspect of the work, I saw that what at first appeared to be independent shining lights, bursts of transcendent inspiration on a dull field, became linked by something unconsciously sensed below the familiar surface. I started to follow these lights, and the rest didn't matter, making my own alternative "history", an anti-history really since one of the primary qualities of what I was pursuing seemed to exist beyond historical time. I thought it was something that couldn't be described, that existed without precedent or models. Then I became aware of the existence of an established, parallel, alternative history running through the history of religion, with very elaborate descriptions and prescriptions for these creative states I was trying to understand. I became drawn to the work of the mystics, East and West, and people such as Jallaludin Rumi, Chuang Tzu, St. John of the Cross, and Meister Eckhart began to embody for me the qualities and true

nature of the work of the artist that I felt had been so confused and distracted throughout the course of material expression through the history of human affairs.

ZUTTER: Is there a distinctive difference between European and American mysticism that is relevant to your work?

VIOLA: First it is important to look at the term "mystic". In Western culture, the term is imprecise, often applied by people with little if any experience or knowledge of the subject and living within a society with no criteria and poor terminology to judge or describe inner states. Historically, it becomes loaded down with the political history of the Christian church, which discouraged or brutally suppressed any deviations from the accepted canon. Not least, it includes a wide variety of individuals doing very different things and has become a catch-all phrase to include anyone doing something different.

Historically, the use of the term becomes more widespread and necessary the further European culture diverged from its original pagan shamanistic sources, the last great purge being the Inquisition and the persecution of female "witches" (the shamen), the place and energy of the woman being the last place these energies resided. Looking at rock and roll and the counterculture of the late 1960s, it is interesting to see a revival of what European culture has traditionally defined as "Dionysian" tendencies. That entire episode was really about a rediscovery of the body and the attempt to break out of (in America) the Protestant ethic's denial of the same and to bring the technologies of the body, from basic instinctual sex to high-level meditation, back into the discussion, on a par with the cornerstone of the European intellectual tradition, the faculties of reason in the mind alone. To return to your question, obviously most of the influential mystics in the Western tradition are European. In America, individuals such as Walt Whitman and Mother Ann Lee of the Shakers come to mind, but for the most part they are integrally bound up with the social reformist utopian directions that the promise of the New World offered. The European mystics, on the other hand, were primarily involved with individual vision, although many of them were reformers and definers of new social and political orders.

This is because many European mystics were concerned with reintegrating into the Christian tradition an ancient teaching that had been expelled since the early centuries just after Christ. This is traditionally called the via negativa, or negative way, and is a teaching traced directly back to Eastern religious concepts (Hindu and Buddhist), present in the teachings of the Gnostics of formative Christianity, and embodied most notably in an obscure shadowy figure from the fifth century called Pseudo-Dionysius the Areopagite. Most probably a Syrian monk, Pseudo-Dionysius' teach-

ings of the Celestial Hierarchy (he introduced the word), and the inability
to know or describe God directly, became central to the later Neo-Pla-
tonic movement of the twelfth century and beyond, and the source of in-
spiration for many notable mystics such as the anonymous English author
of a classic fourteenth-century text who described it in the title as "The
Cloud of Unknowing", and St. John of the Cross who called it "the dark
night of the soul".

The basic tenets of the "via negativa" are the unknowability of God; that
God is wholly other, independent, complete; that God cannot be grasped
by the human intellect, cannot be described in any way; that when the mind
faces the divine reality, it becomes blank. It seizes up. It enters a cloud of un-
knowing. When the eyes cannot see, then the only thing to go on is faith,
and the only true way to approach God is from within. From that point, the
only way God can be reached is through love. By love the soul enters into
union with God, a union not infrequently described through the metaphor
of ecstatic sex. Eastern religion calls it enlightenment.

The essence here is the individual faith, and as God is said to reside within
the individual, many aspects of it bear a close resemblance to Eastern con-
cepts and practices. The "via negativa" represented a place where Eastern
and Western religion found themselves on common ground, but through
the forces of Inquisition and beyond, the "via negativa" was eventually
dominated by the more familiar "via positiva" of today, a method of affir-
mation that describes positive, human attributes such as the Good and
All-Knowing to the image of a transcendent God. Although still beyond all
human understanding, the divine has an important connection to the
human world through these attributes expressed in orders of magnitude,
a quantitative rather than qualitative difference.

After spending so long investigating Eastern religion and Islamic mysticism,
and after rejecting my own Christian roots, I was so excited to find the
same thread running through my own cultural history, something I never
expected to find. I viewed it as a basic human tendency rather than a spe-
cific historical movement, and it clarified a lot of things about the univer-
sal nature of mystical experience, the essence of creativity and inspiration,
issues of solitude versus community and the role of individual vision in so-
ciety, as well as my own artistic practice. I relate to the role of the mys-
tic in the sense of following, a "via negativa", - of feeling the basis of my
work to be in unknowing, in doubt, in being lost, in questions and not an-
swers - and that recognizing that personally the most important work I
have done has come from not knowing what I was doing at the time I was
doing it. This is the power of the time when you just jump off the cliff into
the water and don't worry if there are rocks just below the surface.

ZUTTER: Notable in your works is the direct inclusion of fundamental as-

pects of human life, birth and death, for example. What is the role of these direct, often documentary-like, elements?

VIOLA: Video currently bears the weight of the truth in our society. Most people feel that what they are seeing through a video camera is a truthful record of an actual event. This perception has its roots in certain characteristics of the medium such as its ability to display a "live" image and is often described pictorially as a quality of "immediacy". Think of the difference, for example, of displaying a painting of a woman in childbirth as opposed to a videotape of the actual event.

I have felt for a long time that contemporary art, as well as philosophy, has neglected the fundamental energies of our beings. It is easy to see how notions of a "progress" of ideas can pass over issues as basic as birth and death. Yet these are the great themes of so much of human creative expression. Since so much of my work has to do with "seeing" in an extendend sense, I have found that raw and direct recordings in our current context can have great power. These essential experiences are universal, profound, and mysterious, and lie like unsolved equations in contemporary society that have been put off to the side of the mathematician's desk because they are unsolvable with the math currently in use. But that's the point, they are mysteries in the truest sense of the word, not meant to be solved, but rather experienced and inhabited. This is the source of their knowledge. It is my hope that for future generations, these images will lose their shock value because I feel that in some ways this clouds the real essence of their nature, even though at present the shock response is a necessary measure to how far from life's sources industrialized society has come. These "power images" are like wake-up calls, and I feel today there is a need to wake up the body before you can wake up the mind.

Despite the onslaught of media images that incessantly confront us and skew our perceptions. I maintain great faith in the inherent power of images (and by images I mean the information that comes through sight, hearing, and all the sensory modalities). The images we have created throughout history and prehistory are our companions and guides, separated selves with their own lives and beings. For the ancient Greeks, one of the main questions that fueled all philosophical speculation was what is alive and what is not, what is imbued with "psyche". For modern science, the question has become what has mind, what does not. This narrowing down of parameters to the realm of thought, specifically human thought, makes possible an attitude that divides and separates ourselves from nature and ourselves from our total beings, leading to disastrous consequences. It can allow nature to be exploited and abused. Animals can be eliminated, slaughtered, and even tortured with no moral consequences, or at least within no ritual framework.

For me, one of the most momentous events of the last 150 years is the

animation of the image, the advent of moving images. This introduction of time into visual art could prove to be as important as Brunelleschi's pronouncement of perspective and demonstration of three-dimensional pictorial space. Pictures now have fourth dimensional form. Images have not been given life. They have behavior. They have an existence in step with the time of our own thoughts and imaginings. They are born, they grow, they change and die. One of the characteristics of living things is that they can be many selves, multiple identities made up of many movements, contradictory, and all capable of constant transformation, instantaneously in the present as well as retrospectively in the future. This for me is the most exciting thing about working at this time in history. It is also the biggest responsibility. It has taught me that the real raw material is not the camera and monitor, but time and experience itself, and that the real place the work exists is not on the screen or within the walls of the room, but in the mind and heart of the person who has seen it. This is where all images live.

Jörg Zutter, an art historian, is director of the Musée cantonal des Beaux-Arts in Lausanne.

The interview originally appeared in the catalogue Bill Viola, "Unseen Images", edited by Marie Luise Syring, Verlag R. Meyer, Düsseldorf, 1992.

The photographer who dares to take pictures of flying angels has already crossed the boundaries of direct photography, but digital montage techniques enables the photographer to create imaginary pictures. Jeff Wall's pictorial art is oriented towards the model of cinematography. The more he uses technology and staging, the better able he is to put together poetic images that create the illusion of a random moment in time. His portraits of people appear as if painted against a backdrop of interchangeable sets. The background may be a city or suburban street scene or the interior of a house. If the portrait as genre is to be regarded as a form of communication, then it says something about the relationship between the actor/performer and the outside world. Changes in this relationship evident near the close of the 20th century are reflected in Jeff Wall's redefinition of painting. His pictures are concisely formulated, much like short prose poems; they have the appearance of fleeting moments that capture the irresolvable tension that grips the human being between retreat and active appropriation of the world. (G.D.)*

Jeff Wall
An Interview with Jeff Wall

BY MARK LEWIS

MARK LEWIS: Art has always been concerned with articulating a position with regard to the question of rights. To understand aesthetic rights simply in terms of combating interdiction, however, would be to risk abnegating art's own identity in favour of putative contents that may or may not be censored according to the myopic interests of petty state officials. The intimate bond that once tied interdiction to art's modus operandi (its historical and delicate attempts to circumvent the laws and protocols that forbade its invasion into certain areas of the territorial subject matters of the state, the church, or the privileged) has long since expired. Today in the West, art is free to represent what it likes with regard to subject matter.

JEFF WALL: I think that the critique of art has been approximately accomplished. That is, the interrogation of the foundations of its validity has reached a point at which the experience of art is now primarily an experience of the problem of its own validity. I do not think that this problem is related directly to the problem of rights. I don't know what "aesthetic

* 1946 Vancouver / lives in Vancouver.

rights" are. Art is covered by the democratic rights to free speech, freedom of expression. I have never been concerned with interdiction on the level of subject matter because it barely exists on our society. Look at Joel-Peter Witken, for example. The provocations, like Robert Mapplethorpe's, are too much a mirror game of publicity to be artistically interesting.

LEWIS: To think of aesthetic rights it may be necessary to return to and rethink the theory of disinterestedness articulated by Kant in his "Critique of Judgement". A long line of commentators have tried to keep some form of this articulation alive (Schiller, Adorno, Greenberg, Focillon, etc.) and they in turn have been subjected to critical work that has undeniably pointed to some of the impossible engagements that these thinkers have entertained with the world. But to acknowledge these critiques is not all to dispose of the underlying drama in these, for want of a better world, formalist texts. I wonder how that inquiry, that formalist inquiry, might be revitalized and understood now? And can we be sure that this enquiry will not get reduced to a kind of caricature of aesthetic connoisseurship - the name of Walter Pater comes to mind.

WALL: I am not interested in formalism. I think that the existence of an attitude such as formalism is a symptom of the decay of aesthetic language among the intelligentsia and the elites who support art. There are obviously many reasons for this, but it's a sore point since Clement Greenberg wrote "Avant-Garde and Kitsch", where he located its causes in the decay of the bourgeoisie and the proletariat in the imperialist epoch. The philosophic reflection of the inner contradictoriness of art demands an acceptance of the dialectical relation of "form" and "content". The collapse of these dialectical reflection could be seen as Greenberg sees it, as a symptom of capitalist crisis. To an extent, I think it is that, but I do not want to participate in a "progressive consensus" which has been so uncouth about "unprogressive" phenomena, like Matisse, Mallarmé, Proust, or Huysmans, and many more over the years up to now. The progressive consensus is itself a symptom of a decline of the left, a decline of the social-democratic elite. Formalism is their bête noire, the taboo that holds them together. There is no formalism in art, really. Your question about how we ensure that this does not evolve into a new Walter Paterism is itself part of the consensus idea of aesthetic thought. If a new Paterism evolves, let it - maybe that will create something marvellous. "We" should desist in imagining that "we" are called upon to determine developments in this way. A critique of a neo-aestheticism would be a challenge to the stultified analytical capacities of many members of the critical elite.

LEWIS: With regard to the "progressive consensus", I am less sure of its

hegemony and the strength of the consensual bond that would hold its opinion together. What I would say is that the dialectical relation between form and content, the "inner contradictoriness" of the work of art, is really a formal concern. What may be at stake here is a general misunderstanding of mimesis. Certainly Kant's articulation of this fundamental relation between art and nature implies a critique of imitation, and this rigourous and formal thinking of the question of representation is, I suspect, what you find so lacking in what you have called the progressive consensus. Formal concerns are central to the question of the work of art's engagement with the world. At the same time, we are aware that a certain conservative connoisseurship would like nothing better than to return art a sort of pre-Copernican antitheoretical universe.

WALL: I would put it a little differently. I'd say that artistic content is realized in the experience of the form of a work. A work does make a "formal proposition" but maybe not in the form of a proposition. It's like when Hegel says that a dialectical concept of identity, which insists on the "Identity of identity and non-identity" must nevertheless be articulated using the word is: the propositional form of identity.

In a way, you could say that there isn't any subject matter in a work of art. Subject matter is like a pre-text. It determines nothing directly artistic about a work, but, as pre-text, it determines the generic character of the work that is about to be made. This is another by society, by institutions and social capital, and by individuals, by citizens and their property, or private capital. Society already has the legal means to do this. Art can be subsumed in a more general economy and still be taken seriously - that is, art can be a commodity (which it really has to be in capitalism) and still be taken seriously. The idea that the commodity status of art prevents people from taking it seriously and developing profound relations with it is another sacred cow of the progressive consensus. We take land seriously and it is a commodity, and this could be said of any other object people are seriously involved with.

LEWIS: There can be no argument about whether or not art enjoys commodity status. As your remarks suggest, a work that is not a commodity is a work that must remain completely invisible. However, the commodity form is not the sum total of our relations to objects and things, and this might explain some of the shortcomings of much recent art that has attached its critique single-mindedly to this aspect of the work's value. I think Adorno is useful here.

WALL: Like Adorno recognized, the orientation here is in terms of the dialectical character of use-value and exchange-value, the "identity of their identity and non-identity". The commodity status exhausts no object's whole existence, and art makes that visible as its beauty.

LEWIS: Identity is something on the cusp of an interpolation that would grant them a definitive identity (from bullies, from the police, from employers, from the CIA, from landlords, from rituals from prescribed moralities, etc.); yet being on the cusp they have not yet received that identity. The tension that surrounds them so theatrically, is, I think, this sense of having not taken the final step, of a resistance - often silent, often no more than a barely visible gesture - that is a utopian and perhaps impossible attempt to imagine oneself as producing an identity outside of any demand to identify oneself, and therefore to be something that is ultimately unknowable (to bullies, to police, to landlords, to bosses, to the state). To be unknowable, of course, is to be useless, a condition which the aesthetic has a close interest in.

WALL: This question of the uselessness of art I understand in its more classical sense of a negation of the instrumental relation to things, people, and images. The validity of art is involved with this negation, in the name of reflection, and of the dialectical relation of "vita activa" and "vita contemplativa", as Hannah Arendt, for example, describes it in "The Human Condition". I like your account of the formation of identity in my pictures - it does correspond to my way of thinking about them. Photography has the problem of being a very definite and static mode of representation - it "fixes" things. So I have been interested in using the static qualities of the image to focus on something fugitive and intagible. This is an aesthetic value which for me often determines the viability of this or that subject for a picture.

LEWIS: Photography is now a classical medium. Your work suggests this significantly because it seems to point to the probability that photography has approached the condition of painting. I would like to ask you about the two media of cinema and painting, the media that technologically and historically antedate and follow photography, meet in your images.

WALL: I agree that photography has now become an art, or a medium with status equal to that of the older ones. Many of the critical problems have not been resolved (like the status of the print in relation to the negative), but in general the debate about whether photography is an art of high ambition and status is over. I think that the debate about whether art will be anything else than photography is also finished. It is clear that the older forms, like painting, are not dead - they will be obviously continue. We have just been fascinated with the glamour of the "end" of things. I hope that's over too! I always thought that photography attained its artistic status by means of the cinema, that before the cinema evolved to the point where it had obviously become a major art form, nobody was in a position to comprehend the problems posed by photography in relation to the pictorial traditions. When cinema permitted photography to become conscious of itself as art, photography also became conscious of itself as

nonpainting. The new imaging technologies are warping this though, and so now we have not-photography.

LEWIS: Earlier you mentioned Huysmans and I began to think about how in the novel "Against the Grain", Des Esseintes leaves the realm of "social utility" and his life becomes determined by aesthetic concerns. Hence his obsessive interest in smell and taste, which are peculiarly productive of the "mémoire involontaire". The gesture of resistance (to identity) in your work is also like the madeleine in Proust, or for that matter the punctum in Barthes. It takes the moment out of its mise-en-scène. The whiff of its presence allows the picture to yield certain truths that are primarly sensed by aesthetic, formal apprehensions (and this is why Proust is very close to Freud). So the decadence that Huysmans stands charged with could be another way of describing how he is able to understand this close relationship between knowledge and form. I wonder, though, if Huysmans's romanticism - and I introduce this new "ism" cautiously - runs the risk of displacing the concerns of, for want of a better word, political action into a wholly private, and ultimately unknowable, realm of taste.

WALL: Maybe there is no real risk of the displacement you are concerned about. I do not think a concern with the formality of art threatens the possibility of making political statements in art. Artistically, there is no other way of making them. Works like Dostoevsky's "The Possessed", or Goya's "Disasters of War", or "Hedda Gabler", "Olympia", or Rodin's "Burghers of Calais", certain of Munch's pictures or Grosz's earlier works, Duchamp's "Urinal" - all have political content formulated as a philosophical problem and experience of a work, an image, or story, etc. Or, referring to the figures you mention, think of Huysman's analysis of anticlerical extremism in Làbas, or Proust's discussions of the Dreyfus case in his novel. The shadings of these works, the fact they open onto different and even conflicting horizons of implied political behaviour, is to me not a problem. It's a phenomenological condition of art. Certainty fleeting along a curve of continually evolving experience is a model of reflexivity, and of a critical attitude. All these works were and are politically effective enough. In art I do not think that there ever has been the kind of polarity between inwardness and activism that you suggest. The relation is elsewhere - maybe it's in terms of the use-value of the beautiful?

Vancouver, October 1993.

Mark Lewis is an artist and writer based in London.

The interview originally appeared in *Public*, no. 9, 1994.

Lawrence Weiner employs language as a universal aesthetic medium, which provides a clear indication of his own position with respect to art: art becomes reality when it is expressed and published; art can be read and translated into every language, "pictures are a language". The universal character of language enables the artist to tap a virtually unlimited resource. Moreover, it fosters the dissolution of categories that delimit the specific. Language as a means of representation in art goes beyond the visual image to designate a perceptible reality. Weiner sifts and sieves signs and symbols until he finds and signifies empirical facts. The artist's work becomes a thought process, a method of achieving and clarifying reality.*

The phrases of Lawrence Weiner have a clear, pure sound; they are unambiguous and amenable to visualization everywhere, regardless of spatial circumstances, because they exist as concepts - totally independent of material conditions and of their creator. (G.D.)

Lawrence Weiner
I Am Not Content

INTERVIEWED BY DAVID BATCHELOR

DAVID BATCHELOR: There has been a certain morphological consistency through much of your work of the last twenty years - typically, phrases or sets of phrases are inscribed on gallery walls. While you have made other kinds of work during this time, does this consistency indicate further consistencies at a moral or political level?

LAWRENCE WEINER: Yes. The consistency is that essentially the presentation of art is a part of the production of it. Art is produced to be presented, and my major concern has been the use factor of art within a society. I'm quite content, as a studio artist, to be working away. But then you come to present something which within its own time will have some use factor, not only within the art world, but within the general idea of the relationships of human beings to objects. For me that is the only reason for the existence of art per se. I think I would have said the same thing more crudely, or perhaps more elegantly, in 1967 or '68. Art, when it's placed into the context of the world, is not just used in the context of what we know as art history; it is an attempt to place material which could be used to enrich the daily lives of other human beings. This is not

* 1942 South Bronx, New York / lives in New York.

to say that as an artist you have some special insights into materials denied to everyone else, but you do have more time to think about what that relationship is. If you can present as concise a work dealing with that relationship, you have done, perhaps, a tiny bit to place yourself within that society as a productive member.

BATCHELOR: I'm not sure about this idea of "use factor".
WEINER: Politically, I remain an American socialist. I believe human beings have a right to health care and education. And public libraries. This is not about democracy, it's about the dignity of human beings. If you can set them up then probably they can deal with the situation. I wish I did, but I don't have the idealistic idea that human beings are inherently good. Perhaps they are inherently terrible. And some of the observations of some of their kind help to temper and tone that down. I think artists serve to do that.

BATCHELOR: Do you think your work has changed significantly over the last twenty or so years?
WEINER: Yes. I hope it's got a little bit better. And a little less crude. Earlier there was a bit of an aggression with the situation that people were not understanding that art was your relationship with your environment. I don't know whether it's from age or from the fact that I've been quite lucky in being able to continue showing for several years, but there's less of an aggression. Once it's presented the work does not have to prove itself, it just has to present itself. There's less of an attempt at imposition.

BATCHELOR: I can think of several artists whose work in one way or another came out of the culture of the late sixties for whom terms like 'use factor' or 'effect' or 'social purpose' became critically important, at least for a while. In more than a few cases the result was something highly declaratory and didactic.
WEINER: I make movies when I want something like that. I write essays, I make speeches. The one thing I adore about Sartre was that here was a man who had produced a certain body of work, and he was found one afternoon standing on a street corner selling "L'Humanité". And one of his older colleagues came over and was really rather upset, screaming and yelling and saying 'Why are you doing this? You are just being used by the Left because you are such a famous person'. And Sartre turned around and said, essentially, "Bullshit... It's the fault of the Right that they can't attract anyone as professional as I am to stand around and help with their cause...". I don't think you have to use these things in your work as long as you are very clear about who you are as a citizen. But if you are going to use didactic material as work, it must always remain content, and it

must never be contextual. There should be no reason why in heaven's name we should have to accept a ball piece of art because it's about, say, bringing up babies. There's no conceivable reason that gives that work more credentials than a work that's just a piece of banana on the table.

BATCHELOR: In an essay from 1969 you said "Art that imposes conditions, human or otherwise, upon the receiver for its appreciation in my eyes constitutes aesthetic fascism. My art never gives directions...". Do you still hold to that essentially moral stance?
WEINER: Absolutely. How dare you take the fact that you are a certain height, your arms are a certain length, your eyes are at a certain level, and say that you are making art for other people. That's why, as trite as it may become, I really feel my statement "The artist may construct the work; the work may be fabricated; the work may not be built" (which means it can be presented just in language) is an important aspect of what I do. Art is always a presentation. It is never an imposition. As an artist you scramble to get a place at the table to present what you have to offer. If somebody rejects it, it does not make them a bad or stupid person. It just means they have no use for it at that particular moment.

BATCHELOR: Would that stop you from doing certain kinds of work?
WEINER: It would preclude me from giving instructions to anyone who wasn't employed to help produce the piece.

BATCHELOR: Would it stop you from doing, say, work in a public space?
WEINER: No. I'm a citizen, I pay my taxes, I get commissions without corruption. If someone doesn't like it they can argue with the person who commissioned it in the first place. It's not as if a work of mine is going to do anything worse than make somebody feel bad. I don't think that my politics make me beholden not to make somebody feel bad. That's within my rights as a person.

BATCHELOR: But wouldn't such a work be, in your terms, an imposition?
WEINER: It's presented. If they take it up they take it up. It's up to them. I can say something, but I can't force them to listen. I hope they might, I might even try to seduce them into listening. You see a work on a billboard which says, "The way you're living your life is incorrect, you should be living your life in a different way" and you don't buy it, you don't do it. Billboards don't come down and hit you on the head and put you in jail. There's always a choice.

BATCHELOR: That sounds like the beginnings of an existentialist argument.
WEINER: That's my generation's background. But more the existentialism of

Genet than that of Sartre or Camus...I have immense respect for all three, but its the difference between slam dancing and Joe Orton. I have great respect for Orton as a playright. And Fassbinder, for the same reasons.

BATCHELOR: In a fairly recent essay Benjamin Buchloh talked of your work as the "negation of painting", and several people working within the orbit of Conceptual Art talked in similar terms - of the "supersession" of painting in favour of newer technologies, or of the written word.
WEINER: It is not the intention of the work to negate anything. It was never involved with that. It was involved with the misuse of painting - the non-materiality of painting, the illusional quality of painting, the things that art is not properly involved with. Art should always be involved with empirical reality. Painting for generations had been used in an illusional situation, in a pseudo-mystical situation. It was using the Jesuit idea: "One day you shall be intelligent enough and perceptive enough to see the world through the eyes of the artist". That's not the point.

BATCHELOR: Aspects of what you say sound approximate to the Modernism of Greenberg or Fried, to their arguments for the segregation of the various verbal pictorial and three-dimensional arts.
WEINER: Their aspirations for painting were not at all terrible. It was the painters they used as illustrations who were reactionary.

BATCHELOR: "Reactionary" in what sense?
WEINER: They were using a pat solution. They were making art about context rather than art about content.

BATCHELOR: Can you be more specific? You make this distinction quite often, but I'm not clear on what terms it's made.
WEINER: Art about context is art that uses either the negation of an accepted premise in art history, or the negation of a pat or standard form of art, or the acceptance of art history as its holstering and its bulwark, and that's all it does. Art about materials, art about content, fits within that context of history (it might negate, or shore up, or whatever) but that's not the subject matter of the work. For me that's the major moral distinction in the making of art. When I said (in a piece I did with Joseph (Kosuth) and Kathy Acker) that I was not "content", I intended the "double entendre", and I was saying that the emotional state of the artist is not a legitimate subject matter for work. Which is not to say it is not a legitimate reason for making a work.

BATCHELOR: So what is the legitimate content of a work, given that expressionism and its predicates are out the window?
WEINER: Still to this day I don't understand the acceptance of expres-

sionist work. All art's an expression of what you have to say. But your personal enlightenment or your personal angst is not a fit subject for art. It might be a fit subject for literature, or poetry perhaps, but art is about material objects.

BATCHELOR: Would you make the same kind of argument in respect of the kind of social realism which treats the medium or means of representation as something essentially transparent?
WEINER: Yes, except I find myself in a dilemma here in not wanting to be against didactic work that agrees with my own political and moral convictions. And yet: ...I fudge on it. I guess we all do.

BATCHELOR: Less and less, perhaps. I think there is something morally dubious about making work from ever-so-correct political themes presented in unproblematic artistic forms. I also find it uninformative as politics and uninteresting as art.
WEINER: You're getting older. And that kind of work doesn't change anything. It all ends up on the same wall in the same bank. Decent art, if it is a material reality for your own times, an honest apprehension of the material, can be used as a metaphor in any other time without imposing the values of that generation upon the generation that uses it next. If it's a metaphor just upon the temporal situation it will work just at that moment. And that is what agit-prop is about. Most of the artists we know about who made agit-prop saw it as what it was. They brought all their competences and knowledge from their practice as artists to that work, which is fine, but that doesn't make it art.

BATCHELOR: Do you do agit-prop work?
WEINER: When the situation arises. Just the same as any other human being. You do what you can for a particular cause. The Vietnam War made that quite clear.

BATCHELOR: How significant do you think the wider political and cultural moment of "1968" - the Vietnam War, the events in Paris - was to the critical artistic work of that period which went under the name of "Conceptual Art"?
WEINER: Let's say it was easier from 1966 onwards to make good work. There was a "frisson", a sense that if you didn't pull together and try to make the best culture you could we were going to be living as abject animals. It was very hard to make bad art in the late sixties.

BATCHELOR: I can think of a few who succeeded... Is it easier to make bad art now?

WEINER: It's not as easy to make good art. It's harder to know whether you're throwing pearls before swine. At least in the sixties you found yourself living your entire existence amongst people who, at least, were fighting for the same human rights as you. That gives you a different sense of your audience... I was on some panel once - God, it was dreary - a discussion about then and now. I was trying hard to say there was a time when everybody was fighting for something worth fighting for, and it sounded nostalgic and terrible. But when there is a collective apprehension of the need to survive, you try your damnest to make the best things possible for your culture.

BATCHELOR: What about Conceptual Art? Many things were made under that name by many people.
WEINER: There were artists who were trying to make a place in art where discourse became pan of the content - Art & Language in England, Kosuth in the early days. The majority of artists, though, used discourse only as context. I was asked to participate in the first issue of Art-Language, which I did with great pleasure, and I even got a money order for twenty-eight dollars for a reprint of a book of mine.

BATCHELOR: Sol Lewitt and Dan Graham were the other American artists who were invited to contribute to that issue.
WEINER: I'm pleased to be associated with them. Again, these are artists who attempt to make discourse into content. And that's what art is about - it's taking things that perhaps were on the side of the road and bringing them into content. It's the reason I don't find Duchamp an interesting artist: all he was interested in was the opinions of his elders, only in the context. When art is made only to please and to instruct the people who are buying it, it's not good art. When it's made to enrich the people who are buying it, when it's giving a good quality product for hard-earned money, that's good art. That's a slight difference, but a slight difference is a big deal.

BATCHELOR: You talked earlier about how seeing Pollock's work had affected your thinking ...
WEINER: People have forgotten what Abstract Expressionism was about. It certainly wasn't some macho fantasy; it was the first time that American men could acknowledge inner feelings. They made paintings that were celebratory of the end of the war, celebratory of an international culture, and celebratory of the fact that men had feelings which meant something. They presented psychoanalysis as a kind of understanding, not as self-indulgence. It was nothing to do with U.S. imperialism; it was the opposite of that. And David Smith... Here was a steel worker who built submarines,

and his work is so "feminine", and about "failure". I still think that John Chamberlain was one of the most important sculptors to come out of the States. This was the generation which formed me.

BATCHELOR: Typically, your work has had a fairly transient character, in the sense that it is inscribed on the walls of a gallery for the duration of an exhibition...

WEINER: It's a practical convention, and not one invented. A person in Italy who was interested in my work, and had purchased quite a bit, invited me to his place when I was in Turin making a book. He had got someone to paint some of my work on the walls. I looked at and thought "My God, this doesn't do anything wrong, why not". And over the years, out of respect for your public, you attempt to figure out ways to present it that will not endanger the work itself. It's quite practical.

BATCHELOR: The convention of temporary wall drawing or inscription carries with it some substantial implications regarding objecthood, authorship, ownership, and so forth. These are not incidental, are they?

WEINER: First, the graffiti on the gallery wall may no longer exist after it's been sandblasted, but the work still exists. But if the graffiti had a content, and you saw it, you would remember it... Second, it's temporal, it's my own relation to the times, it's my own relation to what I sense as a sense of style, it's my own relation to my own dignity of how I want to present myself.

BATCHELOR: In terms of technique, and perhaps in other ways also, your work shares something with Lewitt and Buren.

WEINER: I take it as a compliment to be linked with two artists I respect. But there are differences. You may see a photograph of Buren's work, or a 'souvenir' as he calls it. And you may see the documentation of Lewitt's presentation or installation of mine, essentially all you have to remember is the meaning of the words. You don't have to remember the architecture.

BATCHELOR: Yes, there are differences. Lewitt and Buren don't use words in their installations, although some kind of text is normally causally significant in the production of the work. In a way, whether the words are visible or not, much of this work still seems to highlight the complexities of relationship between texts and images.

WEINER: What you see you translate into language. Art is a legible, readable thing. Pictures are a language. There is no difference, according to Chomsky.

BATCHELOR: Pictures and texts both refer, or denote, but as Goodman points out, they do so in different ways.

WEINER: I made a pin for Printed Matter. It said "Learn to Read Art". Goodman made one mistake. He saw nomination as a creative act, whereas it is a non-creative act. It is just a means of communication.

BATCHELOR: On the issue of how you install or present your work again: its transient character seems also to draw attention to or unsettle the conventional distinction between the studio as a site of production, and the museum or gallery as site of distribution and consumption. Much of the recent Art & Language work has dealt with the idealisations implied by such distinctions, at least as they are applied to recent art.

WEINER: Absolutely, but there is a slight difference. When I make a show in a commercial gallery and there is no charge for admission, no cultural or emotional imperative on the person who comes in, in effect the gallery gives away its saleable object. The person who buys the work knows damn well that they're not buying something that someone else has not been privy to. Once they buy it there's no possibility that that work can he hidden away in a vault. And whenever practically possible I either put the work "itself" or a synopsis of it on the invitation card. So there is an important difference between what we saw as the role of the gallery - which was a question long before Conceptual Art, as it is called - and what it is now. The gallerist becomes a complicit conspirator with me in the presentation of the work to a public. If the public cannot afford it, they can still have it. This makes making a living a bit complicated sometimes, but it also makes making the art a lot more rewarding.

BATCHELOR: You seem to be arguing that the work can in some essential sense be "had" irrespective of the conditions of its display. I don't find it that easy to prise apart "content" from "context". We don't just see, we see as. Surely a phrase emblazoned on the walls of the Leo Castelli gallery is not likely to be regarded the same way as that phrase scratched on a toilet door. Also, the graphic form of your work is often striking. Is this important?

WEINER: I work very hard to make decent installations for people to take the trouble to look at. For the same reason I try to make posters as "legitimate" as humanly possible. The drawing is also important in these works; they give a visual paradigm, as pictographs. Pictographs are a kind of visual notation. They represent an idea, and you can still have this when the work is no longer physically present.

BATCHELOR: Practically, how do you go about designing and producing a work?

WEINER: These are two different things. There's the presentation of the work, which involves certain kinds of decisions - technical, political and so on. We have talked about this. Then there is the work itself. This starts out as a very simple proposition. I become enamoured, or intrigued, or interested in a particular material. Often I bring the material upstairs into the studio, because while you may have a certain insight about the material there are many other things you don't know about it. You deal with the material in relation to other materials, and from that you begin to test the premise or insight you began with. I translate what I learn from this into language. That is my job as an artist. I then take on the role of professional artist. I take what I've translated, try to clean it up, find a usage, a sentence fragment, a means of presenting that in a way which would be, if not immediately comprehensible, then at least understandable to the majority of people I'm interested in. Then you have to hustle around and try to find a means to show it. When you're closed out of the gallery system, you make a book. If you have something to say you can always do it, you can put it out on a poster, that's very cheap to do. In each case - gallery or book or poster - you have to design the presentation as best you can out of courtesy for your public. In the gallery you attempt to set a "mise en scène", a presentation that politically and morally is concurrent with how you feel about the relationships of human beings to the society. And that's it. It's that simple. After so many years I hope I've got reasonably good at making a design and a presentation which presents what I stand for.

David Batchelor is an artist and writer on modern and contemporary art, he is a Tutor in Critical Studies at the Royal College of Art, London.

The interview originally appeared in *Artscribe*, no. 74, March/April 1989.

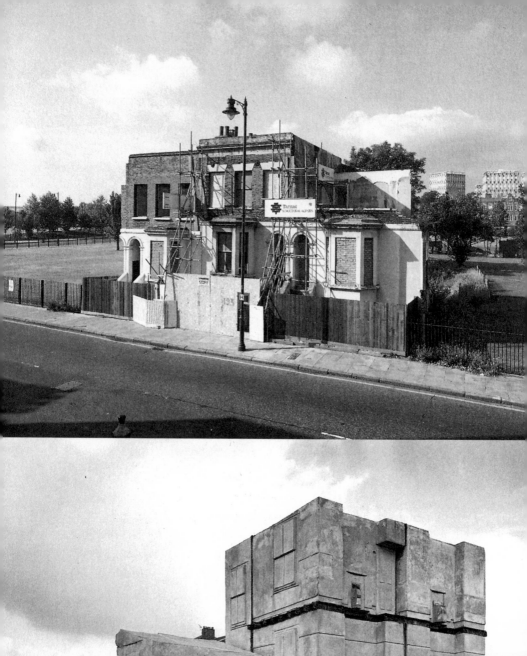

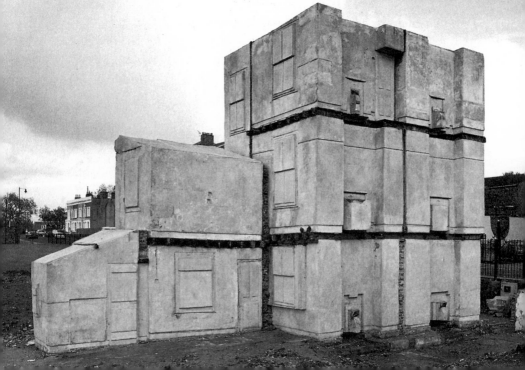

A hollow space can be a place of concealment, protected against the unwanted gaze. Children love to crawl into such hiding places. Alone and temporarily free to do as they wish, they create an imaginary world within the empty space. Turning empty spaces inside out engenders entirely new ways of seeing.

Inside-Outside. With her casts of ordinary, utilitarian objects from everyday life, Rachel Whiteread* makes the negative sides of things palpable and visible. The resin and rubber objects are simple, their aesthetic form radically reduced. The negative image of a utilitarian object disregards function as it embodies a purely aesthetic manifestation. Nevertheless, the artist's primary intention is not to visualize an object's physical presence. Instead, Rachel Whiteread's artworks are meant to prompt the viewer to unite the processes of perceiving, imagining and remembering. "Ghost" (1990), a cast made from a real space, and "House" (1993), that of a building scheduled for demolition, allude to the symbolic significance of hollow spaces as memory. The compact sculptural aesthetics of the negative preserve the memory of neglected, hidden spaces. (G.D.)

Rachel Whiteread
Everything is Connected

INTERVIEW BY OTTO NEUMAIER

OTTO NEUMAIER: One of the first things that people experience when entering one of your exhibitions is that they are invited by your works to touch them, on the one hand, but are not allowed to do that, on the other. I can imagine, of course, that one reason for this is the condition of the works, that is, their surfaces should not be impaired. One side effect of this is, however, that the visitors are restricted to one perceptual channel: they can only look at the pieces instead of having also a tactile experience of them.

RACHEL WHITEREAD: The easiest way to talk about this is with a piece called "Ghost" which I made at the beginning of the nineties. It was the cast of a room. It wasn't a cast of my student room, however, as it is said in the catalogue of the Salzburg exhibition. It was a room near where I lived, but it wasn't somewhere that I actually had a connection with. At the time when I made the piece, I had very little money; so I was making it in quite difficult circumstances, and I was working inside this room, working on my own, just casting the room, with plaster, by hand. I have

* 1963 London / lives in London.

been working maybe three months making this. When we came to take it out of the room and to re-install it in my studio to make a structure for the inside of it, it hadn't really occurred to me what I had made until I came in one day after I had actually installed the object, opened my studio door, and there was the back-to-front door of the room. And suddenly I realised that I was the wall. And I think this is always the case with all of my works. You look at it, and you are the mould or you are the wall or you are the chimney breast, and so on. It has this very strange perception, it changes the way you look at something.

NEUMAIER: Could we say, then, that the whole process of creating such a negative image of a room becomes part of your experience as the artist and that your experience enters into the piece and becomes perceptible to the viewers too, so that they can imagine what it is to cast the inside of such a room?

WHITEREAD: In a way. But I think you can regard a piece like this and my work in general quite differently. Many years ago, someone described "Ghost" as being like the dust in his pocket. For him it was like putting his hand in his pocket, of some overcoat that he hadn't worn for six months, and he would find all this residue in there. To me it was a very nice idea that it was like this sort of forgotten dark space that everybody has on their clothes or in their rooms or underneath their beds of wherever. These places are a sort of forgotten places, things that we completely take for granted, that we have invented for ourselves to use, but we always forget about what's under here.

NEUMAIER: I think it is an important aspect that you direct our consciousness to things that we take for granted. In some sense, everything that surrounds us is something we take for granted. To perceive something means then, however, to realise that it means more to us or that it means anything at all to us.

WHITEREAD: I remember saying a long time ago that it was like giving these forgotten places an authority, giving them a place in this world. Finally, they have a voice of their own. But I have been working at this now for eight years or so, during which the world has obviously changed and different things happened, and now the way I make works is much more complicated. I was originally just using the objects and casting directly from them. Now I take the object, and I make the mould of the object, and it becomes a much more complicated process that is in a way much more traditional, a sort of sculptural process, with mould making and casting.

NEUMAIER: There are two rooms that you casted, which are very different from their aesthetic appearances. One is "Ghost" and the other one

"Room". You could say, of course, that these are just different rooms...

WHITEREAD: Well, "Ghost" was from an actual room in a building, whereas "Room" was an invented room. I made the façade of a room, I made the room in wood and decorated it, I wall-papered it, I painted it, I put windows in, and so on. So, it was exactly like a room, but there was no light-fitting and the like, there was nothing there. It was untouched by human hands. It was almost like making the antithesis of a room, something that was just so particular and so much part of what we experience now as architecture. So it looks like blank architecture.

NEUMAIER: This sounds a little bit paradoxical, because the piece called "Room" is much more the result of your personal intervention, but it is the less personal room.

WHITEREAD: Absolutely. And I think that this happens a lot with my work. The more I make the work the more personal it is, but the more distanced it is as well. And this is something I tried to do after making "Ghost", because I found that "Ghost" in a way was quite nostalgic. There was this fire place, around the light-fitting there were finger marks, there was wall-paper, and you could see the pattern of the wall-paper, you could see the paint marks of where the wall-paper had been painted over. I was really trying to get away from that, trying to make something that has much more to do with process, that appears much more as heavy-handed.

NEUMAIER: But we could regard all that from another perspective too. If I am informed correctly, you started with castings of your own body and then you changed this to the casting of anonymous objects. Of course, we could regard this just as a kind of generalisation or collectivisation of experience or meaning, but if you say, on the other hand, the more personal it is the more distanced it is, we could also say, the more distanced your objects are the more personal they are.

WHITEREAD: That's true. When I first started casting from furniture, the furniture was very particular and I spent a lot of time choosing the objects and, in a way, they were connected to my childhood. This sort of cheap post-war furniture that you have in England is very much a kind of utilitarian furniture. My parents had it, my grand-parents had it, and I knew this very well. So, in some sense, I used that furniture. But then things changed gradually. I have made a lot of chair pieces since, but it's really using a chair almost as an excuse to make a block.

NEUMAIER: You are talking now about the "Table and Chair" pieces?

WHITEREAD: Yes, the "Table and Chair" pieces, but there is also a piece that was recently in Pittsburgh, called "One-Hundred Spaces". It was a hundred chairs that were cast in resin. The "Table and Chair" pieces happened after

making "House" which was the very large concrete house that I made. I was looking for an architectural equivalent in furniture. So when I was looking for chairs I was really turning it upside down. This has to do with the chairs looking like buildings or somehow relating to buildings. This is what I intended rather than trying to cast a kind of baroque chair. It has to do with this very rigid structures. And this really came from "House", after having made "House".

NEUMAIER: The way how these objects change their characters is something I would like to come back later. Right now, I would like to stick to the point mentioned before, namely, that getting some distance to oneself is a very usual way of dealing with oneself. I can imagine that getting this distance is also a way for you to deal with yourself. It is a kind of looking from the outside or from the space around you upon yourself. And in some sense, this idea underlies the whole concept of your work. Is that true?
WHITEREAD: Yes. But I think you have in some way answered your own question.

NEUMAIER: There are always objects in your work. And, of course, these objects have some meaning. Usually they have some meaning to us in our everyday life, but it seems that the artistic objects mean people, although in an indirect, distanced way.
WHITEREAD: Yes, but I think that this is very much relating to earlier work. And for me it is quite difficult to talk about a work that I have made five years ago. Take, for instance, the mattress pieces: I saw them very much as neglected people, the way you see in streets. This does not happen so much in Austria or in Germany; here it is much cleaner, but in London there is a lot of poverty, there is a lot of homeless people. And you see a lot of rubbish around where I live, in the East End of London which is a kind of neglected place. The mattress pieces are related to this. I am using these mattresses almost as a sort of metaphor for neglect.

NEUMAIER: This brings us back to perception, because to perceive means in some sense to overcome negligence, to give meaning to something. In this sense we could say that your works are invitations to people to give more meaning to their environments and from that to their own lives. Is this again answering my own question?
WHITEREAD: No, for me this is very clear, it is absolutely clear with the work, but it is not something that I tend to talk about so much. I don't give the works titles anymore. You know, they are just "Untitled" and, maybe, in brackets it is said what it is: it's a mattress, or it's a bed, or whatever. I titled some of the earlier works, but then I made a conscious decision to stop making titles for my works, because it gave too much away

and led the viewers into some specific direction. You know, the work is very simple, the objects are very simple.

NEUMAIER: Many of the pieces that are shown in your exhibitions in Salzburg and Vienna are from the beginning of the nineties. So, they have those titles or sub-titles, and sometimes it's strange to see "Untitled" and then, in brackets, there is a title.
WHITEREAD: Well, it's not really a title. It's a word.

NEUMAIER: What's the difference?
WHITEREAD: A title will often describe something. You have a title for a book, and it's describing the book. On your recorder, there is a title, "Walkman Professional", which describes what the object is.

NEUMAIER: But your "word" is not describing what the object is?
WHITEREAD: In a very basic way, yes. It names it. It's like in "A Hundred Years of Solitude". In this story they forgot the names of objects. They would start writing the names of objects, and then they forgot what it was; so they had then to describe what it was; and then it got very very complicated.

NEUMAIER: But some of your most recent pieces, or pieces that seem at least to be re-worked most recently, have titles. I mean the "Torsi". They have even one of the most "speaking" titles of your works, but they are still recent.
WHITEREAD: Well, it's something that I have been working on from 1990. It's an ongoing process that I am using these hot-water bottles and manipulating them so that they take on different forms.

NEUMAIER: When we start making associations from this title, we get into some direction, and we have to conclude that most of your pieces could have this description or title or word, that is, "Torso", because we have to supplement something, and those hot-water bottles are objects as the other ones. Of course, you could name your pieces "Torso 1", "Torso 2", "Torso 3", etc., but even in that case you would give some direction to the viewers.
WHITEREAD: The first "Torso" piece that I made was in 1989 and, in some sense, it just kept that name. It's just the name that it has now. Yes, for me, it is very descriptive. It's not saying "Hot-Water Bottle", but it's actually alluding to a person or parts of a person.

NEUMAIER: At this point I would like to come back to perception. I mentioned already that the viewers are not allowed to touch your objects.

Does this prohibition hold generally? For instance, are even the owners of your pieces not allowed to touch them either?

WHITEREAD: If they want they can touch the pieces...

NEUMAIER: Well, you can't control it, of course...

WHITEREAD: No, this is not my request. It is not me who says, "Don't touch", it's something that the museums say.

NEUMAIER: So, you wouldn't mind if someone touches your works? The reason why I am interested to know this is mainly that if you are allowed to touch something you get different perceptions than if you are not. Touching is a good way to intensify your perception and your understanding. And I don't know how to think of your work in this respect. Because, if we are not allowed to touch an object we have to rely upon one perceptual channel only, we have to regard it. And this means that we need much more time to grasp all those things that we could touch with your fingers maybe much faster. So what the whole idea comes to is that time is a central category in your work.

WHITEREAD: Absolutely, I think that's true, but I think that it's true even if you are able to touch an object. I mean, time is a very important part of the work. It is in some sense immediate: the work is immediate, it's a block of something, it's a colour, it's a form. There are also nuances of the work that take time to look at. But I think that's the same with any art.

NEUMAIER: I fully agree with you, but I'm afraid that dealing with art is not always ruled by taking its time or taking one's time.

WHITEREAD: Well, what can I say? I think the pieces are simple, and they are thoughtful pieces. And you have to have time to look at them.

NEUMAIER: But when we go to exhibitions, we usually don't take enough time, particularly with regard to those great events, to retrospectives, etc. So, in some sense, the art business runs contrary to the intentions underlying your work or all artists' work.

WHITEREAD: Well, it depends. Sometimes, I go to an exhibition and I spend four hours there, and sometimes I go to an exhibition and spend five minutes. It depends upon the exhibition, it depends upon how you are engaged with the art you are looking at. Some things take time, some people give a lot of time to it.

NEUMAIER: Another aspect of time in your work is that most of your pieces are durable. It seems that it is only "House" that was created only for a short amount of time. Or did you create also other works of that kind?

WHITEREAD: No, it was just "House". "House" was a very particular pro-

ject. When I decided to make the piece we had to find a house that was going to be demolished. I had a very strong view so that we couldn't, for instance, buy a house, because I felt that I didn't want to take someone's home. "House" was very much about making a memorial to a home, but it made me uneasy to think that a family could have lived in the house that didn't feel right. Finally, we found this house, and we had six months in which we could use it, make the piece and then show it. But, obviously, for all sorts of reasons, the piece took longer to make etc. and, eventually, when "House" was finished, there were only three weeks left for the piece to stand up. So, then, there was a big fight, because everybody saw the work, and they liked it, and they wanted it to stay up for longer. The matter went even to Parliament, and there was all this commotion, and everybody was screaming and shouting about it, and eventually we managed to get it stay up for a bit longer. Then, many interesting things happened. For instance, one of the politicians looked at it and got interested in it, and he tried to achieve a decision that it could become a heritage site so that it could stay up forever. I didn't want it to stay up forever, but it was just really giving it a sort of stay of execution. But when the politician talked to the lawyers, they said: "No, it's impossible, because it's actually a new building, it's a brand-new building".

NEUMAIER: Your "House" was a brand-new building?
WHITEREAD: Yes. The outside of the house was 120 years old, but that was gone. The inside of the house was a brand-new building, however, so that you could not put a preservation order on it. It's very interesting how these things work.

NEUMAIER: But could the whole construction hold for much more time than it was created for?
WHITEREAD: Yes, it could have done. It was made from concrete, and it had its own foundations. It was a secure building and wouldn't have fallen down.

NEUMAIER: Maybe, "concrete" is a good key-word. You use materials that are also used in everyday production of such objects, but usually, you don't use the same materials that are used for objects of that kind, but you change the materials. In that way, the whole aesthetic appearance, or the value, of the objects is also changed. Would you also think of creating objects that have the same materiality as in our everyday life, or is it a principle of your work to defamiliarise the objects in that way?
WHITEREAD: It is absolutely important for me to defamiliarise objects and, as we said before, to change their perception. A lot of the materials I use were earlier-on connected to bodily functions. Some of them were very

flesh-like, some of them were like dead flesh, some of them had the colour of urine. This was very much a part of some of my earlier work. Now, this has changed a little bit. I know the materials I use. I tend to push them as far as they can go. I'm using materials that are normally invented for making something of, say, the size of only a few centimeters. I phone up the companies and I talk to the chemists and talk to people who invented the materials and say: "Is it possible to use a big volume of this?" And they all say: "I don't know". So, then, I have to try.

NEUMAIER: Do you use the materials also in combinations that are not used before for industrial purposes? For instance, rubber and high-density foam?

WHITEREAD: No, I think this is something that is used in mould-making. The reason why I use a sort of high-density foam is that there is a flexibility in it. For instance, when the "Amber Mattress" pieces are away from the wall they are flat. It is only putting them up against the wall what makes them stay there. So, these pieces are very much like a mattress, they have the same physicality as a mattress.

NEUMAIER: The "Convex Bed" and "Concave Bed", on the other hand, are rigid.

WHITEREAD: Yes, they are made from a plastic that was invented for making skateboard wheels, so, for very small objects. It's a sort of very tough plastic. When I made those pieces I was thinking about bodies in spasm. So, they have this sort of rigidity.

NEUMAIER: Did you also study chemistry in order to know the behaviour of material?

WHITEREAD: Not really. I wouldn't say that I'm a chemist. I understand technical data sheets and I had an assistant who was a chemist, and he worked through it with me. For instance, with a lot of the resins that I have been using, it's very complicated to adjust the catalyst in the resin to cast large volumes, because of the heat. There is an excess of chemical reactions every time you pour a layer; so each time it is only poured maybe one centimeter thick, and it has to be left, and then the next layer and the next layer… These are all things that I have learnt through trial and error, sometimes a lot of error.

NEUMAIER: Now it seems, however, that you have reached a real mastership in using these modern materials.

WHITEREAD: Well, I make everything myself, or with assistants, but everything comes out of my studio. I don't get other people to make it.

NEUMAIER: Anyway, one result of this process is that the real objects change their appearance to something like an architectural space, the "Table and Chair" pieces for instance. But then you have one hundred of such pieces in one room, and this gives the impression that it is not only the inner space of the object you are interested in, but the objects you create are, then, again in a room, or a space, and they are surrounded by this space and, thereby, forming a new space. So it's not just the space you are showing, it's the whole situation, the atmosphere and all that.

WHITEREAD: Absolutely. I am very careful in the way a work is installed. If I can be, I am at every exhibition that I am involved with and install it myself. But with something like "One Hundred Spaces", I think I used eleven different chairs, and I was very interested in grouping them in such a way that they were on a grid so that the space, when you walked through the grid, changed all the time; it was always very different. And I thought of it very much of a sort of "cityscape", it's like a miniature city - with these small buildings and these roads you walk through.

NEUMAIER: In a broader sense, perception does not only consist in grasping something via the senses, but it includes also imagination - that is, the conception of images in consequence of having made sensual perceptions of objects - and remembrance or memory - that is, the keeping of impressions. It is often said that the central category of your work is memory. But, as you said before, everything is connected or related. So, what is essential for your work is, maybe, this connection between perceiving something, imagining something and keeping something in mind.

WHITEREAD: For me, it's really essential that everything is connected. I treat the things that I make as a whole. The work is never finished until it's installed, until I find the right place for it to go, the right way for it to stand against the wall. I remember very early on when I first started working, I made a piece and looked at it, but I couldn't find the situation for it. I thought the piece was a failure, but I couldn't understand why, because it was exactly what I wanted. But it had just to do with placing it, with turning it upside down and leaning it against the wall, and then it was finished.

NEUMAIER: Was this the first piece you made of that kind?

WHITEREAD: No, "Closet" was the first piece that I made, which was the wardrobe. No, it was one of the earlier "Slab" pieces. I just couldn't get it to work, I couldn't find a place for it. It's like if you have a piece of furniture in a room, and it can't fit in the room, and you can't work out where it has to go. You end up changing the whole room around in order to make one thing sit in the right place. And that's really how I make the work. It's very much due to a kind of physical relationship to the pieces and also a

spiritual place for the pieces, all those things which I find very important, and all becomes one in the end.

NEUMAIER: So, a certain kind of spirituality is important for your work?
WHITEREAD: Yes.

NEUMAIER: And we can regard your work as a kind of spiritualising every-day objects?
WHITEREAD: In a way, yes.

NEUMAIER: This brings us back to the nature of the objects you are using. They are everyday objects, objects that are taken for granted by people in their everyday life, they are there, so to say, from birth to death. You can find the presence of death, for instance, in those "Slabs". I think they were shown also in Kassel at the documenta, but I realised only now that they are actually taken from mortuary slabs. But it seems that the begin-ning of life is equally important in your work. For instance, the "Beds" could be understood in that way. At least, babies can be born in beds…
WHITEREAD: Exactly. I mean, babies are also often made in beds…

NEUMAIER: Yes, this happens…
WHITEREAD: And people often die in a bed. I think beds are incredibly rich. A bed, or a mattress, is a very rich area. But when we are talking about this area, I want to talk also about "Plinth" which is the most recent piece in-cluded in the Salzburg show. This is also connected with a mortuary slab. It is actually the space underneath the large ceramic beds or slabs that you have, and you have these stands for them to sit on; there are two ceramic stands, and then under that there is this space and there is a sink at the end for washing down afterwards. I had these two objects in the studio and eventually decided to try to make a plinth. Actually, a plinth is something that I never use. I have always hated plinths. For me they are just like very strange non-places to put something on to get it off the ground. So I want-ed to use that in connection with making a very simple object. It's almost a kind of non-object; you can even dismiss it, because it's hardly there really. But I decided to use this space where all these dead bodies had been be-forehand and to use that in a way of paying respect to that area.

NEUMAIER: Your works have been compared to "death masks" of cultural objects. Death masks are usually taken from dead people but, on the other hand, they are taken from people whom we regard as valuable, whom we think to be worth that death masks are taken of them. Are your works intended to be death masks of those objects or are they rather death masks with regard to the human meaning of the whole thing?

WHITEREAD: Again, I would say it's very much part of the same thing. Yes, they can be seen as death masks. After I have used a mattress or a table or whatever, it's destroyed, it's gone. So all that exists is the sculpture; this is what is left of the object. In this sense, it's a death mask. It's like the death mask of a body that has been buried, or cremated, or bombed, or whatever you want to do to it. But for me this is very much the same thing as giving life to an object, something that would be neglected, something that is going to be completely forgotten - no-one cares about a second-hand mattress. Why should they? It's going to be burnt or put in a rubbish heap or whatever. And it has not really to do with that specific mattress.

NEUMAIER: The point is that it could be regarded as a metaphor of a dying culture. But if this culture is dying or is already dead, we could say - like before with the person - that it is at least worth of having a death mask of it or that we should much more take care of it or estimate it much more. And here we are back to the subject of perception we talked about at the beginning.

WHITEREAD: All of these things are so connected. It's very difficult to pull out an area and to say, it's about this or about that. All of these things are suggestions, are suggestions you are making, suggestions that the work makes to you, etc. I don't like to say: "Yes, that's absolutely correct" or "Yes, that's exactly how I like to think about the work". I make the work, I have my very personal ideas about the work, why I make it, what it is, and what it means to me. And what it means to me could be entirely different to what it means to another person. I like to leave that as open as I can.

NEUMAIER: Your work can also be regarded as a death mask in the sense that it is a remainder of your creative process. What really matters, where your whole personality goes into, is the creative process. And the work is then a kind of residue of this process. But this shows, then, that there is a connection between your work and other artistic approaches of our time, although the aesthetic appearance is quite different. It's certainly not by chance that so many artists now deal with trash or second-hand objects and all that. It seems that you all make us aware of things that we usually neglect.

WHITEREAD: It is the detritus of our culture, it's all that shit or "Müll", it's what's left.

NEUMAIER: Well, it is not only our culture which leaves a lot of things. Every culture leaves something, although these things can be quite different. For instance, if you think of the aborigines in Australia, what they leave

is a part of a song, a song which enables people to create, or to re-create the whole world. But what we leave is garbage, trash, material. Could we say, thus, that your work, particularly in its materiality, is a kind of critique of our culture?

WHITEREAD: You could say that. I am not going to say that, but you could say that. I like things to be as open-ended as possible. Of course, it is some kind of critique of the world I live in. I live in the twentieth century, and I am fullly aware of what goes on around me. And all that becomes part of the work, but I think it would be very pompous for me to say: "Yes, I am criticizing our culture by making my work".

NEUMAIER: It was not my intention to fix you to this point. I only wanted to suggest that we could regard this as a starting point, the world that surrounds you, and that there is also a critical attitude contained in your work which is shown by your way of dealing with what is left.

WHITEREAD: My work is absolutely connected to contemporary culture, not only in terms of material objects, but also in terms of sculpture and art history. Those things have informed me just as much. I'm not just working in my backyard, going to second-hand shops etc., but I have an understanding of contemporary cultural life.

NEUMAIER: And you would say also in this respect that everything is connected?

WHITEREAD: Yes, absolutely.

Otto Neumaier, a philosoper and writer, teaches at the University of Salzburg; he is editor of *Conceptus* and co-editor of *Noëma*.

The interview originally appeared in *Noëma*, no. 43, December/January 1996/97.

List of Illustrations

John Baldessari, *Yellow (With Onlookers)*, 1986.

Matthew Barney, *Cremaster 1: Green Lounge Manual*, 1995.

Dara Birnbaum, *Transmission Tower: Sentinel*, 1992.

James Lee Byars, *The Monument to Language*, Paris 1995.

Maurizio Cattelan, *Lessico Familiare*, 1989.

Stan Douglas, *Hors-champs*, 1992.

Luciano Fabro, *Demetra*, Münster 1987.

Peter Fischli & David Weiss, *Untitled*, 1988.

Dan Graham, *Star of David*, Schloss Buchberg, 1989 / 1996.

Damien Hirst, *Hanging Around (Filmstill)*, 1996.

Jenny Holzer, *Florence Text*, Firenze 1996.

Joseph Kosuth, *Passagen-Werk (Documenta-Flânerie)*, Kassel 1992.

Jannis Kounellis, *Untitled*, Palermo 1993.

Sol Lewitt, *1/2/3 (Progression)*, 1993.

Maurizio Nannucci, *Lets talk about art... maybe*, Edinburgh 1992.

Bruce Nauman, *Andrew Head / Andrew Head Stacked*, 1990.

Giulio Paolini, *Contemplator Enim*, 1995.

Hiroshi Sugimoto, *Regency, San Francisco*, 1992.

Diana Thater, *Electric Mind*, 1996.

Rirkrit Tiravanija, *Elements of Untitled (Free)*, 1992.

Niele Toroni, Chicago Renaissance Society, 1990.

Bill Viola, *The Sleepers*, 1992.

Jeff Wall, *The Stumbling Block*, 1991.

Lawrence Weiner, *More Salpeter Than Black Powder...*, Helsinki 1995.

Rachel Whiteread, *House*, London 1993/1994.

Printed in January 1999 by Grafiche Morandi, Fusignano (Ravenna) / Italy